F.V.

JOURNAL FOR THE STUDY OF THE OLD TESTAMENT SUPPLEMENT SERIES
261

Sheffield Academic Press

Goddesses and Trees, New Moon and Yahweh

Ancient Near Eastern Art and the Hebrew Bible

Othmar Keel

Journal for the Study of the Old Testament
Supplement Series 261

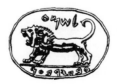

Published by
Sheffield Academic Press Ltd
Mansion House
19 Kingfield Road
Sheffield S11 9AS
England

Typeset by Sheffield Academic Press
and
Printed on acid-free paper in Great Britain
by Bookcraft Ltd
Midsomer Norton, Bath

British Library Cataloguing in Publication Data

A catalogue record for this book is available
from the British Library

ISBN 1-85075-915-4

I dedicate the volume to Professor Dr Tryggve N.D. Mettinger and to the Faculty of Theology of the University of Lund, Sweden, to the former as a sign of respect for his important scholarly work, to the latter as a token of gratitude for conferring to me the *Doctor honoris causa*.

CONTENTS

PREFACE

The two studies presented in this book are concerned with two natural phenomena—namely trees and the new moon—as perceived and assessed in ancient Near Eastern art and the Hebrew Bible. It is remarkable how differently these two phenomena were adapted into the symbol system mirrored by the latter. Yahweh is a god on high, who can be associated with mountain peaks but not with caves (cf. Keel 1997a: 181-82), with heavenly bodies but not with trees. The reason for this difference in adaptation is based upon the perception that everything connected with the life out of the earth, from the depth or from the darkness, is associated with transience and death. Yahweh is only exceptionally related to these realms (cf. Ps. 139.8, 15). One consequence of this one-sidedness is that, the tree sprouting from the earth was eliminated from the religious system of early Judaism in an increasingly radical way. Yet on the other hand, a specific festival was devoted to the new moon. In contrast to almost all other festivals mentioned in the Hebrew Bible the new moon festival was never brought in line with Israel's 'salvation history'. It represents the theoretically unproblematic (cf. Ps. 135 and 136) but barely ever realized case of a creational instead of a historical 'work' of Yahweh that became the object of celebration.

For publication, assistance with the English version was given by Anthony Clark, Inés Haselbach (translation of Part II), Hildi Keel-Leu, Frances Klopper and Christoph Uehlinger. The drawings not taken from the publications mentioned in the footnotes were carried out by Inés Haselbach and Hildi Keel-Leu. I thank Aurica Nutt for stimulating discussions on Hos. 2.4-15 and Christoph Uehlinger for many valuable suggestions improving different aspects of the text. Ulrike Beelte-Henkenmeier checked the bibliography. I thank Professor David J.A. Clines for accepting the two studies as one volume of the Supplement Series of the *Journal for the Study of the Old Testament.*

Othmar Keel
Fribourg, Switzerland, September 1998

ABBREVIATIONS

AB	Anchor Bible
AfO	*Archiv für Orientforschung*
AJA	*American Journal of Archaeology*
AJBA	*Australian Journal of Biblical Archaeology*
AnSt	*Anatolian Studies*
AOAT	Alter Orient und Altes Testament
ATD	Das Alte Testament Deutsch
BA	*Biblical Archaeologist*
BARev	*Biblical Archaeology Review*
BASOR	*Bulletin of the American Schools of Oriental Research*
BBB	Bonner biblische Beiträge
BK	*Bibel und Kirche*
BKAT	Biblischer Kommentar: Altes Testament
BN	*Biblische Notizen*
ConBOT	Coniectanea biblica, Old Testament
FRLANT	Forschungen zur Religion und Literatur des Alten und Neuen Testaments
HKAT	Handkommentar zum Alten Testament
EBib	Etudes bibliques
ICC	International Critical Commentary
IEJ	*Israel Exploration Journal*
JAOS	*Journal of the American Oriental Society*
JBL	*Journal of Biblical Literature*
JNES	*Journal of Near Eastern Studies*
JSOTSup	*Journal for the Study of the Old Testament*, Supplement Series
JTS	*Journal of Theological Studies*
KAT	Kommentar zum Alten Testament
LCL	Loeb Classical Library
MDOG	Mitteilungen der Deutschen Orient-Gesellschaft
NTOA	Novum Testamentum et Orbis Antiquus
OBO	Orbis Biblicus et Orientalis
Or	*Orientalia*
OrAnt	*Oriens Antiquus*
PEQ	*Palestine Exploration Quarterly*
PJ	*Palästina-Jahrbuch*

RA	*Revue d'assyriologie et d'archéologie orientale*
RB	*Revue biblique*
RHR	*Revue de l'histoire des religions*
SBL	Society of Biblical Literature
SBLMS	SBL Monograph Series
SBS	Stuttgarter Bibelstudien
SBT	Studies in Biblical Theology
Sem	*Semitica*
SJOT	*Scandinavian Journal of the Old Testament*
TD	*Theology Digest*
ThWAT	G.J. Botterweck and H. Ringgren (eds.), *Theologisches Wörterbuch zum Alten Testament* (Stuttgart: W. Kohlhammer, 1970–)
VF	*Verkündigung und Forschung*
VT	*Vetus Testamentum*
VTSup	*Vetus Testamentum*, Supplements
WBC	Word Biblical Commentary
ZA	*Zeitschrift für Assyriologie*
ZAW	*Zeitschrift für die alttestamentliche Wissenschaft*
ZDPV	*Zeitschrift des deutschen Palästina-Vereins*

Part I

EARTH AND TREE GODDESSES IN ANCIENT NEAR EASTERN ART
AND IN THE HEBREW BIBLE*

* The paper was originally presented as a lecture at the Theological Faculty in Lund, Sweden, on 30 May 1996 on the occasion of receiving an honorary doctorate from that university and, additionally, at the Bible Lands Museum, Jerusalem, on 17 July 1996.

Chapter 1

INTRODUCTION

My thesis is as follows: both real and artificial trees were objects of worship in Syria and Palestine for centuries because they were seen as manifestations of a single female deity or of a number of different ones.[1] A close and wide ranging relationship between tree and tree figures on the one hand and goddess and goddess images on the other is now and then called into question, but has most recently been vigorously contested by Christian Frevel in a quite detailed, thousand-page Bonn doctoral dissertation, 'Aschera und der Ausschliesslichkeitsanspruch YHWHs' (Frevel 1995).

In the first part of his work he analyzes biblical texts mentioning Asherah. In the second part he criticizes the positions of U. Winter, S. Schroer, C. Uehlinger and me, that is the 'Freiburg School' as he calls it, on the subject of 'tree and goddess' in the Middle Bronze age IIB, in the Late Bronze age and in the Iron ages. It is Frevel's express intention to bring the Asherah 'boom' of recent years under control. To do this, on many points he carries skepticism 'to extremes, in order to concede again a greater right to the realm of "open questions"'.[2] Frevel's attempt at intellectual honesty is in itself laudable. Still we have to bear in mind that the interpretation of works of art presupposes a minimal confidence in the intent and the capability of a culture to create a more or less coherent symbol system. Consistent mistrust in this regard is as much of an obstacle as consistent credulity in any

1. For earlier discussions of this and other aspects of tree symbolism and cult see, for example, Danthine (1937); Kepinski (1982); Metzger (1983, 1991, 1992); Winter (1986a, 1986b); Schroer (1987b); Nielsen (1989a, 1989b); Keel (1993a).
2. Frevel 1995: 836-38, 915, 923-24; esp. 837: 'Der hier vorgelegte Versuch treibt in manchen Punkten deshalb die Skepsis auf die Spitze, um dem Bereich der "offenen Fragen" wieder ein grösseres Recht einzuräumen'.

effort appropriately to understand any given state of affairs. In addition to this Frevel's culture of mistrust and question marks seems to me quite often to derive from a modern model of thinking whose favourite instruments are a rigorous syntax and a binary logic, a model for which there hardly exists anything except identity and difference (*x* is *y* or *x* is not *y*). He seems to me to be fairly unsympathetic to the ancient Near East's preference for parataxis, association and ambiguity. For example, he narrows the use of the concept 'sacred marriage' to the precisely defined understanding of the Sumerologists (Frevel 1995: 595-628) and rejects its use for Northwest Semitic culture, without the slightest effort to understand and to name the icon of the weather god who steps up to his spouse while she is uncovering her pudenda.[3] Frevel is not concerned to make a constructive contribution to a better understanding. He is rather concerned to cut back on—what he calls—wild speculation and (1) to show that the 'interchangeability of goddess and tree' is unprovable and that the motif of the caprids on the tree does not consistently manifest the goddess (Frevel 1995: 791, 837, 852-53). (2) He wants to demonstrate that there is no iconographic phenomenon which can with certainty be identified with Asherah. On this second point his result is rather dramatically 'diametrically opposed to the most recent study of O. Keel and C. Uehlinger: none of the images can be certainly characterized as Asherah images. *There is no genuine Asherah iconography*'.[4] In his last sentence he moves, however, to a certainty that is in no way supported by his detailed work. His detailed results are in no way diametrically opposed to ours. The difference is rather one of general stance. Where he prefers to be suspicious, we are more confident.[5] He asserts that it cannot be convincingly disproved that the Asherah had the form of a stylized tree (1995: 583-84).

3. For the relevant material see Winter (1987: 272-83) and Keel and Uehlinger (1995: 40-45).

4. Frevel (1995: 924): 'Das Ergebnis fällt diametral zu der neuesten Studie von O. Keel und C. Uehlinger [Keel and Uehlinger 1995] aus: Keine der Darstellungen läßt sich sicher als Ascheradarstellung bezeichnen. *Es gibt keine genuine Ascheraikonographie*'.

5. Conversely, when, in order to avoid the idea of Asherah as a tree, the 'planting' of the Asherah in Deut. 16.21 is understood metaphorically by Frevel (1995: 183-85) on the basis of very late texts (Dan. 11.45; Qoh. 12.11; Ps. 94.9), he is full of confidence although that is a statement of personal preference, not a research result.

Considering the Lachish jug (fig. 49) he remarks 'that a relation to Asherah cannot be completely ruled out'.[6] On the terracotta fragments from Afek and Revadim he comments that 'the connection with Asherah is certainly possible in principle but must be designated as quite uncertain'.[7] The identification of Asherah with Qudshu or Qedeshet pictures is not beyond all doubt (Frevel 1995: 853). All these statements are cautious but far from being diametrically opposed, particularly because Uehlinger and I myself are not always that affirmative as Frevel seems to suggest.

Among all the questions which Frevel asks, there is one he does not even raise: What should the evidence look like that would allow us to claim unambiguously that an artifact was an Asherah? Presumably it would have to be an image with inscription on it: 'This is an Asherah.' Such a combination of text and picture is not common in Syria–Palestine,[8] and the Egyptian evidence demonstrates how problematic such an occurrence would still be (cf. Chapter 2.4 below on 'name'). As for the Biblical text, after Frevel has cut the connection between Asherah and tree through his metaphorical explanation of 'plant' (נטע) in Deut. 16.21 (cf. note 5), Asherah and Asherah worship resemble a 'black hole' (Frevel 1995: 587). Even Frevel, however, with his minimalistic view concedes that the Asherah pillar or sculpture or whatever was made of wood (עץ).[9] We have to keep in mind that wood was not at all a material normally used to produce representations of deities, at least not as primary material. Materials used to make the bodies of the gods were gold, lapis lazuli, bronze, stone and other precious and durable

6. Frevel (1995: 810): 'daß sich ein Bezug zu Aschera nicht völlig ausschließen lässt'.

7. Frevel (1995: 817): 'muß die Verbindung mit Aschera als grundsätzlich zwar möglich, aber sehr unsicher bezeichnet werden'; a similar position is held in respect to Lapps cult-stand from Taanach (1995: 847).

8. For a similar criticism of Frevel's work see Zwickel (1996).

9. 'Über das konkrete Aussehen jedoch, über identifizierende Merkmale oder ähnliches erfährt man aus diesen Nachrichten nichts. Auch für das Aussehen des Kultsymbols der Göttin, die Ascheren, geben die alttestamentlichen Belege nicht viel her. Über die wenig konkreten Basiswerte, daß es sich um einen aufrecht stehenden hölzernen Gegenstand handelt, kommt man mit den biblischen Nachrichten nicht hinaus' (Zwickel 1996: 923).

materials.[10] For the representations of Asherah, however, wood was apparently essential. The only imaginable reason for exclusively using wood (עץ) is the close relation of Asherah to the tree (עץ) (Nielsen 1989b).

I shall come back to the problem of how to identify particular iconographic phenomena as 'Asherah representations' after taking a look at Egyptian tree goddesses and the iconographic evidence of tree and goddess in the first half of the first millennium. More immediately I would like to address Frevel's first question concerning the relation of one or more nameless female deities to particular representations of trees. Many of his question marks will be seen to be unjustified.

As C. Uehlinger and I did in our Monograph (1995), Frevel starts with the material of the Middle Bronze age IIB. He does not take into consideration the earlier history of the problem 'tree and goddess' in the Early and Middle Bronze age IIA. The following chapter seeks to demonstrate how old and widespread the relation between tree and goddess in the ancient Near East was, dating from at least the third millennium.

Figure numbers in bold refer to figures in this book.

10. Exod. 20.23; 32.2-4; Lev. 26.1; Judg. 17.1-6; Isa. 30.22; Ezek. 7.19-20; cf. also Exod. 34.17; Lev. 19.4; Keel (1977: 255-60). Kletter (1996: 77) gives no evidence for his statement that wood was common to cult statues in the whole ancient Near East. The statement is baseless. If it was used at all, it was used as a core, hidden to the eyes of the beholder.

Chapter 2

VEGETATION, TREES AND GODDESSES IN THE BRONZE AGE

Vegetation, Trees and Goddesses in the Early Bronze Age and in the Middle Bronze Age IIA

The image of goats at trees with their front legs extended as they try to reach leaves and buds is a familiar one to those who have watched caprids in the open. Caprids climbing trees can frequently be seen on Egyptian tomb reliefs of the fifth and sixth dynasties (c. 2500–2200 BCE) (**fig. 1**).[1] In this context they are one element in richly detailed country scenes. In Mesopotamia this affecting scene of hunger and its satisfaction has, since prehistoric times, been represented in isolation,[2] rather than as part of a larger scene. The sculptures from the tombs of the kings of Ur from around 2650 (**fig. 2**)[3] are a well-known example. The isolation of the scene elevates it to an eminent case of physical hunger and its stilling, and thus to a symbolic level. The rosette-shaped leaves of the tree belong to the sphere of the goddess Inanna, as we know her from seals from Uruk. On one of these seals in the Vorderasiatisches Museum, Berlin, the 'prince and priest' (*ensi*), flanked by bundles of reeds, the sign of Inanna, is seen feeding the horned sheep of the goddess with rosette-shaped leaves (**fig. 3**) (Moortgat 1940: no. 29; Strommenger and Hirmer 1962: pl. 17d).

A goddess emerging from the earth (?) is represented on a seal from Shadad near Kerman in Iran dated to the middle of the third millennium (**fig. 4**) (Orthmann 1975: fig. 283b). Plants sprout from her arms, her shoulders and her head. To her left are four animals. To her right is a

1. Moussa and Altenmüller 1971: pl. 4; cf. also pls. 18 and 19; *idem* 1977: pl. 20 and fig. 8; Keel 1980: 72-73 figs. 29-31.
2. An early example is Delougaz (1952: pl. 14 [Khafadje IX 60]).
3. Strommenger and Hirmer 1962: pl. XIV; cf. Pritchard 1954: nos. 667-68 (the original objects are in the British Museum, London, and in the University Museum, Philadelphia).

second goddess in human form. This representation of the goddess is most probably related to fertility deities on Akkadian seals (c. 2350–2150 BCE), sometimes male, sometimes female, from whose shoulders sprout branches or stalks (**figs. 5a-b**).[4] A goddess sitting on a heap of grain holds an additional branch in her hand. She is approached by three gods of fertility. Two of them carry a box with a scorpion underneath, an age-old symbol of fertility (Keel and Schroer 1985: 26-38, with figs. 1-8). Fig. 5b shows the same goddess as fig. 5a. She holds three branches in each hand. Branches are on her skirt and are flanking her (cf. figs. 22-27). A seal impression from Tello (ancient Girsu) from the time of Naramsin (2260–2223 BCE) shows the same type of goddess as fig. 5a sitting on a heap of grain with stalks sprouting from her arms and shoulders. With one hand she grasps the flowing vase (Van Buren 1933) (**fig. 6**) (Delaporte 1920: 11 no. T.103). The plant emerging from the flowing vase is almost completely destroyed but traces can still be seen. The interesting figure behind the sitting goddess most probably represents a statue standing on a truncated cone. The stalks sprout not just from her shoulders but also from her body. Similar figures can be seen on a famous late Akkadian (2250–2150 BCE) cylinder seal from Mari on the Euphrates (**fig. 7**),[5] which R.M. Boehmer classifies with the group of Akkadian seals here represented by figs. 5 and 6 (Boehmer 1965: 97). The Mari seal clearly shows two tree goddesses since there are not just *stalks* sprouting from their shoulders but *leafy branches* growing from their bodies. They flank a god who sits on a mountain. The one on the left holds a little tree in her hands, the one on the right, a vessel. Both emerge from the water at the foot of the mountain which flows out of bird- or snake-like heads.

Two goddesses with flowing vases with emerging plants (fig. 6) are represented in the anteroom on the well-known painting of the Ishtar temple at Mari dated to about 1750 BCE (**fig. 8**).[6] A statue found at the

4. Fig. 5a = Collon 1982: no. 209 = Boehmer 1965: fig. 541; fig. 5b = Frankfort 1955: no. 611 = Boehmer 1965: fig. 547; the group is discussed by Boehmer 1965: 94-97; cf. also Matthews 1997: 369) for an Akkadian seal impression from Tel Brak showing a god with a flowing vase beside a fertility deity.

5. Parrot 1954: 153 and pl. 15.1; Parrot 1962: 189, fig. 228; Keel 1997a: 47, fig. 42. The impression from Tell Brak mentioned in note 14 is in some respects a link between the Mari seal and the ordinary Akkadian representations of fertility deities.

6. Parrot 1958: 56-57 and pls. X.2, XI; Parrot 1962: 279-80, fig. 346; Keel 1997a: 143, fig. 191.

same place and from the same period (**fig. 9**) (Parrot 1962: 272-73 figs. 339-40; Keel 1997a: 188 fig. 256) was made with a hole in the back, leading to the vase, so that water could flow out of it. According to the pictorial representation of fig. 8 the vase probably contained a live plant. The deities with the flowing vase are usually male.[7] Still there is evidence also from Old Syrian glyptic for female deities holding the flowing vase with a plant (**fig. 10**).[8]

The combination of goddess, plants and water on figs. 6-10 can explain the noteworthy iconography of an Old Syrian cylinder seal (c. 1850–1720 BCE) from the former Marcopoli collection (**fig. 11**) (Teissier 1984: no. 535: Christie's 1993: Lot 205), today held by the Biblical Institute of the University of Fribourg in Switzerland (BIF Inventory no. VR 1993.3). It shows a stylized palm tree flanked by two fish, perhaps dolphins, and two worshippers. The central position of the palm tree—shown on the Mari painting (fig. 8) as an attribute of the goddess—and the presence of worshippers demonstrate its supernatural quality. The fish strengthen the thesis that the tree has to be related to a goddess. Parallels make it clear that this combination is not a matter of accidental and unhappily chosen visual padding.[9] On a contemporary seal the worshippers and the fish flank instead of the palm tree a naked winged goddess grasping a flower (**fig. 12**) (Porada 1948: no. 963; Winter 1987: fig. 134). The seal is, if not from the same workshop, at least from the same region and period as the curiously drawn spirals in the terminal suggest. On another contemporary Old Syrian seal two high-stretching goats, domestic or wild, or ibexes (caprids) flank a highly stylized tree (**fig. 13**) (von der Osten 1936: no. 98). It is surprising that two fish are again seen at the base of the tree. The entire composition is once more flanked by two worshippers. The one on the

7. Van Buren 1933: pl. 8 fig. 30; pl. 12 figs. 40-42; pl. 13 figs. 43-44. A figure grasping the flowing vase on a cylinder seal in the Louvre is certainly male (Delaporte 1920: pl. 96 no. A.914). Winter knows it (1987: 428), but the incomplete drawing published by him suggests that the deity should be female because the beard is omitted (1987: fig. 440; cf. el-Safadi 1974: figs. 61, 169). The impression that the deity should be female is supported by the animals behind the figure: caprid, hare, dove, scorpion. They all are part of the entourage of Syrian goddesses.

8. Porada 1948: no. 929; Winter 1987: fig. 441; cf. also Porada 1948: no. 928.

9. At the end of a long list of animals which can flank palm trees in ancient Near Eastern pictures Danthine (1937: 105) adds 'même des poissons... ou des sauterelles'. See, for example, Ward 1910: 305 fig. 960 = Danthine 1937: 105 fig. 89. The two devotees are replaced by two winged goddesses (?).

left holds an Uas sceptre whose head is turned in the wrong direction. On the right a god with a slit coat and a horned crown steps into the symmetrical composition. He holds a tree sceptre that is typical for the weather god.[10] The weather god on the one side and tree and goddess on the other face each other on a seal from the former Moore collection (**fig. 14**) (Eisen 1940: no. 158). The naked goddess raises her hand here. It is not clear whether she thus wants to protect the tree or to greet the weather god. Since the palm of the hand is turned outward, it is more likely a matter of protection.[11] Figs. 13 and 14 both combine the tree and the weather god. Fig. 14, however, does not express the relation between tree and goddess by caprids and fishes flanking the tree but by the anthropomorphic figure of the naked goddess protecting the tree, which is menaced by the snake representing the sea (Keel 1986: 308-10).

An Old Syrian seal in the Ashmolean Museum shows a partially unveiled goddess with a fish in front of her and two caprids flanking a tree behind her (**fig. 15**).[12] She is led by a double-faced god into the presence of the highest god (see fig. 7) characterized by the flowing water. On an Old Syrian cylinder seal found in east Karnak, Upper Egypt, a stylized tree grows out of the head of the goddess, the so called 'Hathor head' (**fig. 16**) (Porada 1983: 237-40; Teissier 1996: 102-103 and fig. 202).

To sum up: In Syria at the end of the third millennium and during the first quarter of the second millennium (Middle Bronze I or IIA) images of trees, some highly stylized, occur in portrayals of goddesses, as her manifestations. Goddesses appear as the trunk (fig. 7) or as the root (fig. 16) of a tree. The goddess can appear in a palm tree flanked by fishes

10. Williams Forte 1983: 18-43, esp. 40-42 figs. 6-15; Keel, Keel-Leu and Schroer 1989: 263-66. On the classical Old Syrian seals the weather god usually wears a short apron. In fig. 7, however, we find a slit coat with a figure that is most probably a weather god.

11. An additional instance of a naked goddess beside a tree can be found in Teissier (1984: no. 502). In this case her hand is turned inwards to greet the Syrian mistress, who stands on the other side of the tree (cf. Teissier 1984: no. 501, where a worshipper takes the place of the Syrian mistress). On another Old Syrian cylinder seal the naked goddess stands beside a little sanctuary with a twig (Keel 1994a: 224 and pl. 23.3-4). The Syrian mistress herself is flanked by a huge flower and stylized tree opposite the weather god on a cylinder from Ugarit (Schaeffer–Forrer 1983: 54 no. RS 28.025).

12. Buchanan 1966: no. 864; el-Safadi 1974: fig. 129; Winter 1987: fig. 263.

(fig. 11) or fishes and caprids (fig. 13) or standing in anthropomorphic form next to her tree (fig. 14). In these instances the tree is closely related to water (fish). The goddess with the flowing vase (figs. 8-10) represents a possible way of connection between goddess, water and plant. Similar but not identical patterns of portrayal (the flowing vase, for example, disappears from the iconography in the second quarter of the second millennium) will be encountered again in the Middle Bronze age IIB, in the Late Bronze age and in the Egyptian New Empire.[13]

Trees and Goddesses in the Middle Bronze Age IIB

Frevel emphasizes that he does not want to give an overview of 'tree goddess' iconography. 'Thus we will only use illustrations sparingly. In the appendix will only be found drawings of the most important or thoroughly discussed pieces.'[14] But there one will look in vain for the clearest proofs of a connection between goddess and tree from the end of the Middle Bronze age and the beginning of the Late Bronze age: the group of metal pendants. These are indeed mentioned in a note, but not discussed, and their importance for the matter is ignored.[15] These metal pendants or lockets of Middle Bronze age tradition, as found especially on the Tell el-'Ağul south of Gaza, in Minet el-Beida, the harbor of Ugarit, in Ugarit itself, but also elsewhere, show as a rule a female figure reduced to head and body, in which the breasts and the navel are

13. It seems that already in Old Syrian glyptic the tree is not exclusively related to a goddess but is also linked to kingship (cf. Keel, Keel-Leu and Schroer 1989: 252-59). Taking into consideration the close connection between the ruler and the city goddess during the Middle Bronze age II A, however, the question of whether the tree relates to kingship in itself or only through the intermediary of the goddess cannot be satisfactorily answered (cf. Teissier 1996: 26-32). The matter is much less ambiguous when in Palestinian glyptic the male gods Horus and Sobek, as the patrons of kingship, flank the stylized tree (cf. Keel 1995a: 225-26 and figs. 512-13).

14. Frevel 1995: 781 n. 190: 'Daß die folgende Darstellung nicht das Ziel verfolgt, einen Überblick über die Ikonographie der Zweiggöttin zu geben. Dementsprechend wird nur sparsam mit Abbildungen umgegangen. Im Anhang finden sich nur die wichtigsten oder ausführlicher diskutierten Stücke in Umzeichnungen.'

15. Frevel 1995: 785 n. 207. It is difficult to avoid the suspicion that Frevel unconsciously ignored the group just because it displays a connection between goddess and tree/branch which is so obvious that it cannot be contested.

often merely sketched in but the pudenda are strongly emphasized.[16] On a piece from Tell el-'Aǧul (**fig. 17**)[17] the head is framed with shoulder-length locks. At the throat there is a lotus flower. Again we have the 'Hathor head', which in fig. 16 is closely connected with a stylized tree. Here a branch or tree is growing out of the navel, as in many others. Schroer has rightly maintained that branch, young tree and stylized tree are not easily distinguished iconographically (Schroer 1987a: 202 n. 4). In another pear-shaped pendant with a 'Hathor head' from Ugarit the branch grows out of the pudenda (**fig. 18**) (Schaeffer 1938: 322 fig. 49:5; Negbi 1976: 190 no. 1690) and that is not an isolated case.

Besides the pear-shaped type there is another type, where the head is contoured. In this type too we find the connection pudenda-branch, as on a piece from Ugarit (**fig. 19**) (Schaeffer 1937: 145 and pl. XVIII; Negbi 1976: 96 fig. 108, 188 no. 1661), and the link navel-branch, also from Ugarit (**fig. 20**) (Schaeffer 1937: 319 fig. 48:11; Negbi 1976: 96 fig. 110, 188 no. 1664). All these examples demonstrate that in Syria–Palestine toward the end of the Middle Bronze age and well into the Late Bronze age, the image of a goddess served as an amulet which was venerated as a creator of vegetation, if not of life itself. The differentiation between vitality for plants and animals or vitality for humans only, much used by Frevel, corresponds well to modern European ways of thinking but is rather out of place in the ancient Near East, as many biblical texts also show.[18] That without the growth of plants no animal and no human life was possible was obvious to the Levant, which was so often afflicted by drought and famine.[19]

In another type of metal pendant the body is stretched out lengthwise and comes to a point at the bottom. One may well ask whether this rather unusual form for a pendant does not imitate a cultic pole or stake carved out of wood. In one example of this type, from Kamid el-Loz in

16. See Negbi 1970; Negbi 1976: esp. 95-103 and Catalogue nos. 1657-707; Keel 1994b: 175 figs. 104-107.

17. A poor colour photograph can be found in the *editio princeps* by Mackay and Murray (1952: pl. B, second row from above, to the left); a good one is in Winter (1986a: fig. 25).

18. For his splitting up of elements that, according to ancient Near Eastern patterns of perception, are closely connected see, for example, Frevel (1995: 787, 814); biblical texts are Gen. 49.25; Deut. 28.4; Hag. 1.10.

19. Both biblical stories of the creation, Gen. 1 and 2, closely connect the creation of plants and that of humankind.

Lebanon, the head is shaped like a branch or a tree (**fig. 21**).[20] This recalls the Egyptian custom of mounting the appearance form of a deity, for example, a scarab, on an anthropomorphic figure as a head.[21] There can hardly be a clearer representation than the one displayed by these metal pendants. The connection between a goddess who manifests herself through the earth which produces vegetation and, *pars pro toto,* trees, is here particularly clear. The almost unavoidable connection of this goddess to the weather god is shown by images of a type seen in figs. 13 and 14, and probably already in fig. 7 where the threatening floods (in fig. 14 represented as a serpent) still appear simply as water.

Contemporary with the metal pendants are scarabs typical of Palestine, displaying a naked goddess, frequently with strongly accentuated sexual features. She is flanked by branches or is holding branches.[22] The motive should be interpreted in connection with the iconography of the metal pendants. Scarabs are certainly a less elegant medium for images than pendants of gold, silver or bronze. However, since the beetle form and the technical know-how necessary for their production were both borrowed from Egyptian culture, which was much admired in Palestine at that time, and because its material had to be imported (Keel 1995a: 147-48 §§386-90), the scarabs must have had a special prestige. Usually the goddess is presented with her head *en face* or in profile, simply flanked by two branches or trees. The arms simply hang down parallel to the body (**fig. 22**).[23] Or else they are held on the stomach (**fig. 23**) (Schroer 1989: 97 no. 5 [from the Jerusalem antiquities market]) or on the chest (**fig. 24**) (Schroer 1989: 97 no. 3 [Jericho]). In several examples the hands hold branches (**fig. 25**) (Keel 1995: 211 fig. 422 [British Museum, London, EA 66 165]). On two scarabs of this group the relation of the branches to the pudenda is especially stressed, analogous to the metal pendants (**figs. 26**[24]**-27**[25]). In both pieces the

20. Hachmann (1980: 51 and pl. 16.9 [no. 130]); cf. also a bronze figure from Hazor with a 'tree' at the top of the head (Negbi 1976: 97 fig. 112).

21. Hornung 1963: I Zehnte Stunde no. 710.733-36; Elfte Stunde no. 762; Thausing and Goedicke 1971: pl. 3.

22. Cf. Schroer 1989: 89-207, esp. 92-138; Keel 1994a: 222-24 and pl. 22-23; Keel 1995a: 80 fig. 130, 210-12 § 574-76.

23. Tufnell *et al.* 1958: pl. 32.99; for a naked goddess flanked by two stylized trees on an Old Syrian cylinder seal see Keel (1994a: 224 and pl. 23.2).

24. Giveon 1985: 114f. no. 16, Gezer.

25. Giveon 1988: 50f. no. 44: Keel 1997a: Afek no. 21.

connection to the flanking branches is also especially close. In fig. 26 the goddess is holding the branches. The elements that we interpret as branches right and left and over the vulva, Frevel interprets as pubic hair (Frevel 1995: 785). His reason is that there are only a few[26] parallels (metal pendants) to the vulva–branch combination and there is only *one* branch to be seen. There is, however, absolutely no parallel to a stylization of pubic hair such as is here present. According to Frevel the shaping of the horizontal line over the pubic area is evidence against the 'twig symbol' interpretation (Frevel 1995: 785). In fact this is much more likely to be a stylized hip belt (cf. fig. 22) analogous to a neck chain, which did not leave enough room for a vertical branch (see metal pendants) and so forced the artist to place the branch on a slant and to double it symmetrically.

In fig. 27 the flanking branches allow the body of the goddess to appear at the same time as a tree trunk from which the branches sprout out (cf. fig. 7). In place of the *pubes* we see a leaf or branch which links the two.[27] Frevel cannot contest the close connection between goddess and branch, but he tries to minimize its importance:

> Without wishing to deny a certainly existing connection to vegetation, the interpretation as a goddess who 'personifies the power of the fruit-bearing earth' (Keel and Uehlinger 1995: 32) seems exaggerated: the branch on this image belongs to the sphere of the goddess, but the goddess does not belong to the sphere of the branch. The goddess and the branch are neither identical nor automatically interchangeable; the goddess can be portrayed *with* a branch, but *not as* a branch.[28]

That sounds quite logical and stringent and yet makes as little sense as if one would comment on a picture of Christ with the cross: 'The cross belongs to the sphere of Christ on these images, but not Christ to

26. There are some dozens (at least) found at many places between Ugarit and Tell el-'Aǧul south of Gaza.

27. Even Frevel (1995: 786) thinks that a close connection between leaf and *pubes* is not erroneous in this case, but he pretends that the piece is isolated and thus does not have much significance. The iconography of the Afek scarab is not unique at all, if one does not ignore the metal pendant (figs. 17-20 this volume).

28. Frevel 1995: 787-88: 'Ohne einen sicher existierenden Bezug zur Vegetation leugnen zu wollen, erscheint die Deutung als Göttin, die die "Macht der fruchtbringenden Erde personifiziert" überzogen: der Zweig gehört *auf diesen Darstellungen* zur Sphäre der Göttin, nicht aber die Göttin zum Zweig. Die Göttin und die Zweige sind weder identisch noch beliebig austauschbar; die Göttin kann *mit* Zweig, aber *nicht als* Zweig dargestellt werden.'

the cross. The cross and Christ are neither identical nor automatically interchangeable. Christ can be shown *with* a cross but *not as* a cross.' Yet clearly the plain cross without the body on the lintel of a door, on a loaf of bread, the ornate cross on the neck of a Baroque lady—all these plain crosses were easily understood for centuries by every child as a Christian sign. Even if they evoke Christ and his work differently from a powerful miracle-working altar cross or Grünewald's Isenheim altarpiece, still there is a clear connection.[29]

Of course the connection between tree and goddess and that between Christ and the cross is quite different. The point of comparison, what they have in common, is their function as signs. The branch and the cross are central elements in their respective symbol systems; even set in the most varied contexts imaginable, they remain easily recognizable as *partes pro toto*. Both can represent by itself the orientation and blessing provided by a complex symbol system. The vagueness of this type of representation is part of the game.

In view of the close connection between goddess and branch/tree it is obvious and plausible to connect the different images of tree veneration on Middle Bronze age scarabs and cylinder seals with the veneration of a tree or rather an earth goddess (see Chapters 4 and 6). A scarab from Tell el-'Aǧul (**fig. 28**)[30] shows an anthropomorphic figure with a hand raised in veneration in front of a simple 'branch tree'. There is an almost identical composition on a cylinder seal from Tell el-Far'a-North (**fig. 29**).[31] The additional element between the worshipper and the tree is perhaps to be seen as an altar. More complex than these two compositions is that on a scarab from Shechem (**fig. 30**) (Pieper 1930: 195-96; Keel and Uehlinger 1995: 32-33 fig. 14a). On the goddess head (cf. Schroer 1989: 139-99; Keel 1995a: 212-13 §§577-79) flanked by

29. One should not regret that Frevel neglected to deal at length with differences between symbol, cult symbol, marker, etc. (Frevel 1995: 931). Distinctions of this kind are usually not very appropriate to the material dealt with. It would, however, have been of importance to take into consideration the functioning of central signs in a given symbol system and their impact on an entire culture (cf. Geertz 1973; Freedberg 1989).

30. Mackay and Murray 1952: pls. 9.16; Keel and Uehlinger 1995: 32-33 fig. 14b; very similar is the iconography of an item from Lachish: Tufnell *et al.* (1958: pl. 36.237).

31. Mallet 1988: pl. 84.2; Keel and Uehlinger 1995: 32-33 fig. 14c; Amiet *et al.* 1996: 24 and pl. III.5; Amiet cuts the impression in such a way that the worshipper and the tree are separated.

uraei and falcons is a gold sign (*nbw*), and under it a tree which splits into three branches. Two kneeling female devotees flank it and touch it. They can similarly flank the naked goddess or head of a goddess (Keel 1995a: 225 figs. 506-507; Keel 1994a: 223 and pl. 22, 3-4).

A haematite cylinder seal from Tell-el-'Ağul (**fig. 31**) (Petrie 1931: pl. 4, 136; Collon 1985: 62 no. 1, 66 no. 1), imported from North Syria, shows two anthropomorphic winged figures kneeling on either side of the tree and protecting it with their wings. Collon sees in them two humans fitted out with wings for cultic purposes.[32] **Fig. 32** (von der Osten 1957: no. 307; Collon 1985: 66 fig. 2) illustrates an Old Syrian seal whose style and iconography are very close to those of fig. 31. This time the worshippers are without wings. Hare and dove in the terminal belong to the entourage of the goddess. An interesting variant is **fig. 33** (Buchanan 1966: no. 888; Collon 1985: 66 fig. 3). The seal cutter substituted the Egyptian sign for 'life' (*'nḫ*) to the stylized tree. The veneration of trees on figs. 28-33 clearly shows that this tree was considered sacred. The close connection between goddess and tree shown by figs. 17-27 strongly suggests the conclusion that the veneration of the tree was actually intended for the life-giving goddess represented by the tree.[33]

Besides worshippers flanking the sacred tree a number of scarabs show caprids in this type of composition, although in contrast to fig. 13 we do not have worshippers and caprids on the same object. Caprids flanking what resembles a tree can be seen on a Middle Bronze age scarab from a private collection in Geneva (**fig. 34**),[34] on one from Gezer (**fig. 35**) (Macalister 1912: III pl. 205a, 20; Rowe 1936: no. 183) and on another one at the Biblical Institute of the University of Fribourg (**fig. 36**) (Schroer and Staubli 1993: 67).

To sum up: Precious objects like metal sheets, scarabs and cylinder seals of the Middle Bronze age IIB portray an anthropomorphic goddess who manifests herself in a stylized tree (or trees) either sprouting

32. Collon 1985: 59. For similar figures see Porada 1948: no. 991; Mode 1950: 87 pl. II,12 (Biblical Institute of the University of Fribourg Inventory. no. VR 1981.164). The two spirals flanking the trunk of the tree may be part of a Ω of which only parts are visible; the Ω can symbolize the womb of mother earth. But this hypothesis is highly speculative (cf. Keel 1995b: 99-101, fig. 15a-b).

33. The veneration of the holy cross in Catholic churches on Good Friday has, of course as its object not the wooden cross but Christ as a saviour.

34. I thank L. Wolfe, Jerusalem, for drawing my attention to this scarab.

from her pudenda or navel (figs. 17-20), forming her head (fig. 21) or flanking her (figs. 22-27). A tree worshipped by one or two persons (figs. 28-32) is almost certainly related to this goddess. This is particularly clear on fig. 30 where the head of the goddess appears above the tree. Occasionally the tree may be replaced by the Egyptian *'nḫ* sign (compare fig. 32 with fig. 33) or flanked by caprids (figs. 34-36; cf. fig. 13), both features stressing the life-giving quality of this tree.

Trees and Goddesses in the Late Bronze Age

The erotically attractive goddess of the earth, the producer of plants, who may be represented by a plant, was of greatest importance during the Middle Bronze age. She appears frequently on very varied materials, but especially on the most costly ones such as metal pendants, haematite cylinder seals, and scarabs. During the Late Bronze age the number of images increases in absolute numbers to be sure, but they are now for the most part set on cheaper materials, composite seals, cheaply produced terracotta moulded figures and plaquettes and hastily painted decorations on earthenware vessels.

By 1939 H.G. May had recognized the goddess represented on pottery paintings showing a more or less stylized date palm flanked by caprids or on which caprids climb (May 1939: 251-59). We should not retreat from this insight. Such paintings were found all over the country, for example on Tel Qashish (**fig. 37**) and in greater number at Lachish and Megiddo (**fig. 38**).[35] The pieces illustrated here date from strata of the Late Bronze age II (c. 1400–1150 BCE). The date palm had long been closely connected with goddesses in the art of the period (cf. fig. 8 above).[36] The combination of date palm and caprids is not a 'natural picture', but a cultural product. The trunks of date palms are far too high for caprids to be able to reach the palm fronds and date clusters.

The Late Bronze age paintings consistently combine the date palm with caprids and the tradition history of this date palm motive suggests an interpretation in terms of the goddess. On a painted jar of Late Bronze age IIB (c. 1300–1200 BCE) from Tell el-Far'a in southern Palestine fish not only flank the stylized tree, as in figs. 11 and 13, but

35. For Qashish see Ben-Tor (1993: 1203); for Megiddo see Loud (1948: pl. 64.4) = Amiran (1969: pl. 50.7).
36. Besides figs. 8 and 11 see Keel (1994b: 156, fig. 93; 239-50); Bloch (1995).

they are linked with the tree by a (water-)line (**fig. 39**).[37] Tree goddesses (fig. 7) and well goddesses (figs. 8–10) were probably mixed up already in the Middle Bronze age (figs. 11 and 12).[38] The meaning of the fish on the Late Bronze age vase painting probably is that the goddess who feeds the caprids also sustains in life the fish and all animals, since even the 'birds of the air' are occasionally to be seen on the sacred tree (**fig. 40**).[39]

On the hastily painted interior decoration of a bowl from Beth-Shemesh tomb 11, which is to be dated to the very end of the Late Bronze age, the stylized tree is twice painted so that caprids seem to grow out of it (**fig. 41**) (Grant 1931: pl. 19). A much older seal impression (1920–1850 BCE), twice attested in Kültepe (Central Anatolia), shows a similar process (**fig. 42**) (Teissier 1993: 603 nos. 4 and 5). Here the caprid heads rise out of the shoulders of a naked goddess.

H.G. May used as the key to his interpretation an ivory pyxis fragment from Ugarit (fourteenth or thirteenth century) which shows a goddess who sits on a mountain and feeds with branches two caprids, who stretch themselves high on the mountain (**fig. 43**) (Schaeffer 1929: 291-93 and pl. 56; Keel 1994b: 55 fig. 11). May is aware that he is probably dealing here with imported Mycenean goods. R.D. Barnett (Barnett 1982: 30) explains: 'This symmetric arrangement is a purely Mesopotamian and Syrian type, but here executed in a Late Mycenaean style.' If fig. 43 is an example of Mycenean style in Ugarit, **fig. 44** (Barnett 1982: 36-37 fig. 16 and pl. 31d) is an example of Levantine work in Mycene. This fragment of an ivory horn for ointment, found in a chamber tomb and dating also from the fourteenth or thirteenth century, shows caprids on either side of a naked goddess and a small palm tree decorated with Egyptian lotus blossoms. As a further Egyptian element the remains of a vulture are seen above the scene.

37. Starkey and Harding 1932: pl. LVIII, Tomb 972; in the same tomb was found a scarab with the name 'Ramses' (Starkey and Harding 1932: L.105); the painting is also shown in Keel (1997: 138, fig. 181).

38. For a much later period see Ezek. 31.4, 14 where the concept can be found, that the underground waters (the 'Urflut') direct all their streams to the sacred tree and that from there they flow in all directions; there is a similar concept in Gen. 2.10.

39. Guy 1938: pl. 134; Amiran 1969: 163 Photo 166; in the slightly earlier Kassite cylinder seal glyptic it is a mountain (earth-mountain?) god who is shown as sustaining all kind of plants and animals (cf. Matthews 1990: figs. 129-36; 1992: figs. 145-49).

This constellation, which suggests the conceptual proximity if not the downright interchangeability of the naked goddess and the tree flanked by caprids, is also found on the impression of a Mitanni seal of the fourteenth century from Kirkuk (**fig. 45**).[40] A haematite seal iconographically belonging to the same group (**fig. 46**) (Van Buren 1954: pl. 22.9; Winter 1987: fig. 147) shows a still closer relation of the naked goddess to the stylized tree as the goddess grasps one of the caprids by a horn and restrains a lion (from attacking the caprids?).[41]

Another pertinent Mitanni seal, produced in haematite, the usual material for Old Syrian seals, was found in a fourteenth-century tomb in the so-called Persian Garden in Akko (**fig. 47**) (Beck 1977: pl. 21,1; Keel and Uehlinger 1995: 63 fig. 53). The seal has two friezes. The lower frieze has a five part 'centred' composition whose axis is formed by the stylized small palm tree. This is flanked by two reclining caprids being attacked by two griffins.[42] Just above the tree a naked four-winged goddess is seen. On her left two lions attack a cow or a bull. On her right a hero overcomes a lion. One could object that it is accidental that in fig. 44 and figs. 45-46 the same caprids flank tree and goddess and that in fig. 47 the goddess is set right over the caprid-flanked tree. But an accident that repeatedly produces the same constellations ceases to be an accident. On another Mitanni cylinder seal from Megiddo a seven-part central composition is seen. A stylized palm is flanked by a fish (cf. figs. 11, 13, 39) and a human head (*pars pro toto*), two caprids raised on their hind legs and a human worshipper (right) and a squatting cherub (**fig. 48**).[43] In this composition another naked goddess

40. Louvre AO 7771; Keel 1994a: 55 fig. 10; for a goddess between caprids flanking a tree see also Merhav (1987: no. 39); to fig. 45 compare a Mitannian seal, which, instead of a tree, shows a nude goddess flanked by two worshippers beneath the winged sun-disc (Keel and Uehlinger 1996: 151, fig. 175; a similar iconography can be seen on Schaeffer-Forrer 1983: 152, no. RS 25.380).

41. C. Uehlinger drew my attention to a very interesting Mitannian seal impression. It shows in Akkadian tradition the weather god on the lion-dragon (Boehmer 1965: figs. 364, 371, 373). The accompanying anthropomorphic rain goddess is replaced by two symmetrical goats (Porada 1947: no. 738 = Keel 1992: 240, fig. 239).

42. It may be that the outstretched paw should signify protection, but the scenes in the upper register do not hint at this.

43. Guy 1938: 182-83 pl. 176.3; Winter 1987: fig. 143; Keel and Uehlinger 1995: 63, fig. 52.

towers between the worshipper and one of the caprids. She is flanked by a reclining lion and a reclining bull flanking a deer.

The decoration on a jug found in the Fosse temple in Lachish offers a different kind of juxtaposition of goddess and tree (**fig. 49**).[44] The vessel was most probably made in the thirteenth century BCE and went out of use in the twelfth. It is only partially conserved. A row of animals can be seen on the shoulder of the jug. From left to right there are a lion, a stag, a deer(?), a huge bird with spread wings, and a stylized tree flanked by caprids. A similar tree with caprids seems to appear further to the right after a considerable lacuna. Above the animals and the tree there is an inscription which most probably reads: *mtn.šy [l rb]ty'lt*. It may be translated: 'A gift, a tribute [for] my [mistr]ess, Elat.' The first word can also be understood as a personal name: 'Mattan. A tribute for my mistress, Elat' (Sass 1988: 60-61 and figs. 156-60; cf. also Frevel 1995: 796-803). Hestrin has emphasized that the word *'lt* stands exactly above the stylized tree flanked by the caprids. She thinks that the word must relate to this composition (Hestrin 1987a: 212-23, esp. 220). Several other authors support this interpretation (Frevel 1995: 803 no. 291). Frevel once more has doubts about the association of image and text as well as about the identification of the image with Asherah as proposed by Hestrin (for the following see Frevel 1995: 805-806). I shall deal later with the second problem. Frevel argues against the relation of image and text hinting at the paintings and inscriptions from Kuntilet 'Aǧrud where such an association proved to be of no help. But it is quite clear that the paintings and inscriptions on the *pithoi* from Kuntilet 'Aǧrud were produced by a multiplicity of hands without any effort to coordinate whatsoever. That is certainly not true of the Lachish ewer. Frevel is right, of course, when he says that the other words of the inscription cannot be related to the picture beneath, for example, *mtn* to the lion. One must take into consideration that the lion and stag relate to the goddess in the same way as in figs. 46 and 48. The central element of this cluster of motifs, however, is the stylized tree flanked by caprids. Moreover *'lt* has to be considered as the decisive element of the inscription. Even if one considers the positioning of *'lt* above the stylized tree as purely accidental, on a gift for the goddess one should expect representations of the donor or of the goddess. The most important pictorial motif on the ewer is the composition of the

44. IAA 34.7738, displayed in the Pavilion of Hebrew Script and Inscriptions at the Israel Museum; Tufnell *et al.* 1940: frontispiece, pls. 51, 60.

stylized tree flanked by caprids. The other animals are directed toward
this centre. A further proof that this element is central is the fact that it
seems to occur twice. Certainly the tree does not represent the donor—
so there is no better choice but the goddess.

Hestrin (1987a: 212-23, esp. 220) draws attention to another vessel
from Lachish. It is a goblet, which four times shows two rampant
caprids facing each other. Instead of the stylized tree they flank an
inverted triangle strewn with dots (**fig. 50**) (Tufnell *et al.* 1940: pl. 47:
229 and pl. 59). Hestrin identifies this triangle as pudenda. 'The trian-
gles are outlined in red paint, while the dots which represent the hair
are black. This interchange of tree and pubic triangles proves, in my
opinion, that the tree indeed symbolizes the fertility goddess...'.
(Hestrin 1987a: 215). Frevel refers to similar triangles. Two cases show
an additional vertical line at the top of the triangle (Frevel 1995: 808-11
and his figs. 8-10). Frevel argues that these vertical lines need explana-
tion. Without a satisfactory explanation of this element he feels unable
to agree unreservedly with Hestrin's interpretation (Frevel 1995: 809).
Different triangles may mean different things. What matters more are
the flanking caprids. If at the same time, at the same place, on the same
'image-carrier' they flank something else it has to be something closely
related to the sacred tree and this is the case for the pubic triangle (cf.
figs. 18 and 19). Schroer was right when she emphasized the similarity
between the pubic triangles of figs. 18-19 and the way the tree of fig. 39
is stylized (Schroer 1987a: 39-40 and fig. 17 = my fig. 39). Frevel's
alternative proposal misses the point. He interprets the dots of the tri-
angle as a device to represent water. But ancient Near Eastern art con-
sistently represents water by wavy or zigzag lines (cf. figs. 6-8, 15, 38,
42, among others) never by dots.

Additional recently published evidence may confirm the interpreta-
tion of the triangles of fig. 50 as pubic triangles insofar as trees with
one caprid each are here placed immediately to the right and the left of
the pudenda of a mother goddess. During the last ten years three frag-
ments of terracotta plaques, one of which is almost intact, have been
uncovered at three different places in Israel. Most probably all three
were made from the same mould (**figs. 51-52**).[45] They show a frontal

45. Beck 1986: 29-34. In this article Beck publishes a small fragment of a terra-
cotta plaque (fig. 51) found at Afek in area X in stratum XII (mid-thirteenth
century) and an almost complete example (just the feet are missing) which was
probably produced by the same mould as the Afek fragment. This second instance

view of a naked woman adorned with a pendant and six bangles. The head is framed by two long drawn-out locks. She has two sucklings below her breasts. The image is not realistic. The sucklings are not held in place. They hardly touch the breasts. Nevertheless it is clear that they characterize the figure as a great mother. The hands of the goddess are holding open her pudenda. On both thighs, facing towards the pudenda, a caprid can be seen climbing a stylized tree. This element is particularly clear on the fragment from Tel Harassim.[46] The caprids are feeding on the tops of the trees placed just beside the open pudenda. Frevel minimizes this: 'The two caprids on the thighs are a secondary motif.'[47] The pudenda, demonstratively held open, play an important role with the 'twig goddess' on metal pendants and scarabs, and are here exactly placed between the two sucklings and the trees with caprids. In a naturalistic interpretation the sucklings belong to the womb, the trees and caprids do not. However, once we put the contemporary portrayals of caprids seeming to feed at the pudenda (fig. 50) alongside the terracottas of figs. 51 and 52, it is clear that this configuration cannot be relegated to the status of a secondary motif. [48]

To sum up: In the Late Bronze age the subject is relegated to less expensive materials as vase paintings and terracotta figures. The anthropomorphic goddess is to a large extent replaced by the tree flanked by caprids (figs. 37-41; cf. figs 13, 34-36). The tree is the same palm tree that was related to the goddess from the third millennium. The caprids, which in reality are hardly connected with palm trees, manifest the life-giving power of this sacred tree. In some instances the anthropomorphic goddess still alternates with the palm tree flanked by caprids (figs. 44-48). In another instance the term 'goddess' appears immediately above the tree flanked by caprids (fig. 49). In one instance the tree is replaced by the pudenda of the goddess, while in another one

is a surface find discovered near kibbutz Revadim. A third fragment which clearly shows the thighs with trees and caprids was excavated in 1994 on Tel Harassim in the Shefela. See the following note. Fig. 52 represents a drawing combined from all the available fragments.

46. Givon 1995: 42-46 and fig. 16.2. It was found in stratum V, which is dated by the excavator to the fourteenth or thirteenth century.

47. 'Die beiden Capridendarstellungen auf den Schenkeln bilden nur ein Nebenmotiv' (Frevel 1995: 814).

48. For evidence of goddess and tree and tree cult in the Late Bronze and Early Iron ages in Cyprus see Meekers (1987: 67-76); for Bronze age Crete see Marinatos (1989, 1993: 37, 53-54, 180-83).

tree and goat flank the latter. As on the Middle Bronze IIB metal sheets
of figs. 17-21, the Late Bronze age terracotta of figs. 51-52 shows trees
coming forth from the goddess's anthropomorphic body.

Egyptian Tree Goddesses of the Late Bronze and Early Iron Ages in Image and Name

Image

In Egyptian paintings and reliefs of the Late Bronze age, that is, the
eighteenth and nineteenth dynasties (c. 1530–1292 BCE and 1292–1190
BCE), and the Early Iron age, that is, the twentieth and twenty-first
dynasties (1190–1075 BCE and 1075–945 BCE), dozens of images are
known of a goddess manifested in a tree, usually a sycamore, some-
times a date palm. I have discussed these at length elsewhere.[49] There
are a great number of variations. As far as the link between the tree and
the goddess is concerned, we can regularly attest the following types.[50]

Type 1:[51] From the tree protrude one or two human arms and in
isolated cases also a female breast (Keel 1992: fig. 40 = here **fig. 53**;
48, 51b, 59, 60, 66, 69, 70 = here **fig. 54**).

Type 2:[52] From the tree protrude the breasts, the upper torso or the
entire body of a woman (except the feet); sometimes it seems as if the
body grows from the trunk of the tree, at others as if she is within the
tree and only partly visible (fig. 43 = here **fig. 55**; 49, 50 = here **fig. 56**;
52, 53, 54, 56, 61, 62, 66a, 68, 71, 73-77 = here **fig. 57**; 78-83 = **fig. 58**;
84-86).

Type 3:[53] An otherwise purely anthropomorphic figure carries a tree
on the head (fig. 46a, 47 = here **fig. 59, 55**).

49. Cf. the chapter 'Ägyptische Baumgöttinnen der 18.-21. Dynastie. Bild und
Wort, Wort und Bild' in Keel (1992: 61-138).

50. Goldwasser (1995: 120-23) distinguishes seven types. Category V (goddess
with cow's head) is represented by one single instance; Categories VI and VII only
differ by the species of the tree represented: VI shows a palm tree instead of the
usual sycamore, VII a combination of sycamore and palm tree.

51. Goldwasser's Category IVa: 'The tree grows human limbs, hands and
sometimes also a breast' (1995: 121).

52. Goldwasser's Category IVb: 'The female goddess grows from the trunk of
the tree' (1995: 121-22); and Category II: 'The peeping goddess. In some instances,
the representation of the goddess gives the impression that she is hiding in female
guise amongst the boughs' (1995: 120-21).

53. Goldwasser's Category Ia: 'The hairdress category ... The tree becomes a
part of the goddess's hairdress' (1995: 120 n. 16). Relying on Baines (1985: 55)

Type 4:[54] The anthropomorphic figure of the goddess is fully visible. She stands in front of the tree (fig. 41?, 63 = here **fig. 60**; 88, 89, 91, 93-95 = here **fig. 61**).

Type 5:[55] The anthropomorphic figure of the goddess is fully visible. She stands beside the tree (fig. 42?, 51c, 90, 92 = here **fig. 62, 96, 97**).

When considered diachronically, we have here the reverse of the process of the transformation of the purely human form of Daphna into a laurel tree.[56] Although it is not possible to fit these images into a strictly diachronic scheme, Type 1 clearly stands at the beginning and Type 5 is characteristic for the final phase of development. At the beginning there is a tree from which ever more clearly a goddess comes forth.

Name

In contrast to the Syrian and Palestinian images of goddess and tree the Egyptian pictures usually carry an inscription. However, disappointment awaits those looking for a clear answer to the question: 'Which goddess is represented in the tree?' The inscription on the oldest image (fig. 53) runs: 'Men-cheper-re [throne name of Thutmosis III] sucking at his mother Isis.' Does 'Isis' indicate the goddess Isis or his real mother whose name was also Isis? The determinative form after Isis (goddess or mortal woman) has been omitted, so the question remains somehow open, though the form of the tree does not suggest a mortal woman. Later a number of goddesses are named as present in the sacred tree. In Theban tomb paintings of the eighteenth and especially the nineteenth dynasties the name of Nut, the goddess of the sky, is predominant. On the funerary stelae of Abydos and the tomb reliefs of Saqqara she seems to be outranked by Isis, the divine mother. Hathor appears relatively late as a tree goddess and then, above all, in her role as 'Mistress of the West' (Refai 1996: 28, 33; Keel 1992: 94). These three possibilities alone are enough to shatter binary logic. But matters

Goldwasser doubts if the anthropomorphic figures with a tree at the top of the head are tree goddesses at all (1995: 120 n. 16). I think that there is no reason for these doubts. Goddesses of the hairdress category appear in the same compositions as other types of tree goddesses, for example, of Type 1 (Keel 1992: 104 fig. 48) and Type 2 (1992: 105 fig. 49).

54. Goldwasser's Category III: 'Superimposition' (1995: 121).

55. Goldwasser's Category I: 'The goddess and the tree are represented separately' (1995: 120).

56. Cf. Ovid, *Metamorphoses* 1.545-56; Palagia 1986: 344-48.

are even more complex. In fig. 58 the tree goddess carries the sign of Isis on her head. Yet in the inscription she is described as 'Hathor, Mistress of the West'. In fig. 62 she carries the sign of Neith on her head. The inscription before her runs 'Nut, Mother of the Gods'. To the right of the tree there is a spell spoken by Hathor. Other goddesses can also be found, for example, Maat in fig. 61.[57]

As far as concerns the name of the goddess connected with the stylized tree, there is a lesson which may be learnt from the Egyptian evidence: We should not strive for an exclusive and strict identification. At different places and times the symbol could be attributed to different goddesses.

Since Asherah was the only major goddess surviving in Palestine in the seventh and sixth centuries, it is safe to assume that the tree, natural or stylized and named after her, was connected with her (Kletter 1996: 76-77 and *passim*).

57. See also the list in Baum (1988: 85-86).

Chapter 3

IRON AGE TREE CULTS

Tree Cult in Iron Age I

In the Iron age I (c. 1200–1000 BCE) a stylized tree is sometimes found as a single motif on stamp seal amulets from Palestine (**fig. 63**) (Keel and Uehlinger 1995: 142-43 fig. 153). By the end of the Late Bronze age there is some evidence on stamp seal amulets of the sacred tree flanked by caprids (**fig. 64**) (Fischer 1994: 137 fig. 6,2). More frequent is the traditional motif on stamp seals in Iron age I, for example on items from Tell el-Far'a (South) and Taanach (**figs. 65-66**) (Keel and Uehlinger 1995; 142-44 figs. 154a-b). In this group of seals there are also some with animals suckling their young (Keel and Uehlinger 1995: 151a-52b), a motif that guarantees the connection of the composition with the sphere of the goddess.[1] Another motif from Iron age I is a stylized tree flanked by two human figures which became very widespread in the next phase, Iron age IIA (c. 1000–900).[2] Here it is represented by a typical scarab of post-Ramesside mass production (**fig. 67**; c. 1130-950) from the Jerusalem antiquities market.

In addition to these simple, and more or less traditional, representations, more complex scenes are known from Iron age I which show the cult of a stylized tree. A painting on a vessel from Megiddo (**fig. 68**)[3] from the heavily 'Philistine' stratum VIA (first half of the eleventh century) may be interpreted in this way. It shows a procession, consisting principally of a lion, a caprid, a lyre player and a horse (?) with fish and birds above (cf. figs. 39 and 40), moving towards a huge stylized lotus

1. Cf. the עשתרת הצאן in Deut. 7.13; 28.4, 18, 51 and Delcor (1974: 7-14); Görg (1993: 9-11); Hadley (1996: 115-33).

2. Unpublished: Biblical Institute of the University of Fribourg, Inv. no. SK 1978.27; Enstatite, 13.5 x 10 x 5.5 mm.

3. Schroer 1987b: 211-12 fig. 24; Keel and Uehlinger 1995: 139-41 fig. 149c; Israeli and Tadmor *et al.* 1986: 155-57 no. 75.

blossom, which could be a substitute for an artificial sacred tree.

Even clearer than this are two other objects, one from the western, the other from the eastern periphery of the Near East. A rectangular bronze stand from Cyprus probably comes from Kurion (**fig. 69**).[4] On the four sides the same small palm tree is represented four times. In one image fish are brought to the tree, in another a length of cloth, in a third a copper ingot. All of these can be understood as sacrifices and gifts for a goddess or her temple. The fourth side shows a sitting harp player. As in fig. 68 it is not quite clear whether the stylized tree is intended primarily to represent a goddess or a holy place. In my view, the first seems more likely. It makes sense to play the harp for a goddess, much less for a place, even if it is a holy place.

The second piece comes from the other end of the Fertile Crescent, from Susa (**fig. 70**).[5] It is a bronze plaque with figures consecrated by the Elamite king Shilhak-Inshushinak (c. 1150–1130 BCE). According to the inscription this king had provided the bronze plaque for a *ṣīt šamši*, that is, the depiction of a ritual entitled 'sunrise'. This ritual evidently took place in the open, probably in the temple court. In the centre are two naked men, totally shaven, one of whom is preparing to pour water over the outstretched hands of the other. Behind one is a large vessel which holds the water required for such rites of purification. To the left are two rectangular basins, a massebah, two trees or rather tree trunks (*asherim?*) and what is, perhaps, an altar. The two structures with steps to the left and right are probably stepped altars, but might, less probably, be interpreted as models of the temples to Inshushinak and Ninchursanga mentioned in the dedication. The one on the right is flanked by two rows of what could be sacrificial loaves. The two short columns have between them an altar which has a number of cavities. They probably represent the gate of heaven through which the sun god enters each morning.

These two objects have been introduced into the discussion, although they are not from Palestine, since they show elements of the cult represented on objects from Palestine as part of more complex representations. Complex images are vital for interpretation and may support the understanding of features that appear more isolated on Palestinian

4. Barnett 1935: 179-210, esp. pl. 28; Schroer 1987a: 34, 512 fig. 5; Matthäus 1985: 314-15, no. 704, pls. 100 no. 704, 102 no. 704.

5. Vigneau 1935: 279; Gressmann 1927: no. 468; Pritchard 1954: no. 619; Parrot 1962: 332-33 figs. 408-409; Börker-Klähn 1982: no. 127 with bibliography.

images.[6] The small palm of fig. 69 features as part of a sanctuary on fig. 75 while the sacred tree trunk of fig. 70 also appears on fig. 83.

Iron Age II A (Tenth Century)

The motif of caprids at a stylized tree can be found in the Iron age II A on a cultstand from Taanach (**fig. 71**).[7] The lowest of the four friezes shows the 'Mistress of the Wilderness' between two lions. The two cherubs in the second frieze are guarding the entrance to the shrine; in the latter's courtyard (the third frieze) the stylized tree is depicted, guarded by lions and flanked by caprids. In the uppermost and innermost area heaven and earth come together with the horse of Astarte and the winged disc, as is fitting for the temple area.[8] Caprids at a palmette tree can also be seen on a further cult stand from Taanach, found at the beginning of the century by Sellin.[9]

In contrast to the piece shown in fig. 67 a group of instances from this period which show a tree flanked by two male or female worshippers are scaraboids. These come from Bet-El (**fig. 72**) (Keel and Uehlinger 1995: 171 fig. 179b), Bet-Shemesh (**fig. 73**) (Keel and Uehlinger 1995: 171 fig. 179c), Tel Ḥalif, Tell el-Farʻa (north), el-Ǧib, Lachish, Megiddo, Samaria and the Jerusalem antiquities market.[10] They were evidently produced locally and were equally well known in the Judahite and Israelite areas.

While the entrances of terracotta shrine models from the eleventh and the tenth centuries are flanked by naked goddesses (**fig. 74**) (Bretschneider 1991: 229 no. 78, pl. 84 fig. 73b; cf. also 214 no. 51 pl. 54 fig. 46), the entrances of similar models of the ninth century are decorated by stylized palm trees (**fig. 75**) (Bretschneider 1991: 233 no. 86, pl. 90 fig. 79a; cf. also 233f. no. 87, pl. 91 fig. 80a-b). They take the

6. Cf. Keel, Shuval and Uehlinger 1990: 400-404; Keel 1992: 139-266; Hartenstein 1995: 76-77.

7. Lapp 1969a: 42-44; Lapp 1969b: 16 and pl. 3; Reichert 1977: 191 fig. 45; Israeli and Tadmor *et al.* 1986: 161-63 no. 79 (frontal view in colour); Hestrin 1987b.

8. For this interpretation see Keel and Uehlinger (1995: 175-81).

9. Sellin 1904: 81-82 and fig. 115; for the interpretation see Keel and Uehlinger (1995: 174-75, 177, fig. 182a-b); for both cult stands from Taanach see also Devries (1977: 37-41); Bretschneider (1991: 81-83 , 215-16, nos. 53-54); Frevel (1995: 817-53).

10. Jaroš 1980: 207-209; Schroer 1987a: 34; Keel-Leu 1991: 67-68 nos. 77-78.

place of the naked goddesses, probably to represent the fascinating paradisiacal life-giving aspect of the sanctuary.

It is quite interesting to observe that during Iron age I as well as in Iron age IIA the relation of the tree to the anthropomorphic goddess became less explicit.[11] The development has to be seen as part of a general tendency away from anthropomorphic representations of gods and goddesses. This is not to say that these deities vanished nor did it exclude a comeback of the anthropomorphic goddess in the eighth and seventh centuries, but it prepared the way for an association of the sacred tree symbol to Yahweh and similar divinities like Kemosh and Milkom as manifestation of their blessings.

Iron Age II B (c. 930–730)

A small object from Hazor which dates from Iron age II B shows that the knowledge of the close relationship between the goddess of the fertile earth and prosperity and the tree had not completely vanished. The iconography of the object apparently once more closely relates the anthropomorphic goddess and the stylized tree. The object is an ivory anointing spoon from stratum VI (first half of eighth century). The stem of the spoon is in the shape of a small palm tree; the reverse of the small depression at the end of the stem is a female face framed by two doves (**fig. 76**) (Yadin 1975: 155; Keel and Uehlinger 1995: 224-25, 227 fig. 214a-d).

The best known evidence of the caprids at the tree motif is a painting on storage jar A from Kuntilet 'Aǧrud (**fig. 77**).[12] As was first noted by Hestrin, the link to the goddess is here further strengthened by the lion (Schroer 1987: 38, 513 figs. 10-11). Late Bronze age gold pendants show a naked anthropomorphic goddess holding a caprid in each hand and standing on a lion (**fig. 78**).[13] Neither the tree nor the goddess are standing on the lion in a realistic way. Ancient Near Eastern art very often prefers loose association to strict 'syntax'.

From Hazor, from the same stratum as fig. 76 is a handle carved from

11. Cf. Frevel (1995: 791), who overemphasizes the importance of this development.

12. Beck 1982: 3-68; Keel and Uehlinger 1995: 239 figs. 219, 242-44; Frevel 1995: 884-98.

13. Negbi 1976: 100 fig. 119; cf. also 99 fig. 118; Bass *et al.* 1989: 1-29, esp. 2 and 4 with fig. 3.

bone showing a youthful four-winged god holding a small palm tree in each hand (**fig. 79**).[14] Here it is the youthful male god, probably best understood as a Ba'al figure (Keel 1977: 200-205 with figs. 147-54), who is linked to the stylized tree.

The connection with a male god is made less problematic by the fact that by Iron age I and IIA, and also in Iron age IIB, the sacred tree is more frequently portrayed without a clear connection to a goddess. Examples include a scaraboid from Tell en-Naṣbeh, and a scaraboid from the antiquities market which, according to the inscription, belonged to an individual called *ḥlqyhw* (**figs. 80-81**) (Keel and Uehlinger 1995: 266-67, figs. 233a-b). On this latter piece it is quite clear that the figures are dancing around the tree. This motive is also shown on a scaraboid from Akhziv (**fig. 82**) (Brandl in Keel 1997b: Achsib no. 160). From Chytroi in Cyprus comes a well-known and frequently reproduced instance of this kind of cult (**fig. 83**).[15] The terracotta shows three women dancing around an asparagus-shaped stylized tree. The object is of more recent date than the items of figs. 80-82 and thus demonstrates the longevity of the practice. The tree of fig. 83 may represent a male god later identified with 'Apollo of the woods', Apollo Hylates. Another possibility is that it represents the old mother earth goddess Demeter, or her daughter Kore (Hübner 1992: 124-25).

A scarab from southern Tell el-Far'a found in a tomb of the twenty-second dynasty (945–713 BCE) shows a highly schematic worshipper with one hand uplifted before what is most probably a truncated tree (**fig. 84**) (Petrie 1930: pl. 40, 469). A 'high place' with a similarly truncated tree is shown on fig. 70. A worshipper in front of a schematic tree in Assyrian style is seen on a scaraboid from Samaria (**fig. 85**) (Reisner, Fisher and Lyon 1924: 377 no. 11, pl. 57a2). The worshipper is less schematically drawn than the one of fig. 84. The beard and the long garment are clearly indicated. Both hands are uplifted. The quite rare instance on a scaraboid of the eighth or seventh century from Lachish may be a piece imported from Phoenicia or northern Palestine (**fig. 86**) (Tufnell *et al.* 1953: 365 fig. 35, pl. 44,124; Keel and Uehlinger 1995: 377-79 fig. 323). It shows an anthropomorphic goddess between the worshipper and the tree or branch with a monkey. This demonstrates

14. Yadin 1958: pl. 151; Keel and Uehlinger 1995: 220-21, fig. 210; for similar four-winged figures see E. Gubel in Sass and Uehlinger (1993: 123-25, figs. 64-70).

15. Galling 1977: 13, fig. 4; cf. also Hermary *et al.* 1989: 439-40, no. 908-10; Hübner 1992: 121-32, esp. 123-24 and n. 18, 132 fig. 2.

that even at this time there was some awareness of the age old connection between goddess and tree. The goddess presents her breasts in a way well known from the numerous pillar figurines of this period. Kletter confirms, as already said, although without enthusiasm, the identification of these pillar figurines as representations of the Judahite goddess Asherah. Fig. 86 supports this suggestion (Kletter 1996: 76-77 and *passim*).

At the end of the eighth and particularly in the seventh century the stylized tree is often connected with male figures. This is probably true of a seal from Cyprus in the form of a truncated pyramid (cubical seal). On one side is a standing worshipper, on the other a seated male(?) figure, each before a stylized tree (**fig. 87**) (Gubel 1987: 210 fig. 5; Schroer 1987a: 213 fig. 27). The first motif is the same as on figs. 84-86. The second is different. It represents a seated figure, probably a dignitary rather than a deity, in front of a tree. A Late Bronze age cylinder seal from Ugarit already shows a sitting figure, the hands lifted in blessing in front of a tree (**fig. 88**) (Amiet 1992: 56 no. 128, 64 no. 128, RS 22.249; Schaeffer-Forrer 1983: 127 fig. RS 22.248). The tree is flanked by two worshippers and thus clearly characterized as a sacred tree. The meaning of the vertical line between the enthroned figure and the worshippers flanking the tree is not clear. Since this type of glyptic attests other instances showing a figure seated in front of a tree without the vertical line (**fig. 89**) (Schaeffer 1983: 135 no. RS 23.479), this line cannot be of major importance.

What is the significance of the juxtaposition of the enthroned male figure and the tree? In *Göttinnen, Götter und Gottessymbole* Uehlinger and I thought that a cylinder seal from Bet-Shean (**fig. 90**) (Parker 1949: no. 122) could be understood as a representation of a lunar El and his Asherah (Keel and Uehlinger 1995: 356-60 fig. 308). The lower frieze shows the stylized tree behind the seated figure which is characteristic of the lunar El. Before him stands a stylized palm, between them a servant with a fan. The palm is flanked by a caprid and a griffin. Here the tree of the goddess with caprids is presented in combination with the tree flanked by cherubs or griffins as a symbol of salutary royal order (Keel and Uehlinger 1995: 264-66 §138). Unfortunately the dating of this cylinder remains quite uncertain. It may date from the second millennium.[16] The two registers and many details suggest such a

16. Matthews (1990: no. 520), who dates the object to the second millennium BCE; cf. also Hartenstein (1995: 82-85).

date. But the stylized tree to the right is definitely later. It is unlikely that such details would appear on an early item. Certain details of the cylinder, originally from the second millennium, may have been recut in later times. Another possibility is that the cylinder was cut in Iron age II but in an archaic style.

A kind of parallel to the Beth-Shean seal is a cylinder seal from nearby Tell es-Sa'idiyeh (**fig. 91**) (Pritchard 1969: no. 859) dated to the eighth century by its excavator. It shows

> an important personage seated in a high-backed chair, with cup in right hand and with elongated arm extended toward an offering table. On the table are four loaves of bread (?) and a fish. Behind the principal figure is an attendant... Before the offering table are a stylized tree and a crescent (Pritchard 1969: no. 859).

Both seals (figs. 90 and 91) have in common that the main figure is a sitting person, most probably male, holding a vessel for liquids in his hand. An attendant with raised arm is standing behind him. In front of him is a stylized tree.

It is unclear if the enthroned person represents a god, a deified human or a mortal dignitary. Whatever the solution, the tree may hardly indicate anything else than that the ceremony is situated at a holy place (cf. 47-48 below).

An unstratified cylinder seal from Tell el-'Aǧul (**fig. 92**) (Schroer 1987b: 210-11 fig. 23; Parker 1949: no. 194 [no date given]) probably also belongs to this period (and not to the end of the second millennium). The figure sitting before a stylized tree is sitting at a holy place. As the figures of figs. 90-91 he is not worshipping the tree.

Iron Age II C (c. 730–600)

The male sitting in front of a tree is portrayed not only in Palestine but also in neighbouring Cyprus on a scarab from Kition (**fig. 93**) (Clerc *et al.* 1976: 56 Kit. 511). The find spot dates the object from after Iron Age II C, 600–450 BCE. The style and iconography however permit a somewhat earlier dating. Certain attributes, such as the falcon with spread wings behind the enthroned person and the sign on the brow, recall the pharaoh. In contrast to figs. 90-92 the position of the hands may indicate veneration of the (truncated?) tree.

A scarab with a similar motif was found in Ajia Irini (**fig. 94**) (Gjerstad *et al.* 1935; 772, 844 no. 2719 and pl. 250, no. 2719). A clay

relief on a pot of Phoenician origin found at En-Gedi (**fig. 95**) (Stern 1978: 11-21, esp. 12-13 fig. 1[a] and pl. I A-B) also shows a seated man before a stylized tree.[17]

The remains of a Phoenician metal bowl (**fig. 96**) (Matthäus 1985: 163, pl. 32 no. 427) show a figure seated before a tree similar to the tree behind the sitting man on fig. 90. As there is a second tree to the left and two trees to the right it could be argued that the activities represented here took place between trees. However, the theme of the 'enthroned person/deity before a tree' occurs so frequently in isolation that this is probably another case in point.

To sum up the content not only of this small sub-chapter but of all instances for the motif of 'human sitting in front of a tree': The motif stresses the age old Near Eastern concept of the tree as a symbol and signal of the presence of a divine power, namely of prosperity and blessing, which ultimately resides in the earth.

17. For Masseboth and Asherim in the Persian and Hellenistic periods see Mettinger (1995).

Chapter 4

TREE GODDESS IN EGYPT, AND EARTH
OR PROSPERITY GODDESS IN PALESTINE

If we look at the series of Syro-Palestinian (and Cypriot) images on the one hand (figs. 7-52, 63-96) and the Egyptian pictures on the other (figs. 53-62) one difference is immediately apparent. Wherever tree or branch and goddess are linked on the Syro-Palestinian images the plant elements grow out of the goddess or encircle her as her attribute. Fig. 7 shows two entirely anthropomorphic figures with branches and leaves growing from the bodies. On the metal pendants of figs. 17-21 the human form is reduced to head and torso, but still dominates when compared with the branch which grows from pudenda or navel and which is not always present (cf. Negbi 1970: pl. II: 3-4; Negbi 1976: pl. 52: 1677-78 [Tell el-'Aǧul]). It is even clearer in the case of the twig (or branch) goddess on the scarabs. She is surrounded by branches or trees (figs. 22-24), or holds them in her hands (figs. 25 and 26). In the same way as in fig. 7, in fig. 27 her anthropomorphic body forms the trunk from which the branches grow. Branches sprout from her pudenda (figs. 26-27). Figs. 28-41 and 44-48 show that the tree can appear either with the goddess or in her stead. Figs. 51 and 52, which show the anthropomorphic goddess and tree in very close contact, make it clear yet again that the anthropomorphic goddess is the dominant motif. In the Late Bronze age she is sometimes represented in anthropomorphic form and as a palm tree flanked by caprids (fig. 44-48). The tree flanked by caprids expresses one of her major powers or aspects of divinity, namely her life-bearing and nourishing function.

In Egypt the situation is exactly reversed. Here the tree is primary, and the goddess grows out of the tree and becomes gradually anthropomorphic. Only latterly is she a distinct being beside her tree.[1] In this

1. An exception is an isolated instance which shows a purely anthropomorphic Isis disguised as a tree (cf. Keel 1992: 101 fig. 46).

phase the relation is somehow similar to the one found in Late Bronze age Palestine where tree and anthropomorphic goddess alternate. The modern and rather approximate term 'tree goddess' first finds some justification in Egypt. However, an Egyptian formulation is a good deal more subtle in identifying the relationship: the sacred tree presents 'Nut (or another goddess) *in her name* "Sycamore"' (Keel 1992: 83, 122 fig. 74). The 'name', the reputation of a person, is constituted by what can be experienced of that person. In the sacred tree Nut, the otherwise invisible and incomprehensible goddess, becomes visible and comprehensible.[2] If at first the goddess in her iconography is wholly portrayed as a tree made human only by arms and breast (figs. 53 and 54), at the end she stands in purely anthropomorphic form beside the tree (figs. 61-62). In this representation the Near East and Egypt meet. In each culture the tree goddess or earth goddess respectively can stand alone next to 'her' tree. In both cases, too, the sacred tree can bring forth water (compare fig. 39 with **fig. 97**) (Davies and Gardiner 1948: 51 and pl. 35 top; Keel 1992: 123 fig. 75; cf. figs. 7-8, 26, 28).

For the rest, however, the relationship presents itself in a variety of ways and the term 'tree goddess' seems to me to be rather unsuitable for the Near Eastern area. Here we deal more with a goddess of the Earth, of Plant Life, of Sexuality and Prosperity. She does not reveal herself in the tree, which has its own prior existence. The tree is rather the 'most eminent case', a symbol of vegetation, her most important achievement. The earth goddess existed before the tree, which was brought forth by her. Apart from this she was probably important for everything, whether plant, animal or human life, which the Old Testament in one word refers to as 'blessing' (cf. chapter 2 n. 18).

2. Yahweh's name, which dwells in Jerusalem, can be experienced there according to Deuteronomistic theology.

Chapter 5

BIBLICAL RESPONSES

Biblical Texts Mentioning Tree Cult and Mother Earth Cult

As surprising as Moses' Midianite wife[1] is Yahweh's (or his mes-
senger's) appearance to Moses in a סנה-bush or tree in Exod. 3.1-5 (cf.
Deut. 33.16) (Korpel 1990: 590-94). Epiphanies of Yahweh or his mes-
sengers repeatedly take place under trees (Gen. 18.1 באלני ממרא; v. 4
תחת העץ; v. 8 תחת העץ; Judg. 6.11 תחת האלה; 1 Kgs 19.5 תחת רתם
אחד. In the burning desert it is natural to seek refuge in the shadow of a
tree. But the bread and the water the waking Elijah finds beside him
recall the gifts of the Egyptian tree goddesses.

Early leaders like Deborah and King Saul sit below a tree (Judg. 4.5
תחת תמר דבורה בין הרמה ובין בית־אל 1 Sam. 14.2 תחת הרמון אשר
במגרון; 1 Sam. 22.6 תחת האשל ברמה), not just any tree, but a particular
tree, the palm tree, the pomegranate tree, the tamarisk which is in...
Not only did the living sit in the shadow of a particular tree, the dead
were sometimes buried there too: Rebecca's nurse Deborah (Gen. 35.8
תחת אלון בכות) and Saul and Jonathan (1 Sam. 31.13 תחת האשל ביבש).
Since the dead are said to return to the womb whence they came (Job
1.21; Sir. 40.1; Ps. 90.3, 5 cf. Gen. 1.11-12; Ps. 139.15), the trees, at
least in these two passages, are related to mother earth.

Wacker is right to emphasize that אלה 'big, impressive tree' in Hos.
4.12 alludes to אלה 'goddess' (Wacker 1991: 145). If many trees in the
Old Testament as we know it look quite neutral (Frevel 1995: 291-93),
one should not forget that the text was subjected to repeated editing and
that Yahweh to a considerable degree assumed the role of mother and

1. See the post-exilic polemic against intermarriage in general (e.g. Ezra 9.2;
10.1-19; Neh. 13.23-27) and against marriage with Midianites in particular (Num.
25.6, 14; cf. Num. 31).

earth goddesses and consequently took over their attributes as well (Keel 1989: 233-36).

A tree and a standing stone are constitutive of holy places (Josh. 24.26 ויקח אבן גדולה ויקימה שם תחת האלה אשר במקדש יהוה). All these trees were real trees dispensing real shadow and producing real fruit and, in addition, for one reason or another, they had a particular religious dignity.[2]

The Problem of the Traditio-Historical Background of Yahweh's Wife in Hosea 2.4-14

The conclusion of Chapter 4 has some impact for the understanding of Hos. 2.4-14. This passage presents Yahweh, the God of Israel, as the real weather god who bestows water and all kinds of plants and plant products (v. 10a, 11, 14; cf. Ps. 65.10; Job 5.10-11) on his wife. The wife is not aware of this, attributing all these gifts to her lovers, the Be'alim (v. 7). Who is this unfaithful adulterous wife? The biblical tradition early identified her with Israel (see, for example, the continuation in vv. 16-17).[3] When the metaphor of the faithful or unfaithful wife is used in the book of Jeremiah this wife is indeed Israel (Jer. 2.3), although Jerusalem is addressed by the speech. In Jer. 2.32, also, YAHWEH's unfaithful wife is his people (עם). Only in Jer. 13.27 and in Ezekiel 16 and 23 does the unfaithful wife become Jerusalem or Samaria respectively.

Many modern commentators take it for granted that already in Hos. 2.4-14 the unfaithful wife is Israel (Wolff 1974: 31; Stuart 1987: 50). The problem is that Jacob–Israel (cf. Gen. 32.28), who represents the people, is a male. Jacob, Israel and Ephraim play an important role as one or several forefathers in the Book of Hosea (cf., e.g., 10.11; 11.1; 12.2, 13-14). Thus, 'Israel' first represented a male figure. By what device was Israel transformed into a female? As early as 1889, more than a century ago, W. Robertson Smith suggested in his *Lectures on the Religion of the Semites* that Hos. 2.4-14 makes use of the metaphor

2. Many more instances for tree cult can be found in Jaroš (1982: 119-65).

3. Schmitt (1995: 119-32, particularly 119 n. 2) insists that the name Israel does not appear in vv. 4-14, but in vv. 16-17. This means nothing. Only Israel, not Samaria nor Jerusalem, came up out of Egypt. There can be no doubt (despite Schmitt's note 28 on pp. 126-27) that the faithful wife in Jer. 2.2-3 and the unfaithful in Jer. 3.6-13 is Israel, as the texts explicitly say.

of mother earth (*terra mater*) to describe Israel's position, since the natural consort of the weather god is the earth which is fertilized by the rain (Robertson Smith 1889: 93; 1967: 68-77). The change from an Israel perceived as male to an Israel perceived as female probably occurred through the use of the term אֶרֶץ, which means at the same time 'earth' and 'land', for example 'land (of Israel)'.

Wacker, in her otherwise very stimulating *Figurationen des Weiblichen im Hosea-Buch* (1996), and several other recent writers on Hosea, particularly Schmitt (1995), have rejected this interpretation for lack of evidence (Wacker 1996: 318; Andersen and Freedman 1980: 169). Wacker and her companions argue that Asherah, Anat and Astarte are neither mother earth goddesses nor *terra mater* figures. This is true[4]—but Palestine is not Ugarit.[5] One has to take into consideration that these Ugaritic texts are a kind of courtly epic literature. The pantheon is very sociomorphic. The sociomorphism of the courtly epic literature of Ugarit reflects the complex social structures which produced these texts.[6] Its figures are quite individualized, at least on a superficial level. However, Eliade (1954: 271-98, esp. 297-98) has demonstrated that highly individualized figures with a personal destiny, such as, for example, the Greek Demeter, have not lost touch with fundamental configurations. He quotes Euripides as one among many other examples. In his drama 'The Bacchanals' (vv. 274-76) the seer Teiresias says: δύο γάρ...τὰ πρῶτ' ἐν ἀνθρώποισι. Δημήτηρ θεά. γῆ δ' ἐστίν, ὄνομα δ' ὁπότερον βούλει κάλει. 'Two chiefest Powers... among men there are: divine Demeter—Earth is she, name her by which name thou wilt.'

The iconography of Palestine of the Middle Bronze, Late Bronze and Iron ages testifies to a situation which is quite different from the one suggested in the texts of Ugarit. Moreover it is methodologically inadmissible simply to identify the pantheon of the courtly epic texts of Ugarit and the way this pantheon is presented with the Canaanite pantheon in general. Rather, in view of the fragmentation of the Syro-Palestinian region and the variety of societal forms and cultural influences, it is likely that the pantheon of southern Palestine in the

4. For some hesitance regarding the validity of this judgment see Knauf (1990: 34-45).

5. Lack of awareness of this fact is the main flaw in Dietrich and Loretz (1992: esp. 105).

6. On sociomorphism, cf. Uehlinger (1992: 339-59).

Late Bronze and Early Iron ages did not have much in common with the pantheon of the courtly epic literature of Ugarit apart, perhaps, from a number of divine names.

If we look at other than Ugaritic textual sources a rather different picture emerges. The scene with the weather god striding across the mountains and the goddess in front of him lifting her veil or pushing her robe aside and revealing her pudenda (cf. Winter 1987: figs. 267-306: Keel and Uehlinger 1995: 45 fig. 30-31b) is difficult to interpret without reference to the widespread metaphor of the rain as seed and the goddess as earth or ploughed field. Configurations of this kind form the original complexes of meaning (the basic constellations in J. Assmann's terms).[7] These were developed and given sociomorphic form and historical or biographical detail. By the Middle Bronze age the icon of the goddess uncovering her pudenda before the weather god is enriched with courtly erotic elements. This does not mean, however, that knowledge of the deep dimensions of this metaphor's central area[8] had entirely disappeared, particularly in rural areas. In contrast to the Ugaritic courtly epic tradition, the Palestinian iconographic evidence exhibits a person best described as a mother earth figure as that is still reflected by some Biblical texts (cf. Gen. 1.12, 24; Isa. 45.8 [cf. Knauf 1990: 34-45]; Job 1.21; Ps. 139.15; Sir. 40.1, where the earth holds the same title [חי כל אם] as Eve in Gen. 3.20).

Wacker, in accordance with Schmitt and others, seeks to replace the mother earth metaphor with the metaphor of the city goddess as the background to Hosea 2 (Wacker 1996: 323-25: Schmitt 1995: 119-32). The alternative is not convincing. The passage clearly has in view the land and not just a city. The products given by Yahweh to Jerusalem and Samaria respectively in, for example, Ezekiel 16 and 23 are not agricultural products as in Hosea 2 but works of handicraft and trade befitting an important city (e.g. 'robes of brocade and sandals of stout hide, girdles, jewellery, bracelets, necklaces' in Ezek. 16.10-13). Moreover the notion of 'city goddess' in a stricter sense does not occur before Hellenistic times (Hörig 1979: 129-97; Whitt 1992: 54-56), though some forerunners may already have appeared in the Neo-Assyrian period. The first unambiguous attribute of city goddesses is the mural crown (Keel 1984: 32-39 with figs. 5-8). This attribute clearly

7. For Assmann's concepts 'mythischer Sinnkomplex' and 'Konstellation' see Keel, Shuval and Uehlinger (1990: 403-404).

8. For this, see Gombrich (1979: 13).

demonstrates that the city goddess has no immediate connection with the agricultural world of Hosea 2.

A third solution taking into account the originally male character of Israel and the impossibility of a city goddess in the Iron age was proposed by Whitt (1992). Whitt sees Hos. 2.4-7, 12-14 as a coherent text which was originally spoken aloud by the prophet of the eighth century. According to Whitt the underlying scheme is the divorce of an adulterous wife. What fits this scheme is original, what does not fit is considered secondary. Whitt thinks that everyone in the eighth century listening to a speech about Yahweh's wife would immediately think of Asherah. In his interpretation the text illustrates a symbolic action during which the prophet first took away the jewellery of the statue of the goddess, then her clothing and finally carried the statue out of the temple and smashed it. All this is supposed to have happened in a place called Gilgal (according to Hos. 9.15)—probably the Gilgal south of Shechem.

Whitt's interpretation is quite coherent. One weak point is that somehow arbitrarily the text is shaped according to a hypothetical scheme (divorce speech). In fact Wacker has clearly shown that the text is far from being a coherent unit of oral speech (Wacker 1996: 202-203; cf. also Jeremias 1983: 38-40). The second difficulty is the concreteness of Whitt's proposal. It does not do justice to a text which deals at a quite high level of abstraction with the problem of certain religious practices of the northern kingdom (Wacker 1996: 319-21). Although Whitt's proposal is hardly acceptable in all its concreteness, he may have found the traditio-historical scheme underlying the text. At least this may be true to the extent that one is prepared to understand Asherah not so much as an individualized, historicized goddess in a highly sociomorphic pantheon but rather as a mother earth figure of a type represented by the iconographic evidence of the Late Bronze and Iron ages.

The title אם (vv. 4 and 7) perfectly suits ארץ 'earth, land' (cf. Sir. 40.1; Gen. 3.20). Without the rain of Yahweh or the Be'alim respectively she becomes ארץ ציה (v. 5). דשן, דגן, מים (cf. vv. 7 and 10) are gifts of the weather god for the earth, as Ps. 65.10-12 shows (Schroer 1990: 292-99). The same is true of the vine and fig tree (v. 14), which as trees are closely related to the earth fertilized by the weather god. By the extension of ארץ into ארץ ישראל the originally male Israel becomes female as shown above.

Polemic against Tree Cults

The oldest example of polemic against the tree cult is probably Hos.
4.12-13 (Jeremias 1983: 68-73; Eidevall 1996: 51-77). The first rep-
roach is against 'asking a tree/wood for advice and (consequently)
receiving orders from a staff' (בעצו ישאל ומקלו יגיד לו). Oracle-giving
trees, positively mentioned in 2 Sam. 5.24 (cf. Gen. 12.6 אלרן מורה
'oracle giving "oak"'), are thus reduced to 'wood'. This tactic of reduc-
ing trees as a place of manifestation of the divine to just wood is
repeated time and again (Jer. 2.27; 3.9, for example).

The second reproach is that, attracted by the shadow, people would
desert Yahweh in favour of the trees (על־ראשי :ויזנו מתחת אלהיהם
ההרים יזבחו...תחת אלון ולבנה ואלה כי טוב צלה:) and that, subse-
quently, there would be fornication of all kinds. The Canticle suggests
in a positive attitude that 'the shadow' of trees favoured sexuality,
eroticism, and fecundity (cf. Cant. 8.5c-e תחת התפוח עוררתיך שמה
חבלתך אמך שמה חבלה ילדתך). Since trees in Palestine signalled an
intense presence of mother earth's blessings, to have sex under a tree
meant to participate in her blessing and fecundity.

Deuteronomy 16.21-22 suggests that at places holy to Yahweh there
used to be a tree near the altar (an asherah; sometimes reduced to a
trunk if people were too eager to carry away parts of it as blessings and
relics) and a massebah (cf. Josh. 24.26). Near the centralized and
unique altar, however, there should be no such thing: 'You shall not
plant any kind of tree as an asherah beside the altar of Yahweh your
God which you shall build. You shall not set up a massebah, for
Yahweh your God hates them' (לא־תטע לך אשרה כל־עץ אצל מזבח
יהוה אלהיך אשר תעשה לך: ולא־תקים לך מצבה אשר שנא יהוה אלהיך:).
The apposition כל־עץ (whether secondary or not) must imply that any
kind of tree could serve as an asherah. Frevel understands the 'planting'
metaphorically as 'setting up' a wooden pole (Frevel 1995: 183-85)
(see Chapter 1 above). However, the parallels for a metaphorical use of
נטע are very late (Dan. 11.45; Qoh. 12.11 and Ps. 94.9). Gen. 21.33,
and similar texts (see pp. 43-44 above) suggest interpreting the 'plant-
ing' of Deut. 16.21 literally; so does Judg. 6.25. The altar of Baal was
probably built under an asherah tree (את־מזבח הבעל...ואת־האשרה
אשר־עליו תכרת והרסת). The bamoth, masseboth and asherim על־ההרים
הרמים ועל־הגבעות ותחת כל־עץ רענן (Deut. 12.2; 1 Kgs 14.13; 16.4;
17.10; Jer. 2.20; 3.6, 13; Ezek. 6.13; Isa. 57.5; 2 Chron. 28.4) seem to

contradict the understanding of asherah as a tree. The green and fresh trees, however, are definitely part of these sanctuaries. If the asherah is something special beside them, it may be the trunk of the 'first' tree on the spot, reduced by age and greedy believers to a mere stump. Within the precinct of urban sanctuaries it may have been an artificial tree.

Deut. 16.21 forbids the planting of an asherah. Three Deuteronomistic texts (Exod. 34.13; Deut. 7.5; 12.3) speak of altars, masseboth and asherim in the plural and demand that the asherim be cut down (כרת). The latter are considered as something un-Israelite, characteristic of the pre-Israelite population, something which should not survive in territories under Israelite control. The 'cutting down' (כרת) of trees is an act of war (Deut. 20.19; cf. 2 Kgs 3.19).

Despite all this polemic even after the exile, there seem to have been trees in the court of the earlier second temple. This is at least what Ps. 52.10 and Ps. 92.13-14 suggest. In the fourth century, however, according to Hekataios of Abdera (c. 300 BCE), there was 'no trace of a plant in the form of a sacred grove or the like left in the courts of the temple in Jerusalem'.[9] The polemic against trees and its consequences caused a considerable loss of feeling for the value of real trees (cf. Keel 1995c: 95-113, esp. 111). However, the ancient cult of trees which survived for example in connection with the Muslim *auliyā'*, 'saints', saved the lives of many trees. The only fully grown trees found in Palestine at the beginning of this century were these trees considered as 'holy' (Elan 1979: 89-101).

Symbolism Maintained

The famous inscriptions of Kuntilet 'Aǧrud and Ḥirbet el-Qom suggest that around 800 BCE the asherah tree or pole could be considered as pertaining to the manifestations of Yahweh. In a similar way the עשתרות הצאן 'the Astartes of the sheep and goat' became part of the blessings of Yahweh (Deut. 7.13; 28.4, 18, 51; cf. Keel and Uehlinger 1995: 142-44 fig. 154a-b). Despite such expansionism and imperialism the asherah tree or pole remained related to the goddess Asherah. A certain ambiguity may have been one of the reasons for eliminating it totally.

9. Quoted by Josephus, *Apion* 1.199. Cf. Boniface (c. 750 AD) who cut down the oak of Thor or Donar at Fritzlar in Hessen.

From the eighth century onward real trees were more and more considered first a danger to pure Yahwism and then to monotheism in general. As early as in Hosea the real tree was supplanted by the tree as a simile, when Yahweh says:

> What has Ephraim any more to do with idols? (אפרים מה־לי עוד לעצבים [G לו]).
> It is I who answer and look after him (אני עניתי ואשורנו; cf. Wellhausen אני ענתו ועשתרתו).
> I am like an evergreen juniper tree[10] (אני כברוש רענן),
> from me comes your fruit (ממני פריך נמצא) (Hos. 14.9).

'In the Old Testament trees and plants are often used as metaphors and similes for the description of human beings (...) Israel in its entirety may be called a fig-tree, a vine...and a cedar...' (Korpel 1990: 590). In contradistinction the metaphor of the evergreen tree for Yahweh is unique.[11] Wacker thinks that Wellhausen went too far reading 'his Anat and his Asherah'.[12] She agrees with Day (1986: 404-405) that this is a mere allusion to the two goddesses' names.[13]

Memories of the goddess may have led Jesus Sirach to use a plethora of tree similes not to characterize the qualities of Yahweh but those of his wisdom, his חכמה, which is also presented as a perfect woman (24.12-19).[14]

The goddess seems thus to have enjoyed a kind of survival, although a poor one, as a metaphor. One of her cult symbols, the *artificial* tree may have survived too. It is striking that the seven-branched lampstand of the priestly tradition resembles very much the age old stylized tree

10. Oestreich (1997: 261-66), opts for *Juniperus excelsa* Marshal von Bieberstein.

11. Jeremias 1983: 173; Korpel (1990: 592-93) draws attention to two other possible but rather improbable instances (Judg. 9.14-15; Ps. 58.10).

12. Wellhausen 1892: 21.131; for the history of reception of Wellhausen's proposal see Dietrich and Loretz (1992: 173-82).

13. Wacker 1996: 274-79; Tångberg (1989) and Oestreich (1997: 287-313) draw attention to the royal connotations of forest trees, particularly conifers. But the adjective רענן, and the intensity of the 'I–you' relationship convey aspects that are not typical of royal tree metaphors (cf., e.g., Ezek. 31.1-9; Dan. 4.7-12). Oestreich is aware of this, but I doubt if these additional features, particularly רענן, are best explained as paradisiacal.

14. Fournier-Bidoz 1984: 5-10; Schroer 1996: 103-105. The Gospel of John uses the metaphor of the true wine for Christ (ch. 15); see von Gemünden (1993: 510 s.v. Jn 15).

(Meyers 1976, esp. 95-122). In early Judaism the *lulav* of the Feast of Tabernacles which is based on passages like Lev. 23.40 and Ps. 118.27 may be interpreted as a further remain of ancient fertility rites connected to tree cults.

Trees were only part of the world which became, to Jewish and Christian eyes—in an almost Platonic manner—increasingly just shadows, similes and metaphors of the unseen but *real* world. The return of a more Aristotelian world view, which started in the thirteenth century CE, marginalized this Platonizing view more and more. The early Old Testament as part of the 'Canaanite' experience comprises elements of tradition which may help its followers to orient themselves in a world which has become almost totally Aristotelian. To do so they do not have to sever the umbilical cord connecting them with the tradition of which they are the heirs. The Jewish reception of natural symbols and nature festivals emphasized the historical, the Christian reception the eschatological aspects of the tradition. A closer look shows and will show even more in the second part of this volume how much appreciation of the works of creation is preserved in the Jewish–Christian Bible.

Part II

THE LUNAR EMBLEM OF HARRAN ON STELAE AND SEALS
AND THE CULT OF THE NEW MOON IN THE HEBREW BIBLE*

* The text of this contribution was initially presented as a lecture on the occasion of the centennial festivities of the Ecole biblique et archéologique fran-çaise de Jérusalem on 21 November 1990 in Lyon within the section 'L'Ancien Testament et les araméens' with the title 'L'iconographie d'inspiration araméenne retrouvée en Palestine et Transjordanie'. It was then published in German as one chapter of Keel (1994a: 135-202). For the present publication the article was revised again, enlarged and Chapter 6 added.

Chapter 6

INTRODUCTION: LOOKING FOR MAJOR ARAMAEAN DEITIES

The evidence of the literary tradition (inscriptions, biblical texts) seems to prove that during the first half of the first millennium the main god of the Aramaeans from Sam'al in the north down to Damascus in the south might have been a weather god. Since the Akkadian period, most of the time this god took the name of Hadad; but other names also appear, such as Ilumer/Iluwer, Ramman/Rimmon, Rakib'el or *b'l ṣmd*.[1]

Greenfield reproaches Vanel for not distinguishing between the various weather gods in his book *L'iconographie du Dieu de l'orage dans le Proche-Orient ancien jusqu'au VIIe siècle avant J.C.* (1965) (Greenfield 1987: 75 n. 6). Nevertheless, it is a well-known fact that on the one hand, due to the artificiality of language, different denominations can be found for identical or at least very similar phenomena, while on the other hand, the iconography, which normally follows a phenomenon more closely, shows less variations. Images display roles, names point out individuals.

Therefore a single culture invariably produces many more names of deities than typical figures of its gods. Based on the god lists, ritual and mythological texts from Ugarit, about 200 names of deities are known (Weippert 1988: 294), whereas the iconography of Ugarit confronts us with little more than half a dozen different types of figures (Caquot and Sznycer 1980). A similar fact can be observed in the Akkadian–Old Babylonian period. The Old Babylonian list of gods '*an–Anum*' mentions up to 2000 names of gods (Landsberger and von Soden 1965: 52-53; Lambert 1971: 475-76), whereas the repertory of the Akkadian and Old Babylonian glyptic contains no more than some 30 types of gods.[2]

1. Gese 1970: 216-18, 220-22; Greenfield 1976; 1987: 67-70.
2. Boehmer 1965; Amiet 1977; Collon 1986: 22-31. This fundamental problem has not been taken into account by Lipinski and spoils much of his criticism in his otherwise interesting review of Cornelius 1994 (1996: particularly 258).

As soon as advocates of the literary tradition are not bound to mere denominations of gods, the abundance shrinks rapidly. Greenfield bewails the fact that the Aramaic inscriptions, while naming Hadad, do not provide more information about him. 'We must turn to the texts from Ugarit, both mythological and epic, and to some references with literary overtones in the Amarna letters to learn more about Ba'lu-Haddu, who plays a prime role in the Canaanite pantheon' (Greenfield 1987: 68). Hadad-Rimmon in Zech. 12.11 is only to be interpreted on the premises of the Ugaritic myths (Greenfield 1987: 75 with n. 7). So Greenfield himself does not submit to the rules he stipulates for Vanel. He operates indistinctly with Ba'al, Hadad, Rimmon and other weather god traditions when he aims at a clear image, rather than restricting himself to mere denominations.

There is another fact that many scholars do not take into account. The image of the weather god changed substantially from Middle Bronze age to Iron age II. This was partly due to the identification of the Canaanite Ba'al with the Egyptian Seth, developing from a deity bringing forth the vegetation to a rather bellicose warrior, and finally ending up as the 'highest god' and the guardian of justice.[3] This process can only partially be followed along the changing names.

Notwithstanding the explanation given above, the weather god was neither a specifically Aramaean god, nor was he shaped in a special manner in the Aramaean area. Ingo Kottsieper put forward the theory that the dominance of the weather god is valid only as far as public matters and inscriptions are concerned, while in the sphere of private piety (as documented, for example, by papyrus Amherst 63) according to him El was the main deity of the Aramaeans.[4] Kottsieper overstressed his theory as Ch. Maier and J. Tropper (1998) have shown. Besides due to the fact that the topic of this work is the specific contribution of the Aramaeans to the iconography and religion of Palestine/Israel, I cannot start from a common Syrian figure such as the weather god or the god El, whom the Aramaeans shared with the people of Ugarit and many other cities and peoples. Rather, I study a phenomenon which deserves to be called typically Aramaean.

3. Gese 1970: 216-18, 220-22; Keel, Keel-Leu and Schroer 1989: 259-66; Keel, Shuval, and Uehlinger 1990: 309-21, 411-12.

4. Kottsieper 1988: 69-72. In a lecture held on the occasion of the colloquium of the Deutscher Verein zur Erforschung Palästinas on 13 December 1996 in Rauisch-holzhausen, Kottsieper elaborated further on this thesis; cf. Kottsieper 1997.

Chapter 7

THE ARAMAEANS, THE MOON SANCTUARY OF HARRAN
AND ITS EMBLEM IN MONUMENTAL ART

It appears as if the original homeland, the real country of the Ara-
maeans (*māt Arimi*) was the region today called the 'Mountain of the
Servants' (*Tur 'Abdin*) which is located in the region of present-day
Mardin. However, the Ğebel Bišri, on the west side of the Euphrates, is
mentioned as being controlled by the Aramaeans around 1050 BCE
already. At the beginning of the first millennium they had populated the
region of the big Euphrates bend.[1]

It is at this time that the 'House of Joy' (Sumerian: *é-ḫul-ḫul/É.
ḪUL. ḪUL.*; Akkadian: *šubat ḫidâti*), the shrine of the moon god of
Harran, became one of the major cult centres, if not the main cult centre
of the Aramaeans, who probably identified their old moon god Shaḥar
with Sin of Harran.[2] An inscription of Sargon II speaks of this sanc-
tuary as: *É. ḪUL. ḪUL. maštak ᵈSîn āšib ᵃˡHarrān* 'The house of joy,
the dwelling of Sin, who liveth in Harran' (Campbell Thompson 1940:
86-87, line 6).

This shrine had already been mentioned in the eighteenth century
BCE (Postgate 1975: 123-24), but its importance seems to have
increased during the reign of Shalmaneser III in the ninth century
(Laroche 1955: 8; George 1993: 99, no. 470). A series of stone stelae 1
to 2 m high, showing the moon crescent at the top of a pole are known
from the ninth to the seventh centuries. There are two tassels attached
at the intersection of the moon with the top of the pole or just below it.
Concisely, I shall call this feature (and *only* this one) *the lunar emblem
of Harran* or more shortly *the lunar emblem*, whereas I shall call the

1. Lipinski (1988: 147); see Reinhold (1989: 23-28); for political history and
social organization of the Aramaeans of the first millennium see Dion (1997).
2. Lipinski (1994: 171-92); for Harran see also Green (1992: 19-43); Hol-
loway (1995); Dion (1997: 49-52).

moon crescent without tassels *the crescent on a pole* or *the moon standard*, and the same without a pole just *the crescent.*

The Lunar Emblem Alone

One type of stelae shows merely the lunar emblem. To date, six specimens of this type are known. Three of them were found on the present Turkish territory, and three others in Syria.

No. 1 = **fig. 1** was found in Aşaği Yarímca, some 6 km N.W. of Harran, and is presently exhibited in the Lapidarium of the Archaeological Museum of Ankara. This basaltic stele measures 188 × 49 × 35 cm. The pole with the crescent stands on a two-step socle. The tassels, which spread downwards, follow the pole very closely. The horns of the crescent end almost vertically. The stone has been inscribed (see *Appendix I* at the end of Part II) and seems to date from the time of Sanherib (705–691).[3]

No. 2 = **fig. 2** comes from Sultantepe, about 25 km N.N.W. of Harran, from room 5 of the temple excavated in area M. Its present whereabouts are unknown. The stele (of what kind of stone?) was broken into two pieces and remained unfinished. The lower fragment measures 48 × 36 cm, the upper one 43 × 36 cm. The pole stands on a two-step socle. There is a marked resemblance between the form of this crescent and the one described in fig. 1, but its opening is wider. According to the context of its discovery, the stele has been dated between 648 and 610 BCE.[4]

No. 3 = **fig. 3** was found during the construction works of the Pazarcik Dam in Kizkapanli near the small village Gözlügöl at Kahramanmarasç (Maraş) about 130 km N.W. of Harran. The stele is now exhibited in the Museum of Kahramanmaraş. The basalt (?) stele measures 140 × 44 × 16.5 cm. It is the only stele of this series comporting the bare crescent

3. Gadd 1951: 80, 108-10 pl. 10.3; Spycket 1973: 389-90, 393 fig. 15; Börker-Klähn 1982: no. 206 (Lit.); Kohlmeyer 1992: 97. Concerning the dating, doubts are raised by Frahm (1997: 193). The stele may belong to the time of Esarhaddon, Sanherib being mentioned as Esarhaddon's father.
4. Lloyd and Gökçe 1953: 60 fig. 6 and pl. 4.1; Spycket 1973: 389-90, 393 fig. 16; Börker-Klähn 1982: no. 230; Kohlmeyer 1992: 97.

on a pole, without a socle or tassels. Strictly speaking, it does not, therefore, belong to this catalogue. But the aspects in common with the other stelae are so many that it seems to me justified to include it. The crescent almost encircles a disk, which might represent the full moon. The stele shows an inscription (cf. *Appendix I* at the end of Part II) and dates from the time of Adadnirari III (811–781), or more exactly from the year 805. The inscription stipulates its purpose—the marking of a border which was approved by Shalmaneser IV in 773 on the reverse of the stela. Since line 23 of the inscription mentions very specifically the moon god Sin of Harran as guarantor of borderlines (Donbaz 1990: 9), I am entitled to state that the crescent on a pole, even without its two characteristic attributes, may stand for the moon god of Harran.[5]

No. 4 = **fig. 4** was found built into a wall in the little village of Qaruz located at 14 km S.E. of Arslan Taş and about 50 km W.S.W. of Harran. The basalt stele is stored in the Archaeological Museum of Raqqa. It measures 137 × 55 × 24 cm. The pole of the crescent stands on a three-step socle and the tassels follow the pole so closely as to form a kind of rectangle. The crescent is wide open as on fig. 2. The stele bears an inscription, but the signs are badly damaged (see *Appendix I*). An exact dating is not possible; eighth/seventh century (Kohlmeyer 1992: 96 and pl. 39.5).

No. 5 = **fig. 5** was found on a field near Zaraqotaq. It had possibly been carried there from Tell Aḥmar (Til Barsib), 70 km W.S.W. of Harran. The basalt stele is now on exhibit in the hall of the National Museum of Alep. It measures 162 × 62 × ? cm. The pole stands on a two-step socle. It ends in a knob to which two bell-shaped tassels are attached. The crescent itself comports two loops almost completing a circle. Based on stylistic criteria, the stele has been assigned an eighth-century date (Kohlmeyer 1992: 94-95 and pl. 39.3).

No. 6 = **fig. 6** was found integrated into a shrine of a saint in 'Aran (Bit Agusi) 19 km S.E. of Alep near the lake of Ğabbul, some 160 km W.S.W. of Harran. It is still there nowadays. The basalt stele was set into the ground with only the upper half of it remaining visible. This part measures 75 × 59 × ? cm. The shape of the tassels and the crescent

 5. Börker-Klähn 1982: no. 166; Donbaz 1990: 5, 8-10, 15-24 figs. 7-24; Kohlmeyer 1992: 97-98 with n. 37. Lit.

resembles fig. 1. It cannot be dated more accurately than c. eighth/ seventh century (Kohlmeyer 1992: 91-94 and pl. 38.1).

The Lunar Emblem Flanked by Two Male Figures

A second type of stele, of which two examples are known, shows the lunar emblem flanked by two male figures.

No. 7 = **fig. 7** was discovered in Tavale Köyü near the Orontes, halfway between Antakya and Samandag, about 250 km W.S.W. of Harran. The basalt (?) stele is now in the Archaeological Museum of Antakya, Inventory no. 11 832. The upper part of the stele was broken off. The dimensions of the preserved section measure 127 × 52 × 31 cm. The pole stands on a three-step socle on which the crescent might have reposed directly. The tassels seem to be attached to the crescent. 'On both sides of the standard symbol...one figure in a greeting position: at least the one on the right hand side is bearded, both of them wear a fringe-coat.'[6] Donbaz refers to them as 'royal figures' (Donbaz 1990: 5). If by 'royal figures' he understands Assyrian kings, this is rather unlikely. A comparison with other monuments of the ninth century, for instance the Black Obelisk of Shalmaneser III, shows that the dresses of the persons in fig. 7 resemble the costumes of high ranking officials or local nobles more closely than that of the great king.[7] The inscription (cf. *Appendix I*) dates the stele to the time of Adadnirari III (811–781).[8]

No. 8 = **fig. 8** was found in Göktaşköyü 120 km W.N.W. of Harran. It is exhibited now in the garden of the Archaeological Museum of Gaziantep. The basalt stele measures 125 × 33-36 × 20-22 cm. It is broken into two pieces. The pole of the lunar emblem is placed upon a three step socle. The tassels are attached to the crescent, the ends of which almost form a circle. The two figures, which do not touch the ground, are wearing long dresses, and each one raises a hand in a greeting or worshipping gesture. While the one on the right hand side

6. Kohlmeyer (1992: 98), referring for the fringed shawl tunic to Hrouda (1965: 38-39 no. 3).
7. Pritchard (1954: no. 352), the two uppermost and the last register (no. 355); the upper register; cf. Börker-Klähn (1982: no. 152).
8. Börker-Klähn 1982: no. 167; Donbaz 1990: 5-9, 11-14; Kohlmeyer 1992: 98.

holds a stick, the left one does not, which rules out a mere formal doubling of one single figure. The stele can be assigned only roughly to the eighth/seventh century (Börker-Klähn 1982: no. 244; Kohlmeyer 1992: 98-99).

The Lunar Emblem and the Anthropomorphic Moon God

On two further examples of monumental art, a stele and a relief plate, the lunar emblem is not the only, not even the main, object but appears to be a secondary attribute besides an anthropomorphic figure of a deity which in one case presumably, and in the other most certainly, represents the moon god.

No. 9 = **fig. 9** originates from Ali Gör near Sürüş, some 50 km W.N.W. of Harran. Today it is kept in the Lapidarium of the Archaeological Museum of Ankara. The basalt stele measures $162 \times 67 \times 19$ cm. An anthropomorphic god turning to the right stands on a crouching winged animal. The animal has been identified as a winged bull by Börker-Klähn (1982: 221), but more correctly by Barnett as a lion–dragon (Barnett 1986: 264. Kohlmeyer 1992: 98). It is similar to a cylinder seal in the British Museum showing the moon god standing on a lion–dragon (Collon 1992: 37, fig. 22). The god wears a feather polos (Hrouda 1965: pls. 4, 12-16, 18-21) with heavily worn out feathers and a disk on top 'in the same manner as the deities of Maltai'.[9] To the right the horns may still be recognized. The coiffure and the beard seem to be conventional; below the head a long tress, enlarged at the end, hangs over the back, as is familiar from the mural paintings at Til Barsib. The god's equipment consists of a bow, a sceptre and a sword with a knob, and a curved object in the right hand hanging down. This object (a debased scimitar?) 'is topped by an animal head (bird?) and, in spite of the missing crosspiece, it is identical to the instruments on the Zincirli stele,[10] as well as to the Maltai reliefs'[11] and to a 'sculptor's sketch' of Sanherib (?) in the Berlin Museum (VA 6726), which the god on this stele also resembles in other aspects (Hrouda 1965: pl. 58.6).

9. Börker-Klähn (1982: 221 cf. nos. 207-10), the Maltai relief.
10. Börker-Klähn (1982: 219); 1. Symbolic figure.
11. Börker-Klähn (1982: 221) referring to Börker-Klähn nos. 207-10; 3. Figure of a god on a winged bull.

To the right, at the side of the feathered polos, appears a winged sun, but the highest importance is focused on a further symbol. Between the border and the figure there has been added—in a way which heavily disturbs the whole composition—a stick which carries a half-moon on top of a circular thickening. In the flat, trapezoidal form behind the shaft, the two tassels of the Harran stele (here, fig. 1) and of the relief of Alep (here, fig. 10) can be identified with some difficulty. The knob below the half-moon is repeated on the stele of Sultantepe (here, fig. 2; see also fig. 5)... The stele bears no inscriptions and it never did' (Börker-Klähn 1982: 221, no. 240, fig. 240a-b; Kohlmeyer 1992: 97-98).

No. 10 = **fig. 10** comes from Tell Aḥmar (Til Barsib) 70 km W.S.W. of Harran. The relief plate is broken in two pieces. The origin of the upper part kept in the National Museum of Alep (Inventory no. M.4526) was unknown although it had been published by Bisi in 1963. In 1992 Kohlmeyer showed that the Alep fragment undoubtedly belongs to another fragment which had been found on Tell Aḥmar, published by Thureau-Dangin and Dunand in 1936 (pl. 14.5a-b), and which figures today as Inventory no. AO 26 555 in the Louvre. Seidl independently made the same discovery as Kohlmeyer (Seidl 1993: 72). The relief, consisting of two fragmentary pieces of limestone, measures about 55 × 38-39 × 6.5-7 cm and is carved on both sides. On one side a gate flanked by towers is visible. 'The meaning of it could be the temple of the moon god of Harran' (Kohlmeyer 1992: 100). On the pinnacles of the gate stands a god looking to the right. He wears an Assyrian slashed dress and a feathered(?) polos with only one horn on his head. The polos is topped by a crescent. The short stick which the god is holding in one hand also ends in a crescent, and three more crescents can be seen on the shaft of the sword which protrudes from the back. The building on which the god is standing is flanked by two high poles which overlook the construction. 'The shafts...are crossed by double indentations forming 14 and 15 segments; could not the sum of this, i.e. 29, stand for the duration of a month?' (Seidl 1993: 72). The poles are topped by crescents. At the place where the crescent reposes on the pole, two tassels are visible, shaped very similarly to those of fig. 6. The god standing on the temple could represent the moon god of Harran in an anthropomorphic appearance. The other side of the carved plate shows a four-winged demon in a slashed dress and with a bucket in one hand.

The plate is considerably smaller than the stelae in figs. 1–9.

Börker-Klähn considers therefore that it possibly is a cult stele. This is not to be excluded, but another possibility might be that the plate was a votive offering for Sin... At any rate it seems too big for a sculptor's model. As to the dating the piece cannot be separated substantially from the frescoes (of Til Barsib) of the 8th century BC, even considering the insoluble contradiction to the basic publications on which it is based.[12]

One should note that although the inscriptions on the stelae, as far as there are any, are Assyrian, not a single stele has been found in the heartland of Assyria. The Assyrians evidently adopted an Aramaean shrine worship. In the late Neo-Assyrian times, under the Sargonids, the moon god of Harran gained importance to the extent that it was often elevated to the second position after Assur in the inscriptions (Lewy 1945–46: 453-89).

The Lunar Emblem as Attribute and Object of Worship

From the end of the ninth until the sixth century the importance of the cult of Harran seems to have increased steadily. Around 730 Barrakib, the Aramaean prince of Sam'al (Zincirli), a place located more than 200 km W.N.W. of Harran, had his figure engraved with the typical emblem of the moon god of Harran (**fig. 11**).[13] In the apposition to the emblem he explains: *mr'y b'lḥrn* 'My master is the Lord of Harran' (Donner and Röllig 1962: 236-37, no. 218).

Somewhat later, in the seventh century, the worship of the moon god of Harran spread not only 200 km to the west, but more than 700 km in a south-westerly direction to southern Palestine. There is clear evidence that the moon god of Harran was considered by the Assyrians as the special patron of the extension of the empire to the west and south-west as far as Egypt (see esp. Uehlinger 1997a: 315-23). A letter of the haruspex Marduk-šumu-uṣur to Ashurbanipal describes a ceremony that is said to have taken place at Harran before Asarhaddon left on his first Egyptian expedition (Parpola 1983: 100-101; 1993: 136-37, no. 174).

A first hint of the cult of the moon god in Palestine may be a bronze crescent measuring 17 cm at its maximum width and whose height is

12. Kohlmeyer 1992: 100; cf. Thureau-Dangin and Dunand 1936: 159 no. 9 and pl. 14.5a-b; Bisi 1963: 215-22 and pl. 40; Spycket 1973: 388-89 fig. 21; Börker-Klähn 1982: 222 no. N 240; Kohlmeyer 1992: 99-100 and pls. 40 (Moon god), 41 (Four-winged genius); Seidl 1993: 72.

13. Pritchard 1954: no. 460; Orthmann 1971: 545 no. F/1; Genge 1979: 121, 145-46; fig. 55; Keel 1997a: 245 fig. 331.

21 cm (**fig. 12**).[14] It was found together with a small bronze bell on Tell eš-Šeri'a, situated between Gaza and Beersheba, on a brick floor of the fortress of stratum V (seventh century). An Aramaic ostracon, some Assyrian objects and other minor finds make it evident that the fortress was held by Assyro-Aramaean occupants.[15] The Aramaeans must have been the driving force for this cult in the west as much as the Assyrians.[16] Two loops at the upper end of the knob, which has been widened to a socket, could have served as an attachment feature for the famous tassels clearly visible on the Barrakib orthostat (see fig. 11). Decorated in this manner, the crescent might have topped a standard, which was worshipped as a cult object, as is shown on a relief of Sanherib from Nineveh.[17]

Weippert has added two similar crescents to the piece on fig. 12 (Weippert 1978: 52-53; 1988: 628 with n. 54). One of them, 15.5 cm wide (**fig. 13**) (von Luschan and Andrae 1943: 105, 168; pl. 48z), was found in Zincirli—like the Barrakib orthostat, the other one, somewhat larger, that is, 25 cm wide (**fig. 14**),[18] comes from Tell Halaf, nearly 100 km east of Harran. In contrast to the similar object from Tell eš-Šeri'a, these two pieces do not have any visible gadgets for attaching the typical tassels. They might have belonged to sceptres, similar to the one held by the god on fig. 10.

Summary and Interpretation

The stelae which display the sole lunar emblem of Harran demonstrate the wide expansion of this emblem in the surroundings of Harran and particularly to its west. Nevertheless, little evidence can be gained with regard to the question which aspects of the moon or the moon god were

14. Oren 1993: 1333-34; cf. Weippert 1978: 52; 1988: 627-28 with fig. 4.66 (6).

15. Oren 1993: 1333. Spycket mentioned as further evidence for a moon crescent standard from Palestine a bronze from Bet-Shean (1973: 387-89 and fig. 12). But Dothan has shown that in this instance the item represents the end of a sceptre or a lance, that is, a forked butt—if not of the usual form (1976: 20-34, esp. 23-24 with n. 16 and pl. 4G; see also Weippert 1978: 53 n. 35).

16. Laroche 1955: 9; Holloway (1995: 307) overemphasizes the role of the Assyrians.

17. E.g. Layard (1853: pl. 24); Paterson (1917: pl. 76); Keel (1997a: 235 fig. 322); cf. Bleibtreu (1983).

18. Hrouda (1962: 54; pl. 34.1); see also Van Buren (1945: 67) for crescents in sheet-bronze, sheet-gold and pink marble from Ur.

considered important. The main interest was focused on the crescent, while the full moon was very rarely integrated into it (e.g. fig. 3). The crescent signified the new or the young moon that redeems from a time of distressing darkness, and whose rising was celebrated not only in ancient Israel (see Chapter 11 below), but in the whole ancient Near East (Fleming 1995: 61-62; Dalman 1928: 10-13, 18, 441, 451, 598, 604, 606).

Wilke has collected a wealth of ethnological material from all over the world which clearly shows the widespread fear aroused by the three days absence of the moon and the joy generated by its reappearance. The main rites connected with this phenomenon are the intense watching out for its reappearance and the solemn announcement of the good news of its first sighting[19] and all kinds of greeting ceremonies and expressions of joy. The blowing of horns and other noisy expressions[20] and the kindling of fires were believed to be certain means for disposing of the evil forces that reigned during the absence of the moon (Wilke 1951: 171-73). It is difficult to figure out what special kind of evil the ancient Near East connected with the darkness which was dissolved by the moon's reappearance. Nonetheless, that its reappearance was the happy outcome of a victorious battle is shown by the fact that the moon god in both depictions (fig. 9-10) represented in anthropomorphic form is carrying a sword.[21] One may object that a sword is part of the standard equipment of every Neo-Assyrian deity. This may be true. True also is that Neo-Assyrian deities were in general quite bellicose. The location on a gate flanked by towers, as fig. 10, adds to the moon god's martial character.[22] Evidently the victory over the darkness must have required a violent effort.

Collon has noticed that only about one fifth of the iconographical evidence for the moon god shows him in anthropomorphic shape (1992: 19-31, esp. 28). One reason for this fact is stated in the work called *De Dea Syria* of the second century CE attributed to Lucian. It

19. For the importance of this aspect in early Judaism see Thornton (1989: esp. 97-98).

20. For this element in Judaism see Nulman (1987–88).

21. See also the heavily armed moon god on a Neo-Assyrian cylinder seal from Boğazköy by Boehmer and Güterbock (1987: no. 318); Collon (1992: 37 fig. 19).

22. C. Uehlinger (1997: 321-23) relates fig. 10 to the vision of the Lord standing on a wall of tin (Amos 7.7).

might have been part of a pre-existent world-view. Writing about the great temple in Membiğ (Hierapolis), Lucian says:

> In the temple itself, on the left of those entering, there is placed first the throne of Helios (sun god), but his image is not on it. For only of Helios and Selene (moon goddess) do they not display statues. The reason for this custom I also discovered. They say it is right to make images for the other gods, for their forms are not visible to everyone, but Helios and Selene are completely visible and all see them. So, what reason is there to make statues of those gods who appear in the open air?[23]

In the case of the lunar emblem of Harran, this last statement could have generated not the suppression of a cult statue, but—as seen on many Neo-Assyrian stelae (see Börker-Klähn 1982: nos. 137, 148, 152 A 1-2, 161, 164, 183, and others)—the representation of the astral deities in their natural shape. Although close to the natural shape, the moon emblem of Harran with its pole and tassels is an artificial symbol.

The main reason for its popularity in the area west of Harran was probably the popularity of the moon temple of Harran. As any major Mesopotamian temple it housed an anthropomorphic cult statue of the main god. This cult image may have looked like any other anthropomorphic representation of the moon god. It was, anyway, not easily accessible to the ordinary public. In the temple court or at the temple gates (cf. fig. 10 and *Appendix II*) may have been placed the moon emblem with pole and tassels which is explicitly related to the *b'lhrn* on the Barrakib orthostat. This emblem of the god and of its temple was known to everybody.

On figs. 7-8 the lunar emblem appears flanked by two male figures. The stick in the hand of the figure to the right suggests the representation of an authority. Sin of Harran, or else his emblem, could in these cases be a witness and a warrant of a certain agreement or treaty which two men might have concluded.

From the four stelae bearing inscriptions (figs. 1, 3, 4 and 7) only two of them (figs. 3 and 7) preserve the signs so well as to suggest a coherent interpretation (cf. *Appendix I*). On the rest of them not much more than the signs for 'Sin' and 'Harran' are legible. The inscription on the stele on fig. 7 dating from the times of Adadnirari III shows that the monument served as a ratification of some border. It separated the region of Zakur of Hamat from that of Ataršumki, son of Adramu, and also determined the yield from the waters of the Orontes river. In spite

23. Translation by Attridge and Oden (1976: 44-47, §34).

of the fact that the inscription names in one case six and in the other four gods, Assur, Adad, Ber and Sin, who lives in Harran, or whose name refers exclusively to Sin, only the emblem of Sin is pictured. Evidently in Harran and to the west of this region, Sin was considered as the guardian of treaties par excellence.

The second stele (fig. 3) is called 'border-' or 'boundary-stone' (*taḫūmu* in line 1 and 16 of its inscription. It was erected by Adadnirari III (811–781) and confirmed by Shalmaneser IV (781–772) as a boundary-stone between Ušpilulume king of Kummuḫ and Qalparuda, king of Gurgum. As warrants for this treaty Assur, Marduk, Adad, Sin and Shamash are named twice, and 'Ashur, my god and Sin who lives in Harran' is also given twice. On this stele too, only the emblem of Sin is illustrated.

Their use as boundary monuments explains why most of these stelae were discovered by peasants in the middle of fields. Even if they were found in a temple, like the example of fig. 1, they could well have been erected there as tokens for the security of some border.[24]

24. A boundary-stone in the shape of a carved stele could be meant in Isa. 19.19. The boundary-stone (*mṣbh*) in Gen. 31.45 was obviously thought to be without any inscription.

Chapter 8

THE LUNAR EMBLEM OF HARRAN IN MINIATURE ART

A. Spycket has pointed out that the lunar emblem with tassels was widespread all over the countries of the Fertile Crescent. By 1973 she had concluded that Harran was the centre of this cult (Spycket 1973: 394-95). She seems to have somewhat underestimated the particular importance of this centre, for she wondered why the emblem left so few tracks in Ur (Spycket 1973: 391). Only two of the six big stone stelae with the lunar emblem were known to Spycket (Aşaği Yarímca and Sultantepe = figs. 1-2). She was not aware of any stele on which the emblem is accompanied by two worshippers as in figs. 7 and 8. This made it difficult or even impossible for her to see clearly the correlation between the monumental and the miniature art, to recognize that the latter very probably depended on the monumental art of the region of Harran, and that the objects of miniature art are not evidence of just any moon cult, but that they were—at least at the beginning—most probably objects produced by the cult centre of Harran. We know that many major cult centres had workshops producing this kind of souvenir and amulet (see Keel, Keel-Leu and Schroer 1989: 281-323; Keel, Shuval and Uehlinger 1990: 396-410). Through Harran too leads the line separating two types of seals that can be distinguished by different elements of the composition (the lunar emblem alone, the same accompanied by worshippers, by trees and so on) and by the feature of the particular items (e.g., the steps on which the lunar emblem is standing, or the trees that can be formed as ear-of-corn or as cypresses).

The Eastern or Assyro-Babylonian Group

The Lunar Emblem on Cylinder Seals
The Neo-Assyrian cylinder seal (**fig. 15**) (Keel 1977: 291-93 no. 15, 295, fig. 221; pl. Vb), cut in a classical linear style, might still be attributed to the eighth century. It was found on Tell Dothan in Central

Palestine and perhaps was brought there during the time of Tiglath-pileser III (745–727). The lunar emblem is flanked by the symbols of the gods Marduk (to the left) and Nabu. The emblems of the main deities of the most important neighbouring nations of the Assyrians, the Aramaeans and Babylonians, both exerted a great fascination and an accordingly high influence on Assyrian culture.[1] They are here combined with a cult scene, which is as typically Neo-Assyrian as the linear style of carving.[2] Like the ones of Marduk and of Nabu, the lunar emblem stands on a simple base line, but its central position and size show its importance as main divine symbol.

On Neo-Assyrian cylinder seals from the end of the eighth century and others from the seventh century, the lunar emblem often appears in the centre, and is flanked by *two worshippers*. A *tree* stylized as an ear-of-corn with a star or some other additional figures on top serves as a terminal (**fig. 16**).[3] The lunar emblem is dressed on a stand which is represented by a broad horizontal line based on a number of short vertical lines.[4] On the Neo-Assyrian cylinder seals from the seventh and sixth centuries, characterized by the use of the ballpoint drill, the stand generally consists of several horizontal rectangles, forming the steps of a socle (see **fig. 17**) (Porada 1948: no. 706; Gordon 1953: pl. 69.37; Keel 1990: 240-41, fig. 58) just as we know them from the stelae (see figs. 1-2, 4-5, 7-8).

On a cylinder seal from the seventh century from Kish only a *single worshipper* is represented. Facing the worshipper is a stylized *tree* (**fig. 18**) (Buchanan 1966: no. 609). The piece being damaged, the styling of the stand—if there ever was one—is not discernible. Besides the tree, various other motifs could also mark the visual 'counterweight' for one of the worshippers.[5]

1. For the ambivalent attitude of the official Assyrian theology, ideology ond policy towards Babylon compare, for example, Machinist (1984–85); for the Aramaization of the Neo-Assyrian imperial administration compare Garelli (1982); Tadmor (1982); Millard (1983) (a comprehensive summary is found in Uehlinger 1990: 485-87).

2. See Lloyd (1954: 108 fig. 8.1); Loud and Altman (1938: pls. 57.85, 58.91); many more parallels in Keel (1977: 291-93).

3. Moortgat (1940: no. 679); Keel (1977: 289-90 no. 6 with fig. 212); see also Delaporte (1910: no. 341); Moortgat-Correns (1968: no. 115).

4. See also Loud and Altman (1938: pls. 57.88); Keel (1990: 240-41 fig. 59).

5. See von der Osten (1934: no. 439 [winged sun], rhomboid and fish); Porada (1948: no. 711, life symbol, rhomboid and 'balance').

The Lunar Emblem on Stamp Seals

A 'counterweight' of any kind is often missing on stamp seals, due to the limited space available (see Keel 1989: 230). This is the case on a rectangular piece bought by M. Mallowan in the Ḫabur valley. Its carving shows the Assyrian style of around 700 BCE (see figs. 16 and 20), and just *one* worshipper is seen in front of the lunar emblem of the moon god of Harran (**fig. 19**) (Buchanan and Moorey 1988: no. 315). The latter appears between two trees on a conoid found on Tell Keisan N.E. of Haifa in a stratum which the excavators date around 700 BCE (**fig. 20**) (Keel, Shuval and Uehlinger 1990: pl.IX.24; see Lambert 1966: no. 68). All the details of style and decoration on this conoid reveal its Assyrian origin (see Keel, Shuval and Uehlinger 1990: 238-42). The hatched socle is particularly noteworthy (see above figs. 16 and 19). Like the piece of fig. 15, the seal combines the lunar emblem with the emblems of Marduk and Nabu. While the two lateral engravings show the Aramaean emblem of Harran and the two Babylonian symbols of the gods, the engraving on the base joins the latter into one group together with some astral symbols (moon crescent, Venus star and Pleiades) appearing in front of a worshipper and a twig, together with a worshipper. This is reminiscent of the cylinder seal of fig. 15.

As on the stelae on figs. 1-6 the lunar emblem of Harran appears on Assyrian miniature art, often without any secondary motifs. In these instances, stamp seals which are engraved on one side only can be distinguished from others which show carvings on several sides. Some examples of the former originate from Assur (**fig. 21**) (Jakob-Rost 1975: no. 419; cf. nos. 416-18, 420-23), Nimrud (Parker 1955: 107 with pl. 18.1) and Babylon (Jakob-Rost 1975: nos. 414-15). According to the context of these finds most of them belong to the Neo-Babylonian or even to the Persian period. Among the latter a scaraboid from Assur engraved on both sides (**fig. 22**) (Haller 1954: 92 with pl. 19g; Jakob-Rost 1975 no. 368) and a truncated pyramid seal from Nimrud with decorations at the top and at the base may be singled out (Parker 1955: 108 with pl. 18.5). Both pieces show on their base a mother animal with a sucking offspring. Both of them may be dated to the seventh century. Even though much caution is requested for establishing any relation between the motifs on different faces of an object, in the present instance the mother animals might symbolize the blessing presented by the new moon comparable in this regard to the trees on the items of figs. 16, 20, 27-29. Some rectangular plaques which are decorated

not only on both broad sides, but also on their narrow sides, belong to this group.[6] On three pieces one of the narrow sides shows a tree in the shape of an ear-of-corn, the other one displays the lunar emblem. One of these items was found in Beth-Zur in a Hellenistic stratum (**fig. 23**) (Sellers 1933: 59 fig. 50.5, 61). The affinity in style between the lunar emblem as well as the 'hill' on which the tree stands with the representation on fig. 22 suggests a dating in the seventh century, notwithstanding the later context of the find. Another example is known to originate from the other end of the Fertile Crescent, that is, from Susa (**fig. 24**) (Amiet 1972: no. 2311; see also Delaporte 1920–23: no. A. 1149). According to the worshipper's costume Spycket dated it to the Persian period (Spycket 1973: 391 n. 37).

The Intermediate Group from the Harran Region

The crescent cut in a linear style on fig. 20 (see also Delaporte 1920: no. 341; Loud and Altman 1938: pl. 57.88) and the ends of the tassels drilled with a ballpoint drill on the Assyrian seals of figs. 22 and 23 also appear on a limestone scaraboid recovered at Megiddo as a surface find (**fig. 25**) (Lamon and Shipton 1939: pls. 67.8, 68.8). The rectangular socle upon which the pole is dressed resembles the latest Neo-Assyrian evidence, characterized by the ballpoint drill work and also showing the two rectangles which do not form a stair, but have almost (Porada 1948: no. 711), or even exactly, the same length (**fig. 25a**).[7] Here the lunar emblem stands between the enthroned anthropomorphic moon god (?) and a worshipper. On fig. 25, two drill-hole stars are flanking the lunar emblem instead of two trees. A chalcedon seal with very similar iconography originates from stratum VI (late eighth/ seventh centuries) at Sultantepe (**fig. 26**) (Lloyd 1954: 108, 110, fig. 8.6). It shows the lunar emblem on a stand of two rectangles of the same width too, but accompanied by only a single star. A rectangular limestone plaque from Sultantepe stratum V (seventh century) displays an ear-of-corn shaped tree with drill-hole stars framing the emblem (**fig. 27**) (Lloyd 1954: 108, 110 fig. 8.10). The tree looks rather Assyrian, but this kind of design has also been found in the west as far as Zincirli

6. For such items see Buchanan and Moorey (1988: nos. 354-55).

7. This seal was acquired lately by the Biblical Institute of the University of Fribourg in Switzerland: inventory no. VR 1991.58; whitish stone with a partially beige and pink shade, traces of a bronze setting; 33.3 × 15.7 mm.

(**fig. 28**) (von Luschan and Andrae 1943: 159, pl. 38; Keel 1977: 287-88, no. 3 with fig. 210). The ear-of-corn shaped trees are typical of the eastern and the intermediate group (see figs. 16, 18, 20, 23-24, 27, 29-30 and Lambert 1966: no. 68). The tassels that on fig. 28 are attached at the lunar emblem itself seem to be a typical attribute of the original emblem of Harran (see especially fig. 11). On the Assyrian items, however, most of the time the tassels hang from a small cross-stick of the pole (see figs. 15, 16, 19; see also Lambert 1966, no. 68). The item from Tell Keisan (fig. 20) combines both forms.

Neither figs. 27 nor 28 exhibit typically and exclusively Assyrian features; they rather build up a link between the eastern and the western group. The same applies to two deeply carved clay fragments which were found on packing material from Iron age II on Tell Keisan (**figs. 29-30**) (Puech 1980: 297-98, pl. 90.36-37). They look very similar to the one on the limestone seal of Sultantepe (fig. 27), except that the stylized tree appears at the left hand side of the emblem instead of the right, which might be due to the fact that the engraver had copied an impression of a 'Sultantepe type' seal. The socle with a simple, rectangular or square contour is typical for this whole group. On fig. 28, however, the socle is missing altogether.

A cylinder seal from Gezer shows a procession of three worshippers moving towards a lunar emblem (**fig. 31**) (Parker 1949: no. 190). The crescent is inscribed with a full moon disk as on fig. 11. The long hanging tassels which consist of drill-holes can accurately be attributed to the group represented by fig. 17 (see also Porada 1948: no. 712). The cube on which the emblem is dressed resembles examples from Sultantepe (figs. 26-27). The worshippers are quite close to the ones on fig. 33 without offering an exact parallel. Neither Parker nor Spycket (1973: 338, fig. 5) or Weippert (1978: 54, no. 12) suggest a date for the seal of fig. 31. While the form of the tassels, the feature of the hair and the fringed dresses are reminiscent of the Neo-Assyrian seals of the 'late drilled style' (Porada 1948: no. 711), some other details (moon disk, square stand) do not apply to this group so that these might be a product of the late eighth or seventh century made in north Syria, with a strong Assyrian influence but very closely connected with the intermediate group of Harran.

The Western or Northern Syrian–Phoenician–Palestinian Group

Cylinder Seals

A cylinder seal bought in 1975 by the Museum of Adana differs in one typical detail from the iconography of the classical Neo-Assyrian cylinder seals (**fig. 32**) (Tunca 1979: no. 73). The stand holding the lunar emblem is neither streaked (fig. 16) nor forming a stair (fig. 17) but is represented as a rectangle based on two *short feet*. A Neo-Assyrian cylinder seal found on Cyprus shows a comparable irregularity (**fig. 33**) (Ohnefalsch-Richter 1893: pl. 30.11). On this item the feet are lacking underneath the rectangular stand but the *grid pattern* is unusual for Neo-Assyrian seals.

On a cylinder seal made of fine limestone found in a grave on Mount Nebo in Transjordan the lunar emblem is also dressed on a stand provided with feet *and* grid pattern, which, moreover, curves downward in the middle (**fig. 34**) (Keel, Shuval and Uehlinger 1990: 329-30 with fig. 109). The context of the find and stylistic considerations suggest a date in the eighth or seventh centuries. In this instance the stand on which the lunar emblem is erected, the double-pipe and the lyre player marching from the left towards the lunar emblem, as well as the cypress-shaped tree appearing to the right hand side are all foreign to Assyrian style and convention. In front of each of the two musicians an angularly stylized sign of life may be seen. Some astral symbols surround the emblem. The iconography is almost identical with the four sides of a prism from the Dayan collection (Giveon 1978: 117-20 and figs. 63-64; Keel, Shuval and Uehlinger 1990: 329-30 with fig. 108). Stylized cypress trees also appear on a number of Phoenician metal bowls (Markoe 1985: 244-45, no. Cy 2; 256-57, no. Cy 8; 290-91, no. E5; 292-93, no. E6; 296-97, no. E8; 308-309, no. E13; 348-49, no. U7). Compared with these features in fig. 34 and related pieces we should notice the two lines at the intersection of the stem with the crown of the tree. They might have been transferred from the lunar emblem onto the trees. Alternatively the trees could be traced back to a misunderstood, and later on adapted spade of Marduk (see fig. 46 with figs. 15, 20, 33). Rows of male or female musicians, mostly one lyre, one double pipe and one drum player, appear almost as commonly as stylized cypresses on products of Phoenician craftsmanship (Marko 1985: 246-47, no. C3; 252-53, no. Cy 6; 316-17, no. G3; Barnett 1975: pl. XVIf, no. S3). However, the Phoenician metal bowls show female musicians without

exception. On an ivory from Nimrud the gender of the players is not clear. In the Phoenicia–Aramaean border region, on the Karatepe ortho-stats and in the Aramaean-influenced region of Zincirli, the musicians are male (Orthmann 1971: 394-95; pl. 18c, 63f, g-h) like those on the cylinder seal of fig. 34.

Stamp Seals
To the West, the lunar emblem is shown much more often on stamp seals and related items than on cylinder seals.

The lunar emblem alone. The stand of the lunar emblem on the cylinder seal of fig. 32 is somewhat similar to those featured on three impres-sions on a tablet inscribed in cuneiform from Gezer (**fig. 35**).[8] The selling of land witnessed on this tablet was realized in the year 649 as indicated by the reference of the eponymate of 'Aḫi-ilāya, governor of Kargamiš'. The text starts with: 'Seal of Natanyahu, owner of the field which is to be sold...' There follow three impressions of the same seal containing the lunar emblem and a star. The owner and seller was, as the name suggests, a Judahite citizen, and the seal with the lunar emblem obviously belonged to him. The buyer is not mentioned. Of the four remaining names of the witnesses of the transaction one is Egypt-ian or Aramaean, two are Akkadian and one is not identifiable. On a second tablet from the same period found in Gezer one Egyptian and several Aramaean and Akkadian names are mentioned (Becking 1983: 88; Zadok 1985: 568-69). Moreover, the tablet provides an interesting hint of the surroundings to which the lunar emblem of Harran had actu-ally spread (see also above fig. 12). In a mixed population, in which the Aramaean element was highly important, the lunar emblem apparently found its way into Judahite circles. This evidence was confirmed a few years ago by two newly found impressions on mud sealings. The first one (**fig. 36**) (Keel and Uehlinger 1995: 343, fig. 297a) comes from a seventh-century archive of Jerusalem, from the so-called City of David. The iconographical feature of the emblem is quite singular and should perhaps be attributed to a local workshop. Instead of the flagstaff it shows a thick, hatched column which to some extent recalls the

8. Macalister 1912: I Frontispiece fig. 3 with 27-29; II 297 no. 38; see Becking (1983: 86-89); Reich and Brandl (1985: 41-42 [with lit.], 48 no. 3).

representations of a column with a volute capital of the same period.[9] The two oblique lines at the intersection of the crescent and the pole may be traced back to the tassels of the Harran emblem, but they show that this is an adaption of that emblem. The impression of an anepigraphic seal with the representation of the lunar emblem from the former Judean Ḥorvat 'Uza in the north-eastern Negev, 6.5 km S.W. of Arad (**fig. 37**) dates from about the same time (Beck 1986a: 40-41). The stand is similar to the one on figs. 32 and 35. The pole rendered by a double line and the tassels represented in the same way recall fig. 39.

The shape of the stand on fig. 33 also occurs on a unique prismatic stamp seal at the Bibliothèque nationale in Paris (**fig. 38**) (Bordreuil 1986: 21-22, no. 4). The inscription on one side of the prism, *p'r ḥmn*, could imply that the seal belonged to the city of Pa'ar on the Amanus, not far from Zincirli. Presumably it was used to certify the authenticity of the metals produced in that town. Paleographically, the seal may be dated to the second half of the eighth century. As in the case of the Barrakib orthostat (fig. 11), it proves that the cult of the moon god of Harran had already spread towards the west by the second half of the eighth century. The lunar emblem on fig. 38 is flanked on the right hand side by four drill-holes (stars), on the left by a further drill-hole and a radiant star. A surface find from Naḥšonim, some 4 km S.E. of Petaḥ Tiqwah is unfortunately known only from an impression (**fig. 39**) (Keel 1977: 294-95, no. 17 with fig. 223). Here the lunar emblem is flanked by two stars and a rhomboid (and not by a tree, as I have stated in an earlier publication) (Keel 1997: 294). In that period a rhomboid quite often appears together with astral symbols (Keel, Shuval and Uehlinger 1990: 325, figs. 99-101, see 328). The stand has the same shape as the one on fig. 34. The emblem itself is in all details identical to that on a scaraboid from Tell Ğemme (see below fig. 43).

The lunar emblem with one worshipper. A whole series of stamp seals of the Western group shows a single worshipper in front of the lunar emblem. A stamp seal of this type has been impressed on a cuneiform tablet from Kargamiš which may be dated around 700 (**fig. 40**) (Thompson 1921: 135-42, fig. 54, pl. 26a). The tablet mentions 16 Aramaeans from the Harran region and one native Assyrian. Unfortunately the carelessly made impression neither reveals the stand nor the

9. Keel and Uehlinger (1995: 415 fig. 353a); Sass and Uehlinger (1993: 275 fig. 10); see Keel-Leu (1991: no. 132).

customary tassels. A scaraboid with the same composition was bought by G.J. Chester at Tartus in 1889 (**fig. 41**) (Buchanan and Moorey 1988: no. 316). It shows the now customary western stand, stylized as a rectangle on two feet without grid-pattern, but with vertical rills (influenced by the eastern group?).

A scaraboid from Shiqmona near Haifa, from a stratum dated somewhat generously by the excavator from the ninth to the seventh century, also shows the variety with one worshipper (**fig. 42**) (Spycket 1974: 258-59, pl. 15.2-3; Keel 1977: 295-96, no. 21 with fig. 227). In shape the emblem and the stand resemble the examples of the intermediate group (figs. 26-27, 29-31). As on the original in fig. 40 and on fig. 41 which presents the impression the worshipper is standing at the right-hand side of the emblem. A non-stratified scaraboid from Tell Ğemme is the only original seal to represent the worshipper on the emblem's left (**fig. 43**) (Petrie 1928: 10, pl. 17.49; Keel 1977: 295-96, no. 20 with fig. 226).

The lunar emblem between two worshippers or between a worshipper and a tree. A scaraboid of unknown provenance in the Bibliothèque nationale in Paris (**fig. 44**) is closely related in style to the seals from Naḥšonim (fig. 39) and Tell Ğemme (fig. 43) (Delaporte 1910: no. 648; Keel 1977: 291, no. 14; 295 fig. 220). While scaraboids usually show only one worshipper, this one has two of them as seen on two stelae (fig. 7-8) and especially on the cylinder seals (see fig. 16-17, 32-33). On a limestone scaraboid from Shiqmona originating from the same stratum as the item of fig. 42, the emblem is flanked by a worshipper and a cypress-like tree, and a radiant and two drill-hole stars are shown in the field (**fig. 45**) (Spycket 1974: 258, pl. 15.1; Keel 1977: 291-92, no. 13 with fig. 219). The stars and the tree on fig. 45 so strikingly resemble those of fig. 34 that we may assume them to have been produced in the same workshop. The existence of a northern Syrian workshop manufacturing both cylinder seals and scaraboids is actually quite probable during that period. The worshipper and the tree also feature as flanking figures on a Neo-Assyrian cylinder seal (see fig. 18). Note also fig. 39 for the marginal rhomboid.

Discussion of a group of seal images showing the lunar emblem in combination with Egyptian motifs is beyond the scope of this work.[10]

10. A cylinder seal from Tell Ğemme made a composite material shows the lunar emblem without pedestal flanked by a cypress-shaped tree and an uraeus

The lunar emblem or the moon god between two trees. The eastern (see fig. 20) and intermediate groups (fig. 28) sometimes show the lunar emblem flanked by *two* trees as in the western tradition. The latter, however, does not know the tree in the shape of an ear-of-corn but exclusively as a cypress-like shape. A scaraboid from trench III at Tawilan in the south of Transjordan, which has been dated by the excavator to the eighth or even ninth century on account of the context, may serve as an example (**fig. 46**) (Bennett 1984: 3-4, pl. VI; Keel 1977: 286, no. 2, 288, fig. 209). An eight-pointed star appears within the crescent. The trees are more schematic than the ones on figs. 34 or 45. The question might even arise whether the tree to the left with the three crosslines was not meant to represent the spade of Marduk. The small crosslines between the stem and the tree top, which from a botanical point of view do not make sense, should perhaps be attributed to the influence of the spade of Marduk (see figs. 15, 20 middle, 33; Keel and Uehlinger 1995: 342). On two further pieces—one of them poorly preserved coming from Tell en-Naṣbe (**fig. 47**) (McCown 1947: 296, no. 51; pl. 54.51; Keel 1977: 289, no. 9; 292 fig. 215) and the other one well preserved from Tell Keisan (**fig. 48**) (Keel 1990: 219-22, pl. VII.16)—the lunar emblem is only flanked by two plain rhomboids (see figs. 39 and 45). The lines added at the bottom were probably meant to suggest a kind of tree. Both pieces lack a clear stratigraphical context.

An interesting iconographical variant of the lunar emblem between the trees is furnished by a scaraboid from Shechem (**fig. 49**) (Horn

(Petrie 1928: pl. 19.27; Keel 1977: 293, 295 fig. 222). On a similar cylinder seal from composite material, instead of the tree there is a feather of Maʻat (Parker 1955: 106; pl. 17.3). A third item of this type was found in Gözlu-Kul/Tarsus (Tunca 1979: 21; pl. 9.87). All three are dated to the seventh century. The Biblical Institute of the University of Fribourg in Switzerland has recently acquired three more cylinder seals of this type. One shows the Pleiades and an uraeus with the red crown of Lower Egypt to the right of the lunar emblem; to the left of the lunar emblem is an offering table and above it an eight-pointed star. On the second one the lunar emblem is flanked by an uraeus and the spade of Marduk and the third one shows an uraeus and a mountain(?) with a nine-pointed star above it besides the emblem (Keel and Uehlinger 1996: 156 figs. 180-81b; Uehlinger 1997a: 319, figs. 15-17). On a scaraboid from Gezer the Egyptian sign of life is combined with the lunar emblem (Macalister 1912: II 324 no. 266; III pl. 207.48; Weippert 1978: 55-56 no. 14; Reich and Brandl 1985: 48 no. 5). For the historical significance of this type of seals see Uehlinger 1997a: 315-23.

1962: 12, no. 33; fig. 2.33; pl. 1.33; Keel 1977: 286-87, n. 47, 308 fig. 238c). Instead of the lunar emblem it shows a human figure sitting on a throne, with one hand raised in a blessing attitude. This could well be an anthropomorphic moon god who, in the eastern as well as in the western tradition, eventually appears in the moon boat (**fig. 49a**) (Keel and Uehlinger 1995: 351, fig. 305a; see 349-52 with figs. 305b-307). The origin of the moon god in the boat and more evidence of this motif from Palestine is discussed below.

The Chronology of the Western Group of Stamp Seals
When trying to arrange the seals of figs. 32-49 in chronological order according to their stylistic singularities and archaeological context, the majority are found to originate from within about 100 years covering the time from c. 730–630. Two objects (figs. 42 and 45) originate from a layer dated by the excavator between the ninth and the seventh centuries. The seal from Tawilan (fig. 46) was found in an eighth- or even late ninth-century layer. All the more precisely determined items are dated at the end of the eighth and especially in the seventh century (figs. 34, 36-37, 40). The impressions of fig. 35 were made in the year 649. The period of time marked out by all these pieces is more or less identical to the time of the most intensive Assyro–Aramaean presence in Palestine, which starts with Tiglathpileser III (745–727) and ends with Ashurbanipal (669–631).

However, this large group is preceded by a small number of more ancient seals and seal impressions featuring the lunar emblem, for example, a scaraboid found on the surface on Tell el-Farʻa (south) (**fig. 50**) (Petrie 1930: 9, pl. 22.236: Keel 1990: 37, pl. XX.3). The piece is made of haematite and could be part of a group of seals of the same material which was imported from northern Syria to Palestine and which was most popular in the tenth or early ninth centuries (Keel, Shuval and Uehlinger 1990: 367-77, esp. 376-77; Keel and Uehlinger 1995: 160-62). As on the scaraboid from Zincirli (fig. 28) the emblem on the haematite piece is represented without a stand and the tassels hang down directly from the crescent.

Two impressions on jar handles likewise date from the beginning of Iron age II (tenth century) or even from the end of Iron age I (eleventh century). Unfortunately in both instances the image is rather indistinct. The first example is an impression of a circular stamp seal on a jar

handle from Hazor stratum X (**fig. 51**).[11] In addition to the worshippers the lunar emblem is flanked by two ear-of-corn shaped-trees as we know them from figs. 20 and 28. In the second case there are only two worshippers (**fig. 52**) (Chambon 1984: 114, pl. 80.7; Keel and Uehlinger 1995: 165, 167, fig. 171b). This impression was discovered on Tell el-Far'a (north) in stratum VIIb which has been dated to the end of Iron age I or the beginning of Iron age IIA. On all these early documents from Palestine (figs. 50-52) the lunar emblem appears without a stand. On fig. 52 no tassels are visible, perhaps because they never existed in the first place.[12] This early group from the end of the eleventh and the tenth century shows that at that time some links had already been established between Palestine and the region of Harran. These links resumed in the eighth or seventh century through the mediation of Aramaeans who served in the Assyrian army and administration.

Summary and Interpretation
From seal impressions on contracts written on cuneiform tablets (fig. 35; see fig. 40) and bullae (figs. 36-37) it is obvious that the lunar emblem could represent the moon god as guardian and warrant of treaties on miniature as well as on monumental art. A legal significance may also be assumed for the seal on fig. 38. However, the number of impressions showing the lunar emblem is rather scarce when compared to actual seals. As for the seals themselves, their significance as amulets must have been considerable. The two treaty partners shown on the stelae in figs. 7-8 appear only on one stamp seal (fig. 44) but more often on cylinder seals (figs. 16-17, 32-33, and the quoted parallels to these examples). However, the question remains, whether these should really be understood at all as partners of a treaty. Fig. 31 shows three worshippers approaching the lunar emblem from the left hand side, and on fig. 34 two human figures play the double-pipe and the lyre in front of the emblem. The main significance of these scenes is bound to be worship. A single worshipper standing in front of the lunar emblem may of

11. Yadin (1960: pls. 76.8, 162.4); Keel (1977: 286 no. 1, 288 fig. 208); Keel and Uehlinger (1995: 165, 167 fig. 171a).
12. A 'lunar emblem' on a seal from Tell Beit Mirsim stratum C (1500–1230 BCE) mentioned by Weippert (1978: 55 no. 18) has been proved not to exist by a good enlargement of the seal (cf. Keel, Shuval and Uehlinger 1990: 386 no. 28, 388 fig. 96).

course characterize the latter as a symbol of a heavenly warrant for treaties (figs. 40-43), and may actually manifest himself as a true follower of this same god of the treaty when the seal amulet is used to seal a document. But in the instances where a tree instead of a second worshipper is shown at the side of the emblem (figs. 18, 45; see also fig. 34), and in those numerous cases where a single (figs. 23, 27, 29-30) or two trees (figs. 20 right, 28, 47-49) flank the lunar emblem, the major concern is not with the legal aspect, but with the moon god's power to let the vegetation germinate and grow.[13]

On the cylinder seals (cf. on fig. 16), the tree appears twice only when the seal is rolled out more than once (see Keel 1977: 290, figs. 212-14). The tree is engraved only once and serves as a terminal for the scene (see especially figs. 15 and 18). In the case of the stamp seals with flanking trees, the symmetry is intentional. Spycket wanted to see in those trees a summary characterization of an open air sanctuary (Spycket 1973; 1974 'bosquet'; Weippert 1978 'Höhenheiligtum'). In accordance with the tradition of the ancient Near Eastern and Egyptian iconography, I prefer to recognize in the two trees a symbol of the gate of heaven from where the new moon rises, and which was thought to be a place of the most intense blessing (Keel 1977: 296-303; 1978). I interpret the composition of the lamp-stand between two trees, respectively associated with the two anointed men in Zechariah 4, in the same way. The symbolic content does not exclude a basis in reality, but the artificial trees flanking the emblem of the moon in the sanctuary of Harran and its imitations all over the ancient Near East are more likely to have served as prototypes for the seals' representations of the lunar emblem between two trees than represented some kind of physical wood ('bosquet').[14]

Whether the two trees mark the gate of heaven or not, in any case they illustrate the blessing of the new moon, which not only helps the vegetation to grow, but the animal life as well, as we shall see further ahead. The aspect of fertility, not represented at all in monumental art, is very obvious in miniature art. This has much to do with the

13. Regarding this aspect, it is interesting to note that in Ugarit Anat and Astarte had a particular preference for the moon god (see KTU 1.114.9-13 with the commentary by Cathcart 1996: 4-5). For the significance of the moon for the vegetation see, for example, Philo, *Spec. Leg.* 2.143 (trans. Colson 1937: 393); for ethnographic parallels see Wilke (1951: 181); Eliade (1954: 189-95).

14. Concerning this problem see Keel and Uehlinger (1995: 342-44).

importance of this aspect in everyday life and with the function of the
two kinds of art (monumental and miniature).

The more common representation of the moon god in an anthropo-
morphic appearance in miniature art in Palestine during the seventh
century (figs. 49 and 49a and Keel and Uehlinger 1995: figs. 305b-307
moon god in a boat) may be due to the assimilation of the moon god to
El and vice versa. It may also be due to Aramaean and Assyro–Babylo-
nian anthropomorphic representations of this god standing in the cres-
cent as in a boat (see below figs. 80-84). In the Phoenician–Palestinian
area the crescent shaped boat was replaced by a regular boat under
Phoenician influence (Keel and Uehlinger 1995: 349-61).

Chapter 9

THE ORIGIN OF THE LUNAR EMBLEM
AND THE CRESCENT ON A POLE

The evidence discussed up to now reaches back to the eleventh and tenth centuries. It shows—except for fig. 52—the lunar emblem with tassels to be specifically related to Harran and its famous sanctuary.

The Crescent, Respectively the Crescent and Full Moon
on a Pole in Palestine–Syria in the Second Millennium

A cylinder seal from Megiddo stratum V (eleventh/tenth century) made of haematite shows the crescent without pole-tassels in a context which differs completely from everything encountered thus far (**fig. 53**) (Lamon and Shipton 1939: pl. 66.3; Parker 1949: 12, no. 29). In a procession, five or six human figures carry the king of Egypt upon a throne. The worshippers are kneeling underneath or to one side of the king. Two sunshades are placed behind him and in front two fans on high sticks. In this scene, in monumental art—the standards of the so-called followers of Horus ('Horusgeleit') are preceding the king in a long row (von Bissing and Kees 1922: 24-59). The jackal standard is an integral part of representations of this kind, but the pole with the moon crescent and the full moon is to my knowledge unique in this context. It is probably for this reason that the Egyptologist A. Wiese speaks of a 'not accurately identifiable standard' ('nicht näher identifizierbare(n) Standarte') (Wiese 1990: 74). In my opinion Weippert has associated it correctly with the crescent standards.[1] Human carriers appear on

1. Weippert (1978: 54, 56 no. 6). There is a symbol already on the earliest representations of the followers of Horus that is interpreted today as the 'cushion on the throne'. In the Ptolemaic period this 'cushion' was interpreted as an emblem of the moon god Chonsu. This interpretation is probably older than Ptolemaic (von Bissing and Kees 1922: 37). Since Chons in the New Kingdom became increasingly prominent as a moon god (Brunner 1975: 960-61; Bernett and Keel 1998: 90

scarabs only in the eighteenth dynasty, while throughout the nineteenth and twentieth dynasties they were represented with animal heads, especially falcon heads. Wiese dates the Megiddo cylinder seal into the fifteenth or fourteenth centuries (Wiese 1990: 71-79). However, owing to the presence of the moon standard, which is evidently a non-Egyptian element, the question arises whether the presentation of human instead of animal heads could have taken place under the same influence.

The crescent standard is not totally unique on an Egyptian product. A baboon scaraboid exhibiting a crescent standard was produced in the twelfth or eleventh century. It is accompanied by a tree and a human figure with hanging arms (**fig. 54**) (Keel 1978a: 46, 55 fig. 1). The date can be fixed by the type of the scaraboid[2] as well as by the style of the engraving on its base, which is characteristic of mass-production. These appear at the very end of the Ramesside period or might even be post-Ramesside and have to be dated rather to the eleventh and tenth than to the twelfth century.[3]

As in the case of the cylinder seal of fig. 53, the haematite cylinder seal of **fig. 55** (Petrie 1928: 11, pl. 19.30; Nougayrol 1939: pl. 11 TG 2 no. C) might be older than its archaeological context. Petrie found it in a tenth-century layer on Tell Ǧemme. According to the style and the iconography, however, the seal is related to the so-called common Mitannian glyptic. The disk and the crescent appear separately on a pole on a number of Mitanni style seals of the fifteenth to fourteenth centuries (Delaport 1920–23: pl. 97.16 no. A. 943; Matthews 1990: no. 621). Occasionally two men hold the standard with the crescent and the full moon, for example, on a seal from Ashur (**fig. 55a**).[4]

Two divine or human figures holding a tree or a flower are very common in Old Syrian cylinder seal glyptic of the nineteenth to seventeenth

nn. 397-98), it was quite natural to interpret the old enigmatic emblem that was no longer understood as a representation of the crescent with the disc of the full moon inscribed into it.

2. Jaeger (1982: §§ 519, 1384-87); Stoof (1992: 194-200); Keel (1995a: §146)

3. See for that Keel, Shuval and Uehlinger (1990: 337-54); Keel (1995a: §67; 1995b: 128-29). My recent investigations have compelled me to lower the date in comparison to the publications of 1990 and 1995. The mass production is neither Ramesside nor Late Ramesside but rather post-Ramesside. See Keel and Uehlinger 1998: 534-35.

4. Hennessy (1985: 102 fig. 10.18 [Amman airport temple, thirteenth century; crescent on pole without full moon]) Moortgat (1940: no. 565); Salje (1990: pl. 9.210).

centuries (Keel, Keel-Leu and Schroer 1989: 252-59). On an impression of a cylinder seal from Alalaḫ stratum VII (c. 1720–1650 BCE) a pole with the crescent and the disk can be seen, instead of the usual kind of plant (**fig. 56**) (Collon 1975: no. 148; see Keel, Keel-Leu and Schroer 1989: 252-59). Two rulers wearing the typical mantle with thickly rolled border (Keel and Schroer 1985: 49-107) seem to hold the emblem. The one on the right is only partly preserved, but his back is still visible on the far left end side of the rolled impression. A goddess stands behind each ruler. For both of them the lunar emblem seems to represent the god as warrant of justice, as on the stelae on figs. 7-8, which are about a thousand years younger, but originate from the same region. The other aspect of the moon god, namely as the promoter of vegetal and animal growth, is emphasized on a cylinder seal from the Marcopoli Collection (**fig. 57**) (Teissier 1984: no. 445). Teissier dates the item to the period between 1850–1720. A ruler or a god with a large brimmed cap and a mantle with thickly rolled borders hugs a half-naked goddess. The lunar emblem, which in this instance is held by two naked women, appears as a side motif of this scene from the realm of the sacred marriage.

Figs. 52-57 all lack the tassels which are so typical of the lunar emblem of Harran during the first millennium (but see fig. 3). The lunar emblem of Harran could nevertheless be intended (like that of fig. 3), but this is not at all certain. Even if it is possible to add more pieces to the little evidence that has been dealt with here (see also van Buren 1945: 66), the crescent on a pole combined with the disk of the full moon seems not to have won real importance in Syria and Palestine during the second millennium nor to have been particularly favoured.

The Lunar Emblem or the Crescent on a Pole Dating from the Old Babylonian to the Ur III Period, and Some Isolated Earlier Evidence

During the first half of the second millennium the crescent on a pole was much more common in southern Mesopotamia than in the Levant. Two groups of monuments displaying the crescent on a pole are known from this period. One of these groups consists of seals and impressions of the Old Babylonian period.[5] It is possible that seals that were found

5. Van Buren (1945: 65-66) with numerous examples; a new careful investigation of the Old Babylonian material, particularly of the relation between figurative

in the west, like the ones of figs. 55-57, finally depended iconographi-
cally on Old Babylonian seals like the one at **fig. 58** (Collon 1986: no.
556). The latter was owned by a man named Warad-Amurru, who,
according to the inscription, called himself servant of the god of the
West, Amurru, and of the moon god Sin.

On Old Babylonian seals and seals from the Isin-Larsa period *the
crescent on a pole* is represented much more frequently than the cres-
cent *and* the disk, and the standard is *worshipped* by two flanking
figures (**fig. 59**) more frequently than *held* by two figures (Speleers
1917: 173, no. 495). Seals with this motif were frequently found at Ur
(Legrain 1951: nos. 488, 490, 509-14; Collon 1982: 143-45). In these
instances goddesses instead of human worshippers sometimes appear
flanking the crescent on a pole (**fig. 60**) (Legrain 1951: no. 489; cf. no.
492).

As well as in the central position assumed by the standard in axial
compositions, the crescent on a pole can also be found in other posi-
tions. In these cases the pole and the crescent are often, maybe casually,
decorated with one or several lines, calling to mind the tassels of the
Harran emblem (see figs. 61-66; Buchanan 1981: no. 726). Several
times the pole with the crescent is placed behind the god to whom a
worshipper is introduced by a guardian goddess (**figs. 61-62**) (fig. 61:
Menant 1888: pl. 26.272; fig. 62 = al-Gailani Werr 1988: 74, no.42b;
pl. II.3). On a seal from the Ur III period the pole with the crescent is
grouped with a single worshipper at one side of a vase-shaped altar
flanked by two human figures (**fig. 63**) (Delaporte 1939: pl. 5.27).

The vase-shaped altar was very important in the moon god cult.[6] The
M-shaped stand on fig. 62 appears on a seal from the Early Dynastic
period, on which a female and a male worshipper, both seated, are
flanking the emblem, which is decorated with two 'strings of pearls'
(**fig. 64**).[7] Besides the female figure (right) a branch or a stylized tree is
visible. The crescent with 'tassels' is also shown on Old Babylonian
seals as a sceptre in the hand of the moon god (**figs. 65-66**).[8]

representations, both anthropomorphic and symbolic, and the seal legends can be
found in Braun-Holzinger (1996: 242, 322-26).
 6. See the Urnammu stele (Börker-Klähn 1982: no. 94).
 7. Buchanan 1981: no. 338; Amiet 1980: fig. 1180; concerning the 'strings of
pearls' see fig. 31.
 8. Fig. 65 = Porada (1957: 196; pl. 31.10a-b); see the animals with horns on
which the moon god is standing; fig. 66 = Collon (1992: 32 no. 9), this seal

The crescent on a pole appears as well in the Ur III period as a sceptre (**fig. 67**) (von der Osten 1934: no. 126: see further Delaporte 1920–23: pls. 5.10, 76.1-2). Here the moon crescent always appears without the tassels (but see the sceptre in the hand of the god on fig. 10).

As to the form without tassels, Van Buren cites some scattered evidence from the third millennium (1945: 64-65). On a seal of the early dynastic period the moon crescent on a pole is placed between two rampant lions attacking animals (**fig. 68**) (Gordon 1939: 7, no. 3, pl. 2.3). Seidl (1989: 97) identifies this seal as the most ancient evidence of the standard with the crescent. Even if in this case the standard was not added later, this is an isolated instance, like the Early Dynastic evidence of fig. 64, which is also unique.

The Crescent on a Pole in the Failaka Glyptic of the First Half of the Second Millennium

In the stamp seal glyptic of Failaka, an island off the coast of Kuwait that belonged to the Dilmun area, the crescent standard occupies as equally important place as in the Old Babylonian cylinder seal glyptic. The Danish excavations of 1958–63 have brought to light 367 stamp seals. Almost 10 per cent, 35 items, show a standard with the crescent.[9] Most of them were found in the older layers of the two Tells dating to the period of about 2000–1500 BCE (Kjaerum 1983: 8-9). They might have been roughly contemporary to the Old Babylonian cylinder seal glyptic. In a few instances a single figure holds the standard with the crescent like a sceptre (**fig. 69**) (Kjaerum 1983: no. 150; see also no. 149). More often the standard is dressed on a stand and flanked and held by two humans (**fig. 70**) (Kjaerum 1983: no. 140; see also nos. 109, 111) or bull-headed figures (Kjaerum 1983: no. 115; see also no. 141). On one piece two dancing couples are shown performing variously to the right and the left hand side of the standard (**fig. 71**) (Kjaerum 1983: no. 353). The object above both couples could be a torch or a lightning symbol. The joyful character of the cult, which was

belonged to a certain 'Ammi-ešar, son of Ištarti-ilu, servant of Sin' (see Klengel-Brandt 1989: 293-94 fig. 38b).

9.　Kjaerum (1983: nos. 56, 108-109, 111, 115-18, 120-21, 123, 132-33, 136-37, 139-47, 149-51, 174, 299, 330, 336-38, 353, 355).

associated with fertility and growth,[10] is further emphasized by the branches held by the worshippers (**fig. 72**) (Kjaerum 1983: no. 146; see also no. 108) and the caprids and bulls which appear as secondary motifs on almost all of the 35 seals.[11] The relationships to the Old Babylonian glyptic are not to be neglected.[12] The representation on an Old Babylonian cylinder seal from Ur, depicting the moon standard next to the god Amurru and the naked goddess closely resembles the Failaka moon standards with the crescent and the full moon (**fig. 73**) (Legrain 1951: no. 530). There are also numerous dissimilarities. Above all the Failaka glyptic lacks the cross lines or tassels at or near the point where the crescent and the pole meet, or they are very faintly intimated (figs. 69 and 71), whereas they are typical of the Old Babylonian emblem and the lunar emblem of Harran.

Summary and Interpretation

Notwithstanding all the formal differences, the similarities of content linked to the worship of the moon—which was predominantly a cult of the new moon (crescent)—in the second and first millennium, reaching from Failaka to Harran, seem to have remained unchanged. A rectangular piece with a ridge-shaped handle, which was found at Nimrud but might have had its origin in the West, illustrates this clearly (**fig. 74**) (Parker 1955: 107-108; pl. 18.4; Spycket 1973: 387, fig. 13, 391). The layer in which the item was found dates from the seventh century, but rectangular pieces with ridge-shaped handles are rather typical of the Early Iron age (see Keel, Shuval and Uehlinger 1990: 379-96). An enthroned human figure with a crescent above his or her head is holding a branch in his right hand, while the other hand is raised in a gesture of reverence or blessing. It is not quite clear whether this is a worshipper or a god; in the case of the latter it would be a representation of the anthropomorphic moon god (see figs. 49 and 49a). In analogy to the enthroned moon god, the lunar emblem of Harran is placed on an identically featured but somewhat smaller throne. Beneath is a caprid. The

10. See Wilke (1951: 171-73); Chambon (1984: 114; pl. 80.7); Keel and Uehlinger 1995: 165, 167 fig. 171b).

11. See esp. my fig. 72 and Kjaerum (1983: nos. 108-109, 111, 115, among others).

12. Bull-headed men; for the dancing couple, see von der Osten (1934: no. 148) with the crescent on the standard; Buchanan (1966: no. 472; 1981: nos. 730b, 732).

iconography combines similar elements as on the Failaka seal of fig. 72, showing a standard with the crescent on a stand, a worshipper or a god with a branch and a caprid. Together they suggest joyful renewal and prosperity. The same elements, branch, caprid, worshipper and crescent (this time without a pole) are found on a scaraboid purchased in Jerusalem, which according to its shape must be attributed to the eighth or seventh century (**fig 75**) (Keel-Leu 1991: no. 138). The combination of branches (figs. 64, 72), vase-shaped altars (fig. 63), and animals (figs. 65, 69-72) insinuates that in southern Mesopotamia during the first half of the second millennium the positive influence of the new moon on the growth of plants and animals was considered predominant over the legal which appears on the stelae from the first millennium in the region of Harran.

The tassels, very characteristic of the lunar emblem of Harran in the first millennium, appeared for the first time in significant numbers in the Old Babylonian glyptic. Not surprisingly, the Sin sanctuary of Harran is first attested in the Old Babylonian period (Postgate 1975: 123), although its Sumerian name *É.ḪUL.ḪUL* together with its Akkadian equivalent *šubat ḫidâti* 'house of joy' are first mentioned at the time of Sargon II (Postgate 1975: 124; Thompson 1940: 87). The special shape of the lunar emblem of Harran certainly did not make its first appearance in the Old Babylonian period (see fig. 64), but it might have found a certain propagation in that time. Thereafter, the emblem seems to have been of local importance only for several centuries.

The crescent on a pole appears to be extremely rare in Kassite glyptic (Matthews 1990; 1992: 74, no. 18). In Mitannian glyptic it is also rare, be it as a standard (Matthews 1990: nos. 621, 625) or a sceptre (Matthews 1990: no. 583). In Middle Assyrian glyptic, however, the crescent and the stars are omnipresent (Matthews 1990: 96; e.g. nos. 378, 380, 388, 390, 392, 425, 540), even when the lunar *emblem* seems to be non-existent. Considering the lively cult of the moon known to the Assyrians, the moon worship of Harran must have attracted their attention when they conquered the Aramaean regions in the west. By the intermediary of the Assyrians and the Aramaeans the emblem then spread in its specific shape throughout the ninth to seventh centuries in easterly and westerly direction.

Chapter 10

NORTH-WESTERN SEMITIC NAME SEALS
AND THE ARAMAIC ASTRAL CULT

The supposition of an Aramaean influence with the strong astralization
of the religious symbol system in the west of the Neo-Assyrian empire
in the eighth to seventh centuries is supported by the the evidence of a
wide propagation of the lunar emblem of Harran. A further proof for
the validity and accuracy of this thesis is provided by the iconographic
study of the Northwest Semitic inscribed name seals henceforth termed
'name seals' for convenience.

The Lunar Emblem on Aramaean Name Seals

Apart from fig. 38, which is not a classical name seal, the lunar emblem
of Harran appears rather rarely on these seals. Three out of four name
seals containing the lunar emblem are Aramaean. The first one is an
agate cylinder seal bought in 1889 in northern Syria by G.J. Chester
(**fig. 76**),[1] which belonged to an Aramaean by the name of *b'lrgm*. It is
carved in the 'late drilled style' (end of eighth to seventh century)
showing different emblems, among others the lunar emblem in the
typical form of Harran (see figs. 26-27). On an agate stamp seal pub-
lished by Lemaire (1990: 104-106; Pl. II.4) (**fig. 77**), the Assyrian ver-
sion of the emblem is shown. The owner's name *'wr* appears as *'wjr* in
an Aramaic document dating from 635 (Fales 1986: 258). The *w* is
especially typical of the Aramaic script of the seventh century. The
Israel Museum owns an agate seal with the standard and the crescent,
but it lacks the tassels typical of Harran (but see also fig. 3). The name
of *ḥn'* engraved on this piece has mainly been traced in the Phoenician
culture (**fig. 78**) (Hestrin and Dayagi-Mendels 1979: 160, no. 126). The

1. Buchanan (1966: no. 644); Galling (1941: no. 150); Bordreuil (1993: 96-99
figs. 36-39).

characters point to the eighth or seventh century. The fourth example is very interesting. It is a conoid with characteristic Assyro-Babylonian motifs that were originally anepigraphic (**fig. 79**) (Galling 1941: no. 107). The name *š''n* 'Sin has answered' was engraved only at a later stage. At the same time the lunar emblem was engraved on one mantle side and on the other mantle side the moon crescent was added above the two *apkallū* (Bordreuil 1993: 99 fig. 39).

Considering the numerous anepigraphic seals with the lunar emblem of Harran, the question arises why it is so rare on name seals made of hard precious stones. The answer to this question can only be guessed. My conjecture is that the high society who could afford name seals made of precious stones preferred a less locally determined aspect of the moon god, such as its uranian character, which was commonly known all over the Fertile Crescent, rather than the lunar emblem of Harran. Notwithstanding the explanation for the different representations, it is remarkable that nowhere on the name seals does the moon god feature as frequently as in the Aramaic group of seal amulets.

The Anthropomorphic Moon God on the Crescent Boat

In 1986 P. Bordreuil published 140 name seals kept in public collections of Paris. On account of the onomasticon and/or palaeography he labelled 56 of them as Aramaic. The anthropomorphic moon god standing on the crescent as if it were a boat is shown on 7 out of these 56 seals (i.e. on 12.2 per cent).[2] Bordreuil dates nos. 95 (**fig. 80**), 99, 109 and 111 to the seventh century, and nos. 113, 114 (**fig. 81**) and 115 to the sixth century. There is also the seal of a certain *pqd jhd* 'governor of Judah' from a private collection dating from the sixth century (Bordreuil 1986a: 305-307 with fig. 9).

The oldest evidence of the moon god on a boat might be a so-called Cappadocian seal from the British Museum (**fig. 82**).[3] It shows a

2. Fig. 80 = Bordreuil (1986a: no. 95); Galling (1941: no. 105); fig. 81 = Bordreuil (1986a: no. 114); Galling (1941: no 114); see also Bordreuil (1986a: nos. 99, 109, 111, 113, 115); Kühne (1997) stresses the popularity of the motif during the reign of Ashurbanipal and in its aftermath.

3. Collon (1987: no. 141; 1992: 23 no. 7); another god in a boat can be seen on the Kültepe Level II seal illustrated by Teissier (1994: no. 234); from the shoulders of the god flows water and he is flanked by two fishes; this rather hints at a water god; but the two crescents flanking his head still suggest a relation with the moon god.

mixture of ancient Assyrian and Syrian motifs and was assigned by Collon to the nineteenth century. The weather god on the bull (left) and the naked goddess (last figure to the right) suggest a provenance from southeastern Anatolia or northern Syria. The moon god can be identified by the crescent applied to his cap, his sceptre and his axe, as well as by the boat in which he stands.

Further evidence for this iconography, although younger by some centuries, has recently been found in Samsat (Samosata) on the right bank of the Euphrates, some 40 km from Adiyaman in the direction of Urfa (**fig. 83**) (Collon 1992: 25, no. 12), that is, in the vicinity of, at least not far from, the Aramaean homeland. The style of the seal is Middle Assyrian, late thirteenth century, but the iconography is quite unusual for a Middle Assyrian cylinder seal. In one hand the god holds the sceptre with the crescent (see fig. 10) and in the other the Ω-symbol, originally a symbol of the birth goddess (see Keel, Keel-Leu and Schroer 1989: 39-87). It is not clear whether it later took on an astral significance.[4] Collon pointed out that around 1300 in the tale of 'Sin and the Cow in Labour', Sin appears for the first time as a 'midwife'.[5] The new moon was often related to menstruation, pregnancy and birth (Wilke 1951: 180-81).

On figs. 82 and 83 the figure of the moon god in a boat is shown in full, and in fig. 83 he is even standing on a podium. In the first millennium (figs. 80-81) he usually stands *inside* the boat with his feet hidden. Two of the oldest instances of the god in the crescent boat dating from the late ninth and early eighth centuries are of northern Syrian origin. One of them was found by Woolley in al-Mina, the harbour of Alalaḫ (?) (Barnett 1939: 1-2; pl. I.2). The owner of the other one was a servant of Mannu-kima-Aššur, governor of Guzana (Tell Halaf) in 793 (**fig. 84**).[6]

4. Fuhr 1967: comet; Duchesne-Guillemin 1986: symbol of the stations, through which the moon travels in the course of 223 months, 'noeuds lunaires', *saros* in Greek.

5. Collon 1992: 28; Lambert 1969; Veldhuis 1991.

6. Moortgat (1940: no. 596); as to the history of the moon god in the crescent boat, see Van Buren (1945: 63-64). Figs. 49-49a provide evidence that the motif of the moon god in the boat was known in Palestine too. He is usually shown enthroned in a boat. In 1906 Dalman published a Hebrew name seal engraved on both sides. On one side is the name *'lšm' bn gdljhw*, and on the other a boat whose bow and stern end in bird heads. Enthroned in the boat is a human figure flanked by two small palms? (Culican 1970: 31-33 fig. I d; 1986: 284-86; cf. Keel 1977: 308

Two Men beneath the Crescent

Another moon motif, which appears combined with Aramaic names, shows two worshippers flanking a small table or altar, raising their hands. Sometimes their palms are turned downwards, sometimes upwards. Both gestures may be interpreted as adoring gestures directed at the crescent above them, which is often accompanied by a star. Bordreuil has published two such seals as being Aramaic and dated them to the 7th century (**figs. 85-86**) (Bordreuil 1986a: nos. 97, 102 = Sass and Uehlinger 1993: 67, figs. 61, 65). The name on the seal of fig. 85, *'ḥlkn* is presumably Akkadian *Aḥīya-likīn* and means 'He shall procure me with a brother'. The name on fig. 86 has been partly destroyed; only *l'j* is still visible. Five other seals displaying the two worshippers and the crescent have been classified in the last years as being undoubtedly Moabite, while one has an Arabic name in Edomite script[7] (fig. 88a):

—the seal of *'ḥjḥj*, in which the solar disk is the main motif and the
 moon crescent only a secondary motif (**fig. 87**);[8]
—the seal of *ḥkš* (**fig. 88**);[9]
—the seal of *mškt bn wḥzm* (**fig. 88a**);[10]

fig. 238a). The rather strange iconography of this seal seems to combine the lunar emblem between trees (for small palms in this context see Moortgat-Correns 1968: no. 115) with the moon god enthroned in a boat. An anepigraphic seal with a very similar iconography was acquired in 1971 in Irbid in northern Transjordan (Tushingham 1971: 23-28; Keel 1977: 308 fig. 238b). Two more items with this iconography show a boat without bird heads. They are kept at the Biblical Institute of the University of Fribourg, Switzerland (Keel-Leu 1991: nos. 133-34). The enthronement of the figure in the boat and the two bird heads are probably the result of Egypto-Phoenician influence (Gubel 1987: 111-13). The relevant material is now republished and discussed in Keel and Uehlinger (1995: 349-55).

7. Naveh quoted by Cohen and Yisrael (1995: 24 [Heb.] and 23 [Eng.]).

8. Lemaire (1983: 26-27 no. 12; pl. III.12; Israel 1987: 117 no. XX) ; Timm (1989: 185-86 no. 8); Sass and Uehlinger (1993: 67 fig. 62).

9. Avigad (1978: 68 fig. 5); Bordreuil (1986a: no. 67); Israel (1987: 115 no. 15); Timm (1989: 197-98 no. 13); Sass and Uehlinger (1993: 67 fig. 57).

10. Cohen and Yisrael (1995: 24 [Heb., illustration] and 23 [Eng.]), who first published the seal, described the engraving as follows: 'Two standing male figures, dressed in long robes and apparently bearded. They face each other, with a tall horned altar standing between them. One figure raises a hand in a gesture of blessing, while the other figure extends one arm as though making an offering.' Beck (1996: 108) is more cautious: 'It is also possible that bull horns are depicted on top of the altar between the two worshippers on the stamp seal from 'En Ḥazeva.' If it

—the seal of *jl'* (**fig. 89**);[11]
—the seal of *'zr'* (**fig. 90**);[12]
—the seal of *'mṣ hspr* (**fig. 91**);[13]

Four seals come from the antiquities market, one is a surface find from Kerak (fig. 87) and one comes from a regular excavation, from 'En Ḥaṣeva (fig. 88a). The main argument for classification of fig. 87-91 as Moabite is the shape of the characters, especially the form of the *ḥ* (see figs. 87-88). In fig. 89 the shape of the characters is less typical (see Timm 1989: 202 n. 40). The same applies to the inscription on fig. 90. Besides the shape of the characters, Timm takes iconography as a criterion for determining the Moabite origin. As shown on the seals in figs. 85-86, the same applies to Aramaic seals, and the source of the motif might as well lie in the Aramaean region. The composition could be interpreted as a variety of the lunar emblem between two worshippers (see figs. 7-8, 16-17, 32-33, 44, 59-60, 64). None of the five names on the seals on figs. 87-91 is clearly and exclusively Moabite.

Concerning *'ḥjḥj*, Lemaire mentions a Moabite, an Ammonite, a Phoenician and two Hebrew instances of names which developed from a theophoric element plus *jḥj* (1983: 27). The basic consonants of *ḥkš* are paralleled only by an Aramaic name from Palmyra (Stark 1971: 88). The *jl'* seal from fig. 89 was originally published by Bordreuil and Lemaire as being Aramaic (1976: 53-54, no. 24), and they interpreted the name as Aramaic hypocoristicon. As possible parallels they mentioned a Ugaritic and a Thamudic *jlj* (Gröndahl 1967: 143; Harding 1971: 683). Timm takes the name as an abbreviated verbal clause of the root *l'j/ḥ* 'to be strong' (Timm 1989: 201). On the seal of fig. 99 the

is taken into consideration that the 'En Ḥaṣeva seal closely follows a compositional scheme that was very common at the time and if the design is compared with that on the *bulla* from Jerusalem (fig. 36) the crescent is much more likely than the horns of a bull. Still it should not be forgotten that the crescent was sometimes compared to the horns of a bull (Veldhuis 1991: 1). Beck also considers the crescent on the cult stela from 'En Ḥaṣeva as remains of a bulls head (1996: 109-11, fig. 7), which seems quite unlikely to me.

11. Bordreuil and Lemaire (1976: 53-54 no. 24); Israel (1987: 121-22 no. XXXI); Timm (1989: 201-202 no. 15); Sass and Uehlinger (1993: 67 fig. 59).

12. Avigad (1977: 108; pl. 13.1); Israel (1987: 114 no. XII); Timm (1989: 215-16 no. 21).

13. Hestrin and Dayagi-Mendels (1979: no. 1); Naveh (1982: 103 fig. 89); Sass and Uehlinger (1993: 67 fig. 58).

same name *jl'* appears in conjunction with a typical Aramaic iconography. *'zr'* from the root *'zr* is known in all Northwest Semitic languages. The *'* ending is typical of Aramaic morphology. Even if the shape of the *ḥ* on the pieces of figs. 87 and 88 suggests a Moabite origin, the whole group may hardly be explained without considering heavy Aramaic influence.

It thus seems legitimate to me that Timm refuses to count among the genuine Moabite group two more items solely on iconographical grounds. He classifies them under the category 'seals with dubious attribution':

—the seal of *'ḥ'*, formerly read as *'b'* which was bought in Ashkelon (**fig. 92**);[14]
—the seal belonging to *km*[...] which was excavated in Samaria (**fig. 93**).[15]

On the seal of fig. 92 the *ḥ* is not clearly Moabite, and the name is a hypocoristicon of a name comporting the theophoric element *'ḥ* with the Aramaic aleph ending. On the Samaria seal (fig. 93) only a *k* is clearly visible. The second character may be a *m*. To read this as the name of the god *kmš* is just a possibility and nothing more. A Moabite individual in Ashkelon or Samaria cannot be excluded during the seventh century, but the presence of Aramaeans is more probable.

Aramaic seals occasionally show only one worshipper underneath the crescent instead of the usual two.[16] An even more abbreviated form shows the typical worshipper on the Aramaic seals without any divine symbols.[17]

14. Vincent (1903: 606 fig. 13, 609 no. 13); Bordreuil (1986b: 284-85 no. 2); Timm (1989: 225-26 no. 27); Sass and Uehlinger (1993: 67 fig. 64).

15. Crowfoot and Kenyon (1957: 87; pl. 15.21); Israel (1987: 117-18 no. XXII); Timm (1989: 240-41 no. 35); Sass and Uehlinger (1993: 67 fig. 56).

16. Galling (1941: nos. 124, 126); Cook (1925: pl. 9.3 and 5); an epigraphic item in Keel, Shuval and Uehlinger (1990: 329 fig. 110).

17. Galling (1941: nos. 127-29) and the anepigraphic seal in Keel, Shuval and Uehlinger (1990: 328 fig. 107 [text] = 329 fig. 106 [fig.]). This version makes it unlikely that the two worshippers represent a 'cérémonie d'alliance' (Bordreuil 1986a: 62 to no. 67 = **fig. 80**). In contrast to the theme on Old Syrian cylinder seals, where a king and his servant, a king and a priest or other pairings of clearly differentiated individuals are shown, the above-mentioned stamp seals figure two absolutely identical men. This points to a doubling of the worshipper that was probably done for reasons of symmetry.

The Astral Deities of the Night

The importance attributed to the crescent in the Aramaean area and especially in the region of Harran is highlighted by the seal impressions on a group of 24 clay tablets inscribed in Aramaic script which were acquired by the Musées royaux d'art et d'histoire at Brussels, and which, as stipulated by the dealers and on the basis of the texts, must have had its origin in the surroundings of Harran (Homès-Fredericq 1976; 1995). The dates mentioned on the tablets show that they had been inscribed between 665–620. Out of the 24 clay tablets, 9 carry one or several impressions. On 7 out of the 14 impressions, the crescent is present (Homès-Fredericq 1976: 62). In one instance it has been combined with a caprid (**fig. 94**) (Homès-Frederick 1976: 62, no. 0.3715). Caprids are also related to the crescent on figs. 17, 22, 65, 72, 74 and on the two Aramaic seals of *nbrb* 'Nabu-rabu' and of *ḥwr* 'Ḥawar' of **figs. 95-96** (Bordreuil 1986a: nos. 101, 104). The latter may be a gazelle. Twice the crescent appears above a not clearly identifiable quadruped, and twice above the Pleiades (**fig. 97**).[18] The stars accompanying the crescent are not always the Pleiades. On a scaraboid from the British Museum eight stars are visible below the crescent (**fig. 98**) (British Museum, London, WAA, Inventory no. 128864). On a scaraboid which is kept in the Biblical Institute of the University of Fribourg, Switzerland, at least 16 stars are assigned to the crescent. The item is damaged, otherwise about 20 might be counted (**fig. 99**) (Keel, Shuval and Uehlinger 1990: 222-25 figs. 44a, 47; Keel-Leu 1991: no. 128). Along the left border the name *yl'* is engraved (cf. also fig. 90). The Aramaic clay tablets from Harran show the moon crescent twice above the Pleiades and the Egyptian sign of life, the *'nḥ* (**fig. 100**).[19] The combination: crescent (or lunar emblem), stars and the Egyptian sign of life is also represented on a bull-head scaraboid kept at the Biblical Institute of the University of Fribourg (Keel-Leu 1991:

18. Homès-Fredericq (1976: 62 no. 0.3653); for two additional impressions of this type see Homès-Fredericq (1995: 112-16).

19. Homès-Fredericq (1976: 62 no. 0.3654); for additional impressions of this type see Homès-Fredericq (1995: 112-17). On the same tablet as these two impressions the name 'Laban' is mentioned, which is well known from the Bible, where it is related to Harran. For the connection of Laban and other figures in the stories of the patriarchs with Harran see Reinhold (1989: 39-67).

no. 129) and on an Aramaic cylinder seal at the Louvre (**fig. 101**),[20] and on a duck-shaped stamp seal which has been discovered recently and which was once owned by one *šmš'zr 'bdšhr* (**fig. 102**) (Avigad 1986: 52; Sass and Uehlinger 1993: 97-98 fig. 37). The name or title *'bdšhr* points to North Syria, where the moon god *šhr* is mentioned in a whole series of inscriptions.[21] The lunar emblem of Harran, the Aramaean origin of the motif of the moon god in the boat, and the numerous instances of the crescent and stars represented on seal amulets from the Aramaean area, show that here is a typically Aramaean phenomenon. The numerous anepigraphic seals with symbols of the astral deities of the night from the Palestinian eighth and seventh centuries (see Keel, Shuval and Uehlinger 1990: 322-30), as well as the evidence given in the Old Testament of the widespread cult of the 'host of heaven' in seventh-century Judah, are compelling evidence for the heavy impact of Aramaean culture on Judah as well as on the whole of the Levant at the end of the eighth and, mainly, in the seventh century.

20. Bordreuil (1986a: no. 94); Keel, Shuval and Uehlinger (1990: 325-26 fig. 102); Sass and Uehlinger (1993: 97-99 fig. 38).

21. Donner and Röllig 1968: no. 202B Z. 24 (Afis); nos. 225 Z. 2 and 9, 226 Z. 1 and 9 (Nerab), 258 Z. 5 (Kesecek Köyü, 35 km N.E. of Tarsus), 259 Z. 4 (Gözne, 20 km N. of Mersin).

Chapter 11

THE NEW MOON IN THE HEBREW BIBLE

What is the Reason for the Flourishing of Astral Cults
in Seventh-Century Judah?

The deuteronomistic tradition informs us of a significant increase of
astral cults in Judah during the seventh and the beginning of the sixth
century (2 Kgs 21.3-5; 23.5.12; Deut. 4.19; 17.3 see also Jer. 7.17-18;
8.2; 19.13; 44.17; Zeph. 1.5[1]). The glyptic underlines a strong increase
in astral elements in the religious symbol system of that time all over
Palestine.[2] Oestreicher (1923: 9-10, *passim*) and many others ascribed
the increase of the veneration of the 'host of heaven' (צבא השמים) to
the pressure exerted by the Assyrian conquerors on the subdued
peoples to adopt the cult of the victors. J. McKay denied the existence
of any such a coercion and saw in this boom the revival of some old
autochthonic astral cults which were merely enhanced when they came
into contact with the Assyrian environment (1973: 45-59). M. Cogan
pointed out the difference between the Assyrian attitudes towards
peoples and regions which were integrated into the Assyrian provincial
system and those who retained a tributary status. As Judah belonged
to the latter, Cogan's remark that 'Assyria imposed no religious
obligations upon its vassals'[3] must also have applied to Judah. H.

1. For this passage see the comprehensive commentary of Uehlinger (1996:
75-78).
2. Cf. Keel (1977: 284-96); Weippert (1988: 627-28); Keel, Shuval and Ueh-
linger (1990: 322-30); Keel and Uehlinger (1995: 332-69). It is striking that scarabs
with the name of the Egyptian moon god Chonsu (*Ḥnsw*) written in hieroglyphs
also make their appearance at this time in the Levant (Keel 1997a: Achsib no. 4;
Aschkelon nos. 32, 98; Akko no. 225; Tel Ḥalif; Kloner 1983: 68 [this last item
may be earlier]).
3. Cogan (1974: 85; 1993: 403-14) concludes again against Spieckermann that

Spieckermann (1982: 322-44) opposed the latter opinion and empha-
sized some evidence that the Assyrians also forced vassals to pay tri-
butes of obeisance to the Assyrian king as well as to the reigning god
and the 'high gods' (*ilāni rabûti*) (Spieckermann 1982: 322-44). The
thesis that the conquered nations had been abandoned by their own
gods was in some cases corroborated and literally enacted by the depor-
tation of the statues of their gods (Spieckermann 1982: 344-54; see also
Cogan 1974: esp. 22-34; Uehlinger 1997b: 123-28; Uehlinger 1998:
739-76).

In any case, Spieckermann's refutation does not refer to Cogan's
thesis (Cogan 1974: 84-88) that the astral cult mentioned in the Bible
was typical for Syria or for Aram. Weippert (1988: 628) also knows
that evidence of astral cults in Palestine already exists in the Late
Bronze age. In spite of this fact she suggests that

> on its renewal in the Iron IIC Age ... some exterior influences had cer-
> tainly played a role. Above all the influences from the Aramaean area,
> especially the worship of the moon god of *Ḥarrān* must be considered,
> and not so much the impulse coming directly from Assyria.

This assumption, which is only a hunch (cf. the magic word 'cer-
tainly') and partly based on the spread of the lunar emblem in the
eighth and seventh centuries (see Chapter 8 above), should perhaps be
explained according to the principle that different phenomena may have
different causes. It is hardly possible to deny that the cult of the השמים
מלכת 'queen of heaven' (Jer. 7.17-18; 44.15-25) is somehow related to
that of the Akkadian Ishtar as *šarrat šamê*.[4] The horses of the sun in
2 Kgs 23.11 may probably be traced to direct Assyrian influence[5]
though favoured by the fact that the Jerusalem temple was a solar
shrine right from its origin (see n. 10). The hapax legomenon מזלות in
2 Kgs 23.5 (cf. Job 28.32) is an Akkadian loan-word (see Zatelli 1995),
and it may refer to the exceedingly important observations of the uni-
verse and the astral omenas among the Assyrians (Spieckermann 1982:

there 'is not the slightest hint anywhere that the adoption of foreign ways was
imposed'.

4. Winter (1987: 561-76); against Olyan (1987), who sees in the 'queen of
heaven' rather the goddess Astarte, while Koch (1988) identifies her with the
Asherah from Jerusalem, Keel and Uehlinger (1995: 386-90) try to differentiate
between different aspects and 'versions'.

5. Cogan (1974: 86-87); Schroer (1987: 282-300); Keel and Uehlinger (1995:
392-94); Uehlinger (1995: 74-77).

257-73; but cf. Uehlinger 1995: 80, n. 111). The 'host of heaven' may primarily designate the stars.[6] Sometimes the expression צבא השמים seems to have included the moon or even the sun (see Deut. 4.19; 2 Kgs 23.5; Taylor 1993: 105-109). The veneration of the 'host of heaven' in the strict sense of stars and maybe also of the moon seems to have originated from the Aramaeans, who during the eighth and the seventh centuries had very often occupied prime positions in the Assyrian administration—especially in the west—and consequently cannot be totally separated from the Assyrians.[7]

The New Moon in Israelite and Judaean Tradition before and after the Seventh Century

The flourishing cult of astral deities, particularly of the deities of the night in seventh-century Judah is, as shown above, not to be understood without a strong Assyro-Aramaean influence. However, there is evidence that moon cults and particularly the cult of the new moon (חדש) on 'the day on which the lunar crescent becomes visible again',[8] existed long before this period.[9] Some Palestinian place names suggest ancient astral cults, cults of the sun (Beth-Shemesh) and the moon (Jericho) all over the country. The pre-Davidic temple in Jerusalem might have been consecrated to the sun (and the moon?) before being dedicated to Yahweh by Solomon.[10]

6. See Deut. 17.3; Jer. 8.2 and the נדגלות in Cant. 6.10: for the latter see Keel (1994b: 220-21).

7. See the literature mentioned in Chapter 8 n. 1 above.

8. Baumgartner (1967: 282); Van der Toorn (1996: 212-13) suggests understanding חדש as meaning the three-day long *interlunium*, Akkadian *bubbulum*, when the moon could not be seen at all. Only so expressions as 'the second or the third day of חדש' (cf. 1 Sam. 20.5, 12, 20, 27) seem to make sense. The etymology and the traditional celebrations related to the new moon (see Chapter 7 'Summary and Interpretation' above) make it difficult to accept Van der Toorn's thesis. For the second or third day of the new moon festival see Chapter 11 n. 11 below.

9. Considering the importance attributed by many biblical texts to the moon, and particularly to the new moon, it is quite surprising that the six-volume Anchor Bible Dictionary (1992) has no entry for 'moon' and that the entry 'new moon' refers to 'calendars', where nothing is said about the 'new moon' as such. Other recent dictionaries contain more or less substantial articles (see, e.g., Dohmen 1995; Schmidt 1995).

10. See Stähli (1985); Taylor (1993); Keel (1993b: 488-89); Keel and Uehlinger (1994: 269-306); Keel (1994c: 165-69). See in particular the quotations from the

New moon and sabbath celebrations were observed in the families
(1 Sam. 20.5, 18, 24, 27, 34)[11] as well as in public (Hos. 2.13; Isa. 1.13-
14). They meant a rest from work (Amos 8.5). The ostracon no. 7 from
Arad also seems to refer to the celebration of the day of the new moon
in this sense (see Loewenstamm 1992: 131-35). On such days 'men of
god' were consulted for oracles (2 Kgs 4.23). It is interesting to note
how many oracles in the book of Ezekiel are said to be delivered on a
new moon's day.[12]

Hosea 5.7 seems to be aware of a tradition of a bellicose new moon
known in north Syria in the eighth and seventh centuries (cf. figs. 9 and
10). This seems to be unknown to the exegetes. They consequently
change חדש to החסיל 'the grasshopper' (Wolff 1961: 120, because of
G), or to מחדש 'conqueror' (Jeremias 1983: 73, with reference to Eitan
1939: 2) or into just any other word that might make some sense and
comply with the appearance of the Hebrew characters (see Rudolph
1966: 117-18). Rudolph himself translates: 'now (only) one month will
destroy them, together with their properties'. But the word 'only',
which is essential for this interpretation, does not appear in the text.
Correctly translated, the text says: 'Now the new moon will destroy
them together with their fields.' The new moon, which they worshipped
enthusiastically (2.13), becomes their enemy (cf. 7.2).[13]

'Book of the Upright' or 'Book of the Songs' in Josh. 10.11-12 and 1 Kgs. 8.12-13
G.

11. For the expression ביום החדש השני in 1 Sam. 20.34, the translaton 'the
second day of the new moon' should be preferred over 'the second day of the
month' or the 'second day of the festival' (Fleming 1995: 64 n. 29). Fleming points
to the fact that in Emar there was a new moon celebration, the 'new moon of
Dagan' (*ḫi-da-aš* [d]KUR; Emar 466: 100), that lasted at least two, maybe three days
and was celebrated only once a year (pp. 57-64).

12. Ezek. 26.1; 29.17; 31.1; 32.1; see also Hag. 1.1 and Isa. 47.13; cf. Wilke
(1951: 174).

13. Another solution is suggested by Van der Toorn (1996: 213): 'Several bibli-
cal passages concerning the *ḥodeš* in the First Temple period...show that the days
of the *ḥodeš*, like those of the *bubbulum* in Babylonia, were considered unpropi-
tious for business activities. According to the prophet Hosea, accumulated riches
could be devoured by the *ḥodeš* (Hos. 5.7).' The context does not suggest this solu-
tion. The *ḥodeš* seems to be one of the gods other than Yahweh whose cult will
reveal itself as disastrous. Van der Toorn himself does not exclude later in his book
the possibility of *ḥodeš* being part of the baalistic domain (1996: 295-96).

The deities of the night underwent a significant revival due to the Assyro-Aramaean occupation of Palestine in the seventh century. The cult of the moon god of Harran in particular, became very popular in the West during that time (see Chapter 8 above). A late deuteronomistic author rationalized the suppression of the cult with the argument that the sun, the moon and the stars are attributed to all the other peoples for devotion, but not to Israelites who are supposed to have a different notion of their God (Deut. 4.19). Still, even Job 31.26-28 realized the strong attraction exerted by the great celestial bodies, but rejected them.

The worship of the new moon nevertheless survived into the post-exilic period. Indirect and unique evidence for the influence of the cult of the new moon on the religion of post-exilic Judah is found in the central vision in the cycle of visions of Zechariah (Zech. 4.1-6a, 10b-11, 13-14). There the prophet sees a lampstand between two trees, instead of the traditional anthropomorphic god seated on a throne (Isa. 6; Ezek. 1). It has been assumed for a long time that an ancient Near Eastern pattern was the source of this visionary constellation. The most convincing prototype for this icon is the crescent on a pole between two trees.[14] The replacement of the anthropomorphic representation of Yahweh by the new moon lampstand symbol may have facilitated the abandonment first of an anthropomorphic and then of any visual representation of Yahweh at all. A reconstruction of the lunar emblem between the two trees according to the archaeological evidence of figs. 20, 28 and 46 (**fig. 103**) and a visual representation of the lampstand between the two trees described in the text of Zechariah 4 (**fig. 104**) (Keel 1978a: 55 Abb. 2) show how close the two are to one another.

Psalm 81 (most probably post-exilic) is also interesting in regard to the celebration of the new moon in this period. Verse 4 demands the blowing of the horn (שׁופר) on the day of the new moon, and the day of the full moon is called '(day of) our feast' (cf. Prov. 7.20). The meaning of this demand is rather obscure. Not less than three expressions (חק, עדות, משׁפט) follow the imperatives to indicate the compulsory character of this practice since the time of the exodus. This emphasis contrasts with the fact that the blowing of the חצצרות (not the שׁופר) figures only in Num. 10.10. The celebration of the new moon is not mentioned elsewhere in the older enumerations of feasts (Exod. 23.14-17; 34.18-23; Deut. 16.1-17). Not even the Priestly Code in its quite

14. Keel 1977: 274-320; Keel and Uehlinger 1995: 348-49; Uehlinger (1997a: 342-44).

systematic presentation of celebrations in Leviticus 23 mentions it. The oldest passage referring to this feast in a legal context is probably Ezek. 46.1, 6-7 (cf. 45.17). The only further occurrence is in Num. 28.11-14, which is a late addition to the Priestly Code. Here, however, the feast of the new moon is provided with the same substantial offerings as for example the feast of the unleavened cakes (two young bulls, one ram and seven yearling rams, one he-goat). In his commentary on Numbers, Noth (1966: 192) wonders about the reason for the significance awarded to this feast. At the beginning of this century the commentators were less hesitant. G.B. Gray says: 'Possibly as a popular festival it was associated with heathen practices, and, therefore, intentionally ignored by the early lawgivers (JE, D).[15] It may have regained its place in this later law partly on account of the importance of the new moon in fixing the calendar and the due succession of festivals, and partly in accordance with the tendency to preserve but transform customs that had a great hold on the people.'[16] In the same year that Gray published his ICC commentary, a less favourable comment was given by Holzinger: 'The portions allocated to the celebration, originally a "day of Baal" in its proper sense and ignored by Leviticus 23 is typical of the Priestly Code: the theology of restoration starting with Ezek. (cf. 46.1, 6-7) seized anything and integrated whatever could be traced of old traditions, even in case of dubious origins.'[17]

The tendency is very strong to minimalize the importance of the new moon festival and to separate it as much as possible from pagan practices. Hallo's statement is just one example:

> Moon worship flourished wherever Mesopotamian culture spread, and even after its demise it survived at places like Harran. But in Israel it failed to gain a foothold; the full moon was not worshipped, the quarters were not specially observed, and even the new moon was ultimately relegated to the status of a half holiday.[18]

15. The same interpretation is offered by Wilke (1951: 175-76).

16. Gray (1903: 410); quoted by Budd (1984: 316); Zimmerli (1969: 1172) follows the same approach.

17. Holzinger 1903: 142: 'Die Ausstattung der Feier des Lev 23 ignorierten Neumonds...eines ursprünglichen "Baalstages" im eigentlichen Sinn, ist für P charakteristisch: die mit Hes (vgl. 46,1.3.6f) beginnende Restaurationstheologie hat alles aufgegriffen und im System untergebracht, was irgend von alter Überlieferung sich aufspüren liess, auch das seiner Herkunft nach Bedenkliche'.

18. Cf., e.g., Hallo (1977: 16); for relics of the observance (including by women) Hallo refers to Hayyim Schauss, *The Jewish Festivals* (1938: 273-76).

As these quotations show, the value judgments of the exegetes on the new moon celebration go from outright blame for the integration of the 'day of Baal' into the orthodox symbol system, to interpreting it as a reasonable und unavoidable outflow of pastoral wisdom. I have not found a single modern interpreter who valorized the positive aspects of the festival.

I do not think that the older sources intentionally ignored the celebration, since many texts show that it had had its place since time immemorial. The pre-exilic legislation texts took interest in 'salvation-historical' interpretation of traditional celebrations, such as Passover, and they connected the feasts with pilgrimages to the temple in Jerusalem (see Staubli 1996: 321-25). Both aspects played no role in the celebration of the new moon. Stimulated by the Assyro-Aramaean influence, the cult of the new moon received its theological dignity partly from the growing importance of the moon-related calendar. The book of *Jubilees* puts a long list of important events of the 'salvation history' at new moon days (Wilke 1951: 177). Philo of Alexandria gives as main reason for the celebration of the new moon 'the beginning of the month, and the beginning, both in number and in time, deserves honour. Secondly, because when it arrives, nothing in heaven is left without light' (*Spec. Leg.* 2.140). Philo gives a number of further reasons, some of which are of astronomical nature and rather far-fetched. In contrast to modern interpreters, he does not have any problems in appreciating more natural aspects:

> As for the services that the moon renders to everything on earth, there is no need to dilate (sic) upon them. The proofs are perfectly clear. As the moon increases, the rivers and fountains rise, and again diminish as it diminishes… The fruits of both the sown crops and orchard trees, grow to their maturity according to the revolutions of the moon, which fosters and ripens everything that grows (*Spec. Leg.* 2.143; trans. Colson 1937: 393).

Among all these reasons for celebrating the new moon, there is not a single 'historical' one.

The new moon celebration remained to a large extent a pure 'nature' celebration. This should not be considered in a negative sense. That would be against the interest of an age like ours, which strives to find anew its roots in the life cycles of the cosmos. Such striving already existed in exilic times. The arbitrariness of historical events and foundations was overcome by the transformation of arbitrary historical

events into events of creation. In this way the Priestly Code placed the origin of the sabbath right at the beginning of the world, waiting to be discovered by the Israelites during their wanderings in the desert. Other exilic and post-exilic texts transformed the exodus into the cosmic battle against the sterile sea (cf., e.g., Isa. 51.9-11; Ps. 114). In the context of 'cosmization' of the 'salvation history' the cult of the new moon was consciously given place. We are used to the fact that the Bible, but particularly the later Jewish and Christian traditions, considered only historical events to be worthy of particular celebrations. The Bible praises God as creator and as director of history (e.g. Pss. 135, 136). But only the works of the director of history are commonly commemorated and celebrated. The new moon celebration is usually ignored. Everybody interested in a better integration of nature values into the Jewish and Christian traditions should pay attention to this almost forgotten tradition of celebrating the creation.

APPENDIX I

The Inscriptions on the Stelae of Figures 1, 3, 4, and 7

Poorly preserved inscription on fig. 1

'What may be gathered from this is necessarily very little: the two certainties are that the Moon-god Sin is mentioned twice (1, 14) and the city of Harran once (3)—gratifying as this confirmation is, they are precisely the two facts which were known before. Among possibilities, the most interesting are: that Sennacherib is named in (1), and thus may have been the dedicator of this monument; several phrases (6, 8, 10) which refer to "his" (i.e. the god's?) possessions (in the plural), especially (8) "cities"—"sons (i.e. inhabitants) of his city"; a very dubious mention (15) of "this image"(??)'.

'It is greatly to be hoped (though perhaps not overmuch to be expected) that direct study of the original stone would give a better result' (Gadd 1951: 110).

Inscription on fig. 3

Obverse:

1.	Boundary stone of Adad-nērārī, king of Assyria,
2.	son of Šamšī-Adad, king of Assyria,
3.	(and of) Sammu-rāmat, the palace-woman
4.	of Šamšī-Adad, king of Assyria,
5.	mother of Adad-nērārī, strong king, king of Assyria,
6.	daughter-in-law of Shalmaneser,
7.	king of the four quarters. When Ušpilulume,
8-10.	king of the people of Kummuḫ caused Adad-nērārī, king of Assyria, (and) Sammu-rāmat, the palace-woman, to cross the Euphrates;
11-15.	I fought a pitched battle with them—with Ataršumki, son of Adramu, of the city of Arpad(da), together with eight kings who were with him at the city Paqirahubuna. I took away from them their camp. To save their lives they dispersed.
16-18.	In this (same) year this boundary stone was *set up* between Ušpilulume, king of the people of Kummḫ, and Qalparuda, son of Palalam, king of the people of Gurgum.
19-20.	Whoever (dares) to take (it) away from the hand of Ušpilulume, his sons, his grandsons:
21-22.	may (the gods) Aššur, Marduk, Adad, Sin, (and) Šamaš not stand (for him) at his lawsuit.
23.	Abomination of Aššur, my god, (and) Sin who dwells in Harran.

Reverse:

1. Shalmaneser, strong king, king of Assyria,
2. son of Adad-nērārī, strong king, king of the universe, king of Assyria,
3. son of Šamšī-Adad, king of the four quarters:
4-5. when Šamšī-ilu, the commander in chief, marched to Damascus,
6-10. the tribute of Hadiyani, the man of Damascus—silver, gold, copper, his royal bed, his royal couch, his daughter with her extensive dowry, the property of his palace without number—I received from him.
11-13. On my return (from Damascus) I gave this boundary stone to Ušpilulume, king of the people of Kummuḫ.
13-15. Whoever (dares) to take (it) away from the hand of Ušpilulume, his sons, his grandsons may Aššur, Marduk, Adad, Sin (and) Šamaš
16. not stand (for him) at his lawsuit,
17. may they not listen to his prayers;
18. and may they quickly *smash* his country like a brick.
19. May he no longer give advice to the king.
20. Abomination of Aššur, my god, (and) Sin, who dwells in Harran. (Donbaz 1990: 9-10).

Inscription on fig. 4

'The inscription is badly damaged, therefore it would be unwise to revert to an interpretation by somebody who is not a philologist. It comports 18 lines, the fourteenth being blank. Clearly discernable is an enumeration of deities in the introduction, Adad, An, Nabu(?) and Sin, and a listing of several cities, including Harran, line 10: ^{al} KASKAL-ni (Parpola 1970: 152-53 and Saḫlalu, line 11, 18: ^{al} Saḫ-la-lu (Parpola 1970: 211 [Kitlala]; as to the Old Babylonian evidence of Saḫlala: Hallo 1964: 78; Goetze 1964: 116) as well as Til...: line 10, 18: ^{al} Til, where it is not clear, whether more signs should follow. Saḫlalu could be identical with the Old Babylonian Saḫala, which was situated between Apqû ša Baliḫa and Zalpaḫ the actual Tall Ḥamam, that means the same place into which Shalmaneser III entered in its 6th palu—near Til Turaḫi (Luckenbill 1926: 222 §610). The line that supposedly should show the name of the commander is mostly destroyed: presumably it was an Assyrian king, because at the end of line 7 the signs 'šar$_4$ ^{mat} aš' are still preserved. A philologist might recognize some more, but in the meantime the inscription is continuing to suffer steadily by the regular spraying with water' (Kohlmeyer 1992: 96).

Inscription on fig. 7

1. Adad-nērārī, great king, strong king, king of the universe, king of Assyria,
2. son of Šamšī-Adad, strong king, king of the universe, king of Assyria,
3. son of Shalmaneser, king of the four quarters.
4-5. The boundary which Adad-nērārī, king of Assyria, (and) Šamšī-ilu, the commander in chief, established between Zakur of the land of Hamath and Ataršumki, son of Adramu:

6-8. the town of Nahlasi with all its fields, gardens [and] settlements is (the property) of Ataršumki. They divided the Orontes River between them. *This is* the border.

9-11. Adad-nērārī, king of Assyria, (and) Šamšī-ilu, the commander in chief, have given it free and clear to Ataršumki, son of Adramu, to his sons, and his subsequent grandsons. His city and its territories [...] to the border of his land he made firm.

12-13. By the name of Aššur, Adad, and Ber, the Assyrian Illil, the Assyrian [Mulliss]u, and the name of Sin dwelling in Harran, the great gods [of] Assyria:

14-16. whoever afterwards speaks ill of the terms of this stele, and takes by force this frontier from the possession of Ataršumki, his sons, and his grandsons; *and* destroys the written name (and) writes another name:

17-19. may [Aššur], Adad, and Ber, Sin dwelling in Harran, the great gods of Assyria [whose] names are recorded on this stele, not listen to his prayers.

(Donbaz 1990: 7)

APPENDIX II

A late Iron Age moon temple on Ruǧm al-Kursī near Amman ?

After completion of the manuscript of this book Professor Dr Ulrich Hübner of the University of Kiel (Germany) drew my attention to a building at Ḥirbet or Ruǧm al-Kursī near Amman (map reference 2280.1533). I would like to thank him for the information he gave me and for the photograph taken in 1997 on which the drawing of fig. 105 is based. Part of the site was excavated in the eighties by 'Abd al-Ǧalil 'Amr on behalf of the Department of Antiquities of Jordan. All published finds relate to the Islamic, Byzantine and Roman periods (cf. Hübner 1992: 152-53 with n. 121, bibliography; Schmitt 1995: 208). A short communication by the excavator says that in the deeper strata Iron Age pottery was found ('Amr 1986). As far as I see the remains of a rectangular building of approximately 18.70 x 12.60 m are not published, not even mentioned in the published record. The building is oriented east-west and has only one entrance to the east. The door forms a recess in the front wall. The threshold is a monumental 2.50 m wide. The most interesting feature of the building as far as it is preserved are two reliefs on the door jambs (**fig. 105**; drawing by Hildi Keel-Leu). The two blocks with the reliefs are about 90 cm high, 85 cm wide and 100 cm deep. The almost identical reliefs show a disk that might represent the full moon within a crescent. The crescents rest on pillars. On the relief on the right, which is better preserved, the pillar is decorated by two rectangles, one inside the other. On both reliefs, the pillar rests on a rectangular pedestal with two (four) short feet and a rectangular design crossed by two diagonal spars.

This kind of pedestal is typical of the western or Phoenician group of representations of the lunar emblem (Part II figs. 32, 34-35, 37, 39, 41-49). The version on a bulla from Ḥorvat 'Uza in the north-eastern Negev (fig. 37) comes particularly close to the al-Kursī reliefs. The thick pillar-like poles may be compared to a representation on a bulla from Jerusalem (fig. 36). Parallels for the crescent almost encircling the disk are mainly found in the Aramaean areas of northern Syria and south-eastern Anatolia (figs. 3, 11, 31). The double representation on the two doorjambs recalls the two lunar emblems flanking the temple entrance (or city gate ?) on a relief from Til Barsib (fig. 10). A representation of two lunar emblems on one building block was found in the Saruǧ plain between the Euphrates and the Baliḫ on Tell Haǧib approximately 50 km west of Ḥarran. The block was published by K. Kohlmeyer (1992a). He relates the double representation to Sin and his consort Ningal.

The date and function of the al-Kursī building are unclear. Hübner first thought that the site was not occupied before the Achaemenid period (1992: 153). Today he considers a late Iron Age date for the building, because of the reliefs and because Iron Age pottery was found on the site ('Amr 1986). The comparison with the relief from Til Barsib suggests that it may have been a temple, a view supported by its eastern orientation. An excavation report would be helpful to find answers to these questions. Confirmation of the two hypotheses (late Iron Age; moon temple) would make Ruǧm al-Kursī the first late Iron Age moon temple known from the Levant. Its monumental dimensions suggest that it was built or at least supported by the ruling political authority.

APPENDIX III

A Sanctuary of the moon god at the city gate of et-Tell (Bethsaida)?

The site of et-Tell (Bethsaida) is situated approximately 2.3 km north of the northern shore of the sea of Galilee and approximately 1 km east of the Jordan. The Bethsaida Excavations Project, directed by Rami Arav and Richard A. Freund, both from the University of Nebraska at Omaha, started excavations on the site in 1991. Together with remains from the Roman and Hellenistic periods they discovered an important Iron Age city (strata 4–6; c. 1000–600 BCE). In June 1997, to the right of the outer entrance of the city gate, the expedition excavated a small platform of 153 × 153 cm, about 80 cm high. Two steps lead up to the platform. On the platform is a water basin, 69 cm long, 50 cm wide and 35 cm high. Inside the basin three cups for incense burning were found. Behind the basin stood an iconic stele, 115 cm high, 59 cm wide and 31 cm thick. Immediately to the left of the platform was an aniconic stele with rounded top, 124 cm high, 59 cm wide and 20 cm thick. Three more aniconic stelae were found in the vicinity of the platform, two in 1997, one more in 1998. All the items mentioned were made of local basalt. According to the excavators the open-air sanctuary was destroyed in the second half of the eighth century.

The 'high place' beside the city gate with its equipment was published and discussed at length by Monika Bernett and Othmar Keel (1998). They interpreted the cult place as a sanctuary of the moon god. Barbara Connell's view gives an idea of how the place may have looked (**fig. 106**) (compare Bernett and Keel 1998: 102, fig. 10). Since the report by Bernett and Keel is in German the main results will be briefly summarized here in English to give as complete a picture as possible of the iconographic data in relation to the moon cult in the southern Levant in the eighth and seventh centuries BCE.

The relief on the stele of Bethsaida (**fig. 107**) (Bernett and Keel 1998: 96, fig. 1d) looks somewhat awkward and archaic. The figure on it has been interpreted as a bull-headed warrior or a bull standing upright on his hindlegs. Many archaeologists thought the motif totally unknown and unique and therefore a mere local phenomenon. This is, however, not the case. In 1938 two stelae from the Hauran with an almost identical iconography were published (**figs. 108-109**) (Bernett and Keel 1998: fig. 11a and 12), one of which is in the National Museum of Damascus (fig. 108). It should be remembered that during the Iron Age Bethsaida formed part of the Aramaic kingdom of Geshur (2 Sam. 15.8) and later of Damascus. Therefore, the Bethsaida stele is probably a relic of Aramaic iconography. On the other hand

the stylization typical of the Bethsaida and the Hauran stelae has never been a characteristic element of either Syrian iconography in general or Aramaic iconography in particular. In contrast to the Bethsaida stele, the Hauran stelae were not found in situ and so were first attributed to the Roman period (Ronzevalle 1937–38). However, long before the stratified stele of Bethsaida was uncovered, this type of stele had been dated to the ninth to eighth centuries on stylistic grounds (Galling 1953). The initial interpretations of the figure as a bull standing on its hindlegs or as a human being with a bull's head have been accepted to this day. Two details point against these interpretations: First, the pole in the middle which carries the rest. One can hardly follow the authors who see in it a phallus, a prolongation of the torso, a throne and so on. Even extremely stylized humans always stand on their two legs, never on a post in the middle (cf. Bernett and Keel 1998: 126-27, figs. 72-73, and 74b). Second, the indistinct way in which the extremities have been rendered. They have been explained either as bull's feet, or human arms and legs or wings and feet. This lack of distinction led to what may be considered an arbitrary interpretation.

In 1959, Seyrig published a bronze box with, on it, two structures consisting of a single or a double post topped by a bull's head (**fig. 110a-d**) (Bernett and Keel 1998: 107, fig. 14a-d). From both sides two beams slope down symmetrically. By the bull's head is a quartered 'wheel' or a quartered disc reminiscent of the quartered rosette on the Hauran stelae. This made it clear that the structure on the Hauran and the Bethsaida stelae was comprised of both figurative and non-figurative elements. In 1997, the box was dated, like the Hauran-stelae, to the Roman period. Much later, M. Krebernik and U. Seidl correctly attributed the box to the Iron Age and recognized the mixture of figurative and non-figurative elements in the Hauran-stelae. This insight led them to an additional parallel, namely a stele in the Museum of Gaziantep (South-Eastern Turkey). Mentioned by J. Börker-Klähn in 1982, it was published by Krebernik and Seidl in 1997 (**fig. 111**) (Bernett and Keel 1998: 105-106, fig. 13a-c).

The structures on the bronze box and the iconography of the Gaziantep stele make it clear that the side beams which are curved on the Bethsaida and Hauran stelae and therefore often interpreted as human or animal extremities, and the added sword on both of them, which is lacking on the bronze box and the Gaziantep stele, as well as the earrings on fig. 107, are elements of an inconsistent anthropomorphization of the south-east Anatolian/North-Syrian composition, which included both figurative and non-figurative motifs. Krebernik/Seidl point to two North-Syrian examples showing a 'stand' without a bull's head but with four globes forming a rosette next to it (**figs. 112-113**) (Bernett and Keel 1998: 108, figs. 15-16). The globes seem to be a constituent element which is already apparent in figs. 112-113. In order to interpret the iconography of the Bethsaida-stele, a number of problems must be solved: (1) the question of the origin and meaning of the combination of figurative and non-figurative elements; (2) the meaning of the four globes; (3) the identity of the god represented; and (4) the reason for the anthropomorphization of a representation in Southern Syria which originally combined non-figurative with figurative elements.

1. As to the problem of the combination of non-figurative and figurative elements, Krebernik and Seidl summarily referred to a representation of a cult-symbol on Old Anatolian/Old Syrian cylinder seals (c. 1850–1650). According to P. Matthiae (1993) this cult-symbol should have been identified as the famous Semeion of Hierapolis. However, neither Lucian's description nor pictorial representations seem to justify this assumption.

Figurative and non-figurative elements are often combined in Egyptian art. The system of hieroglyphic script not only made this possible but also helped to develop it. From 1250–700 BCE a hieroglyphic script akin to the Egyptian one prevailed in southern Anatolia and North Syria. One of its signs, no. 268, perhaps picturing originally a chisel, looks like a post with two beams sloping down symmetrically on either side from its top. Its meaning is 'sculpture' or 'monument' ('memorial'). On the Bethsaida stele the pole with two beams sloping down symmetrically could thus have been read 'sculpture', 'monument' or the like. In North Syrian glyptic of the ninth to eighth centuries this kind of 'stand' often supports a varying number of globes that must be interpreted as stars. The four beams of the 'stand' remain a problem as they cannot be explained by the Luvian hieroglyph no. 268.

2. In a number of examples the four globes, appearing mostly in the form of a rosette in even the most schematic variants of the composition of the Bethsaida stele, are associated with the emblem of the new moon of Harran (Part II figs. 28, 38, 50).

In some cases, the full moon is represented as a quartered disc (Bernett and Keel 1998: 119-20, fig. 41 cf. also 48, 51). It would appear that the different renderings of the element 'four' are related to the four phases of the moon, which play an important part in Assyro-Aramaic astrology. Innumerable astrological texts refer to the moon (Hunger 1992). Isaiah 47.10 also refers to astrological practice on the day of the new moon. The 'hieroglyph', be it a rosette or a series of four globes, seems to suggest the four parts of the moon and its changes, an event that fascinated the whole Near East in the eighth and seventh centuries and that is still marked in the Jewish feast of the New Moon and similar rites in the Arabic world of today.

The four beams of the 'stand' (cf. particularly fig. 110d) may perhaps also be explained by this phenomenon. If one thinks of the lunar emblem as an originally three-dimensional object, the four beams could have pointed to the four directions, symbolizing in this way the influence of the new moon on the four world regions.

3. The interpreters of the parallels of the Bethsaida stele have hitherto neglected or at least minimized the obvious connection between the element 'four' and the iconography of the moon. The bull's head was the main reason for this. All authors, except Krebernik and Seidl, have without hesitation identified the figure on the monuments of the type of the Bethsaida stele with the Syrian weather god (Hadad, Ba'al) precisely because of the bull's head. It is true that the weather god has been shown standing on a bull in second-millennium Syria as well as in Mesopotamia during the Old Babylonian and Neo-Assyrian periods. However, from the third millennium, the new moon had time and again primarily been celebrated as the 'master of horns', as a 'horned bull' and 'as the strong calf of Anu (lord of heaven)' in the Sumerian and Akkadian hymns, a fact that was ignored by the interpreters. In the

myth *Geme Suena* 'Maiden of Sin' the moon god appears as a bull. In Aramaic-speaking Palmyra, the moon is purely and simply called 'Aglibol, 'bull of the lord (of heavens)'. Already in Early Dynastic times (mid-third millennium), we find the moon standard placed on a stand with bull's feet. In Old Syrian iconography the moon god is associated with a bull and bull's head appears along with the moon or the emblem of the moon. In contemporary Old Babylonian glyptic the moon god is standing on two bulls. The fragments of a basalt stele from Hazor from the middle of the second millennium (Bernett and Keel 1998: 120, fig. 52) show a god on a bull who can be identified either as the moon god or as the weather god with lunar features on account of the moon emblem on his chest. In Anatolian/North Syrian glyptic from the thirteenth century there is sometimes a bull's head, sometimes a whole bull associated with the moon (crescent and full moon [Bernett and Keel 1998: 116-125, figs. 42-71]). Merely from a formal point of view the representations of the emblem of the moon god of Harran (figs. 4, 6, and 11) and, for example, the bull's head of the stelae from Bethsaida or Tell Aš'ari (figs. 107-08) are very close. On a Late-Luvian relief from Karkemish the moon god takes precedence over the sun god (Bernett and Keel 1998: 121, fig. 58). The moon god's preeminent position is further to be observed during the Iron Age and becomes a typical feature in Palmyra, which not only preserved the Aramaean language but also a noticeable part of Aramaic culture into Hellenistic times. While the sun god Malakbel is depicted as a modest peasant, the moon god appears as a warrior (fig. 65). Beside the crescent moon that identifies him, a nimbus (halo-aureole) of (luminous) rays surrounds his face (Bernett and Keel 1998: 124, fig. 66). A further point is that in Palmyra the crescent moon is not only closely associated with the bull but also with the bull's head (Bernett and Keel 1998: 125, figs. 67-71), an association from which the weather god seems to be excluded. The weather god is portrayed standing on a bull instead. The association of the moon god with the bull's *head* is probably to be substantiated by the close connection between the crescent and the bull's horns.

4. From the romantic period we have been used to see the moon as a mild and peaceful entity. The South Anatolian–North Syrian tradition has a different view: Not only is the moon god an energetic guarantor and defender of treaties, but he also appears as an aggressive if not warlike figure. The sword, one of the anthropomorphizing elements of the Bethsaida and Hauran stelae, is also to be found on anthropomorphic representations of the moon god (Part II figs. 9 and 10). Fig. 10 is particularly impressive. It depicts the moon god as a watchman of the city, or temple gate. Although he occasionally appeared as a human-like figure it was more common to represent him by the moon emblem of Harran as shown above in Chapter 7. The contrary applies to the weather god: the anthropomorphic representation was predominant while the symbolical one, that is the lightning fork, was (more) seldom.

Thus the question arises whether the anthropomorphization of the Bethsaida and Hauran stelae might not haven been brought on by the South Syrian reinterpretation of the Anatolian–North Syrian composition as weather god, so that the stelae show a moon god interpreted as a weather god, or a lunarized weather god. The

weather god too is sometimes seen beside the gate, as evidenced by the gate-orthostats of Karkemish and probably of Malatya (Orthmann 1971: pl. 20 Karkemis Aa/4 and pl. 41 Malatya A/11).

Many arrangements at gates have already been explained as cultic but some cases still remain unclear. The circumstances in Dan are unequivocal. Between the outer and the main gate of the ninth/eighth-century city a cult place with five masseboth, a deposit table for offerings and remains of incense bowls was found (Bernett and Keel 1998: 130-35, figs. 78-83). The problem of the often quoted cultic installation at the gate in Tell el-Far'a (North) is that apparently the massebah and the basin were not in existence at the same time at the site of the gate (Bernett and Keel 1998: 136-41, figs. 84-89). In the case of the Negev fortifications the position immediately in front of the gate is not given (Ḥorvat 'Uza) or the finds cannot be clearly defined as an indication of a cult (Ḥorvat Radum, Kuntillet 'Aǧrud, Beersheba) (Bernett and Keel 1998: 142-45, figs. 90-95). The same is true for the installation at the gate in Megiddo (Bernett and Keel 1998: 146-48, figs. 96-98)—its position could well point to a cultic place but unfortunately it is not substantiated by elements such as a massebah, incense bowls or similar finds.

The sacred place of the seventh century in 'En Ḥaṣeva in the 'Arava is not located immediately beside the gate, although it is not far from it, but in any case it is outside the city-wall (**fig. 114**) (Bernett and Keel 1998: 150, fig. 101, and the discussion on p. 70). The crescent on the cult stele (**fig. 115**) (Bernett and Keel 1998: 151, fig. 104) and on a seal recovered on the site (fig. 88a above) suggests a local moon cult or at least a cult with lunar aspects.

The cultic installations at the gate may have served individuals and families as a means of practising a cult in public, as is the case with the thanksgiving offering in the temple. They were also the sites where collective cults under the leadership of kings, priests or prophets took place as evidenced by the texts.

There are, among others, two important passages in the Hebrew Bible concerned with cults by the gate: 2 Kgs 23.8b and Ezek. 8.3-5; they testify to a cult in Jerusalem between the outer and the main gate similar to the one in Dan. Both texts possibly refer to the same circumstances. The phrasing in Ezek. 8.3 would seem to suggest a cult including an iconic stele similar to the one in Bethsaida. Psalm 121.8 might elucidate its function, namely to ask for the god's blessing and protection when leaving the shelter of the city and to give thanks for it when coming back home. Iconic (figs. 1-9) and aniconic stelae (Gen. 31.51-52; Isa. 19.19?) served to mark and to guarantee borders. The city gate was such a border. The departure for a military campaign was particularly dangerous. In such cases one had to make sure of god's safeguard by very special rites (1 Kgs 22; letter of Haruspex Marduk-šumu-uṣur to Assurbanipal in the year 667). Finally the sacred place by the gate could have played a part in legal transactions which regularly took place on that site. A relief from Sam'al (Zincirli) however, placed at the entrance of the palace and not at the city gate, shows the ruler Barrakib as a merry reveller (Bernett and Keel 1998: 154, fig. 108) as well as a reliable legal partner accompanied by his scribe before the emblem of the moon god of Harran (fig. 11). Stelae (figs. 1-10), seal-impressions (fig. 35) and bullae (figs. 36-37) with the moon emblem of Harran

testify to this god's importance in matters of contracts and other legal transactions.

Finally there is some indication for memorial stelae and ancestral worship, particularly for a cult of deceased kings at the gate. The three aniconic stelae of Bethsaida (a fourth stele was found in 1998) may have been part of such a cult, although 2 Sam. 18.18 mentions a memorial stele not placed at the gate. In the famous row of stelae in Assur there are some anepigraphic ones among the many others which bear the name of a king or an official. In the city gate installations of Karatepe, Karkemish and Zincirli orthostats were found on which were depicted the very same symposium scenes as appear on the actual tomb stelae (Bernett and Keel 1998: 158-60, figs. 116-117). On a statue of the weather god probably originally from the gate in Zincirli we read: 'May the soul of Panammuwa eat with you (Hadad) and may the soul of Panammuwa drink with you' (Donner and Röllig 1962: no 214, 17). These words or similar ones could well have been incised on the aniconic stelae from Bethsaida. Their meaning would have been that the ancestors as represented by the aniconic stelae would have a share in the libation and the incense sacrifice for the deity (the moon god or the lunarized weather god) of the iconic stele.

A number of questions pertaining to the cult place at the gate in Bethsaida cannot be answered with absolute certainty. Lack of information and the fact that the ancient inhabitants of the city were less keen on clear-cut answers and unambiguous signs may explain this. In his article on cultic stelae and memorial stones, M. Hutter pointed out that cultic stelae could easily take over the function of memorial stelae and the stelae for the dead could in fact become cultic stelae, although they were basically considered different from one another. In the case of a related phenomenon, namely the holy tree in Egypt, we are able, thanks to the often added inscriptions, to demonstrate clearly that there are not only different deities (Nut, Isis, Hathor, Ma'at) manifesting themselves in, let us say, a sycamore, but that a deity present in a particular tree could be represented as 'Isis' in the picture, whereas the inscription identifies her as 'Hathor, the Lady of the West' (part I, fig. 58). Not identification but the function of the tree-goddess for the deceased or the function of the cult place at the gate was most important. The latter was a means for those gathering at the gate to get into contact, through libations, incense sacrifices, and prayers with numinous powers at highly emotional moments such as departure, home-coming, conflicts in legal matters or remembrance of their rulers (memorial stelae).

The symbolism of libations and incense sacrifices, manifesting themselves by seeping into the stone or the earth or rising to heaven better meets the need for communication with celestial powers than the depositing of food (meat, fruit). Incense burning was particularly suitable for reaching astral powers (2 Kgs 23.5; Jer. 19.13). In this way, men and women did not have to bear alone the tensions and hopelessness of life but could share them with the powers of destiny, that, in the eighth and seventh centuries, came to be perceived above all in the astral sphere.

FIGURES FOR PART I

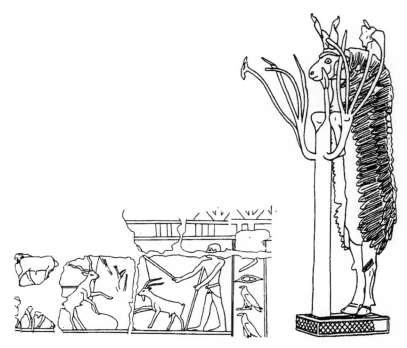

Figure 1 Figure 2

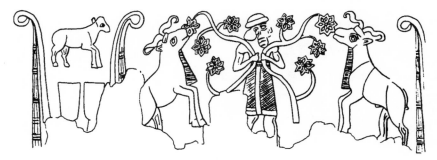

Figure 3

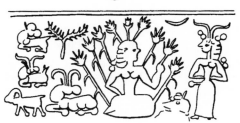

Figure 4

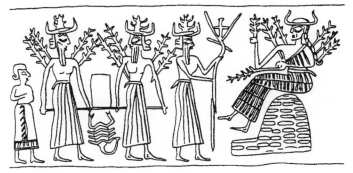

Figure 5a

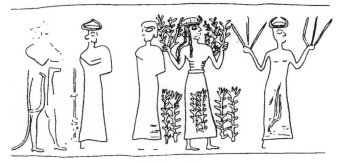

Figure 5b

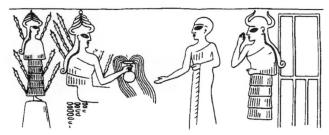

Figure 6

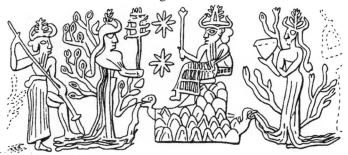

Figure 7

Figure 8

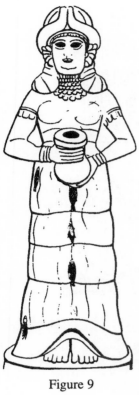

Figure 9

Figure 10

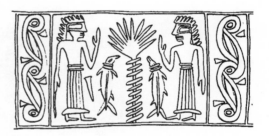

Figure 11

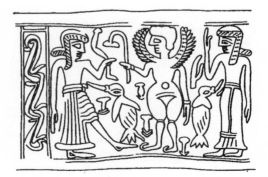

Figure 12

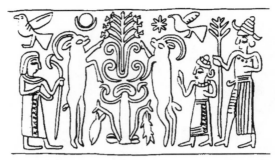

Figure 13

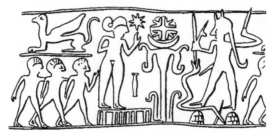

Figure 14

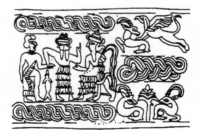

Figure 15

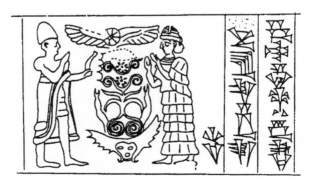

Figure 16

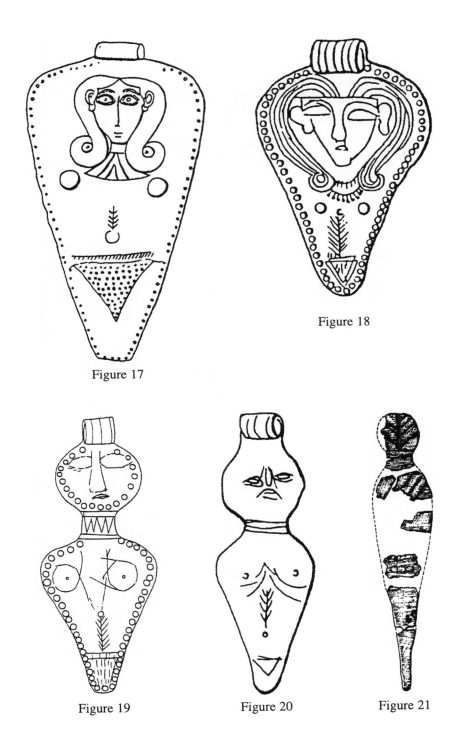

Figure 17

Figure 18

Figure 19

Figure 20

Figure 21

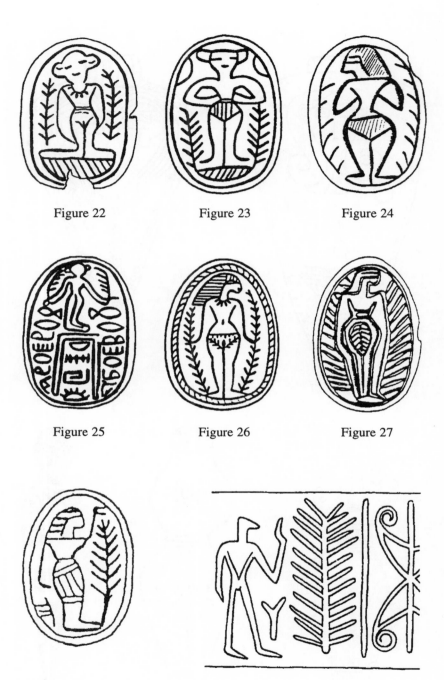

Figure 22

Figure 23

Figure 24

Figure 25

Figure 26

Figure 27

Figure 28

Figure 29

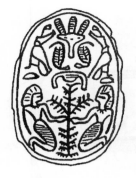

Figure 30

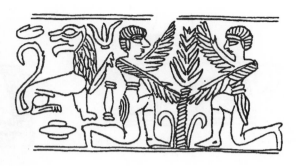

Figure 31

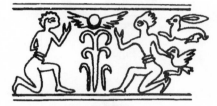

Figure 32

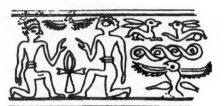

Figure 33

Figure 34

Figure 35

Figure 36

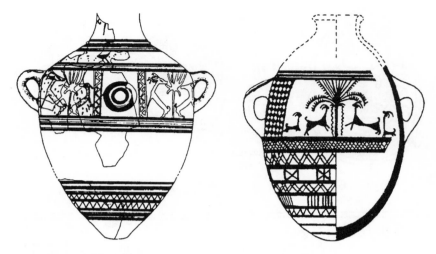

Figure 37 Figure 38

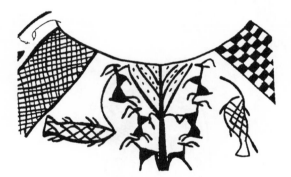

Figure 39

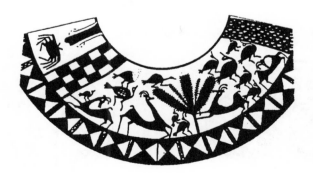

Figure 40

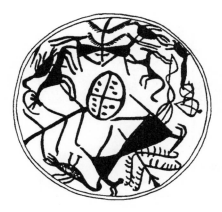

Figure 41

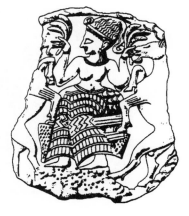

Figure 43

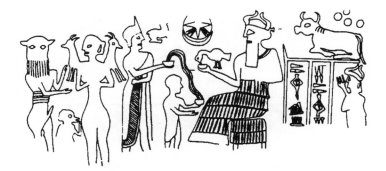

Figure 42

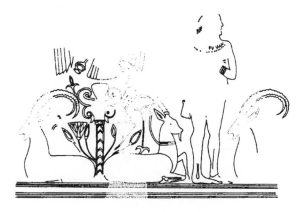

Figure 44

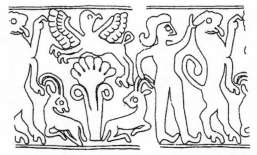

Figure 45

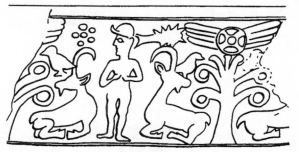

Figure 46

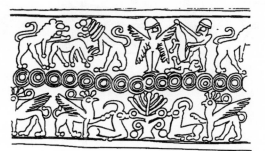

Figure 47

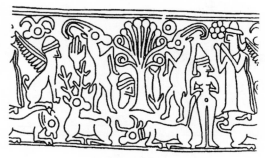

Figure 48

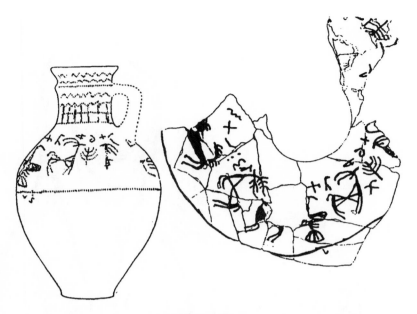

Figure 49

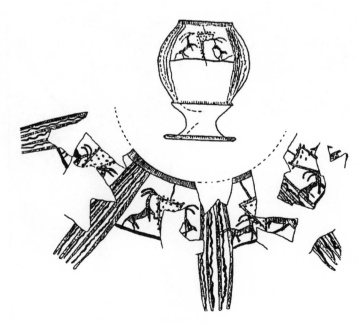

Figure 50

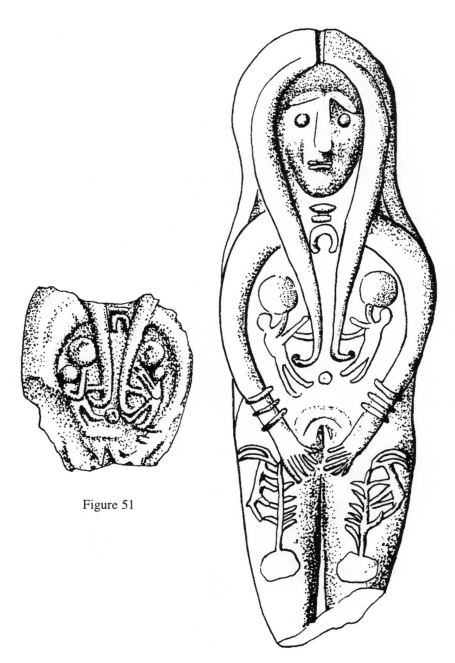

Figure 51

Figure 52

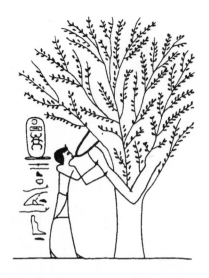

Figure 53

Figure 54

Figure 55

Figure 56

Figure 57

Figure 58

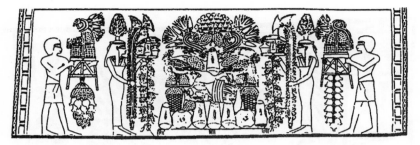

Figure 59

Figure 60

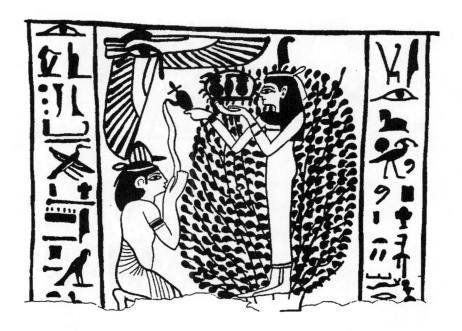

Figure 61

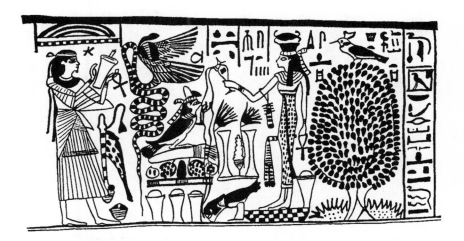

Figure 62

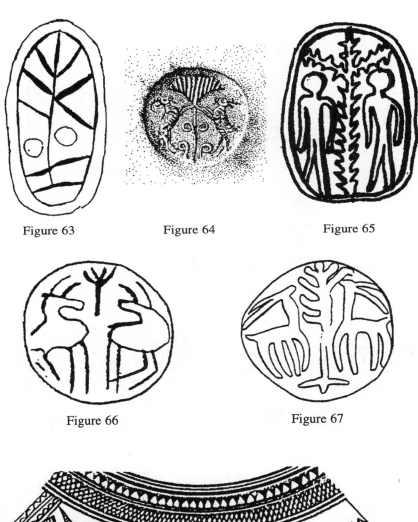

Figure 63 Figure 64 Figure 65

Figure 66 Figure 67

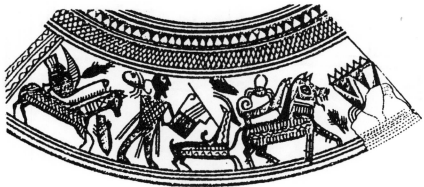

Figure 68

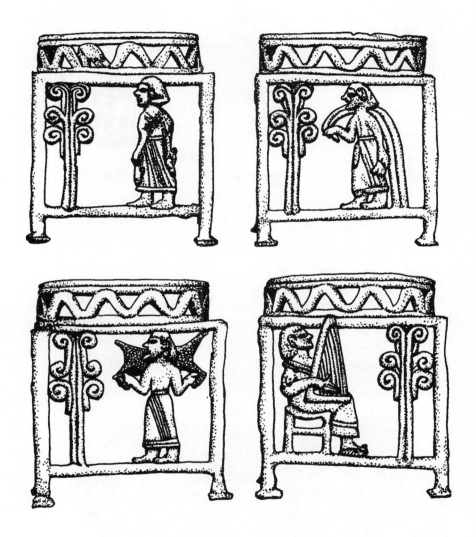

Figure 69a-d

Figure 70

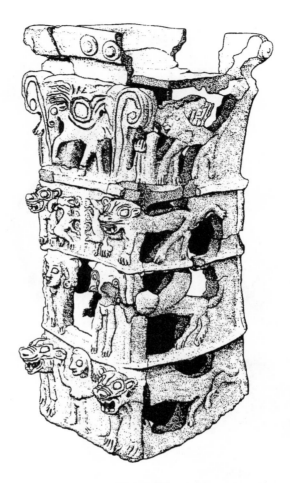

Figure 71

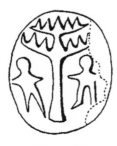

Figure 72

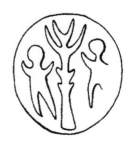

Figure 73

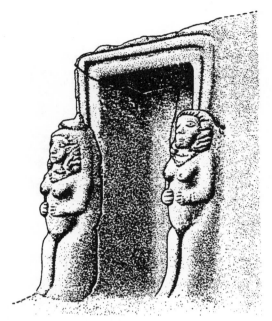

Figure 74

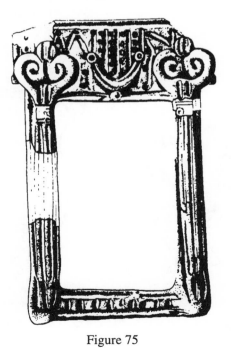

Figure 75

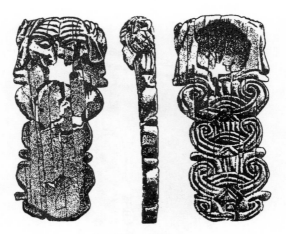

Figure 76

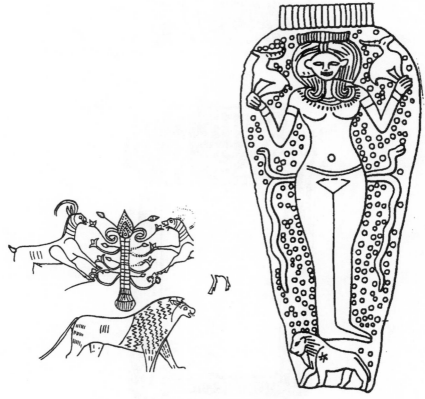

Figure 77 Figure 78

Figure 79

Figure 80

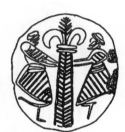

Figure 81

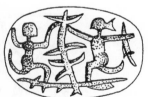

Figure 82

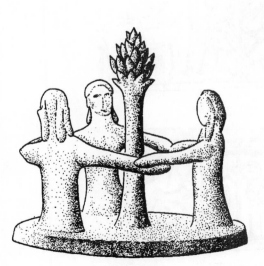

Figure 83

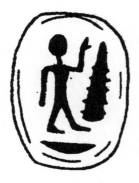

Figure 84

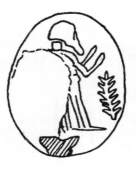

Figure 85

Figure 86

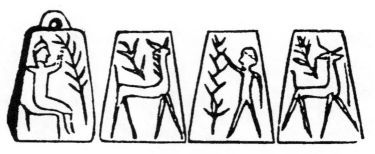

Figure 87

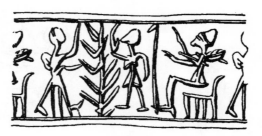

Figure 88

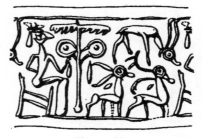

Figure 89

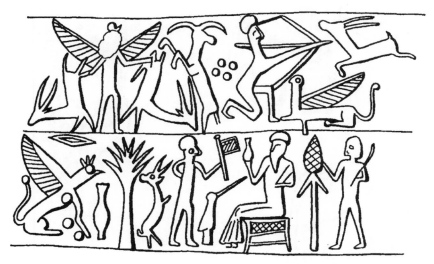

Figure 90

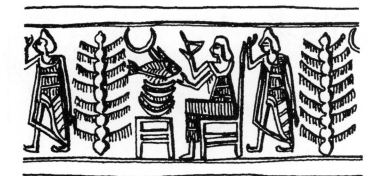

Figure 91

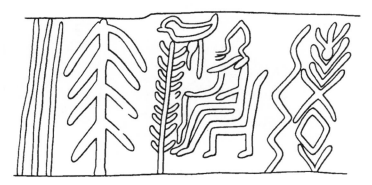

Figure 92

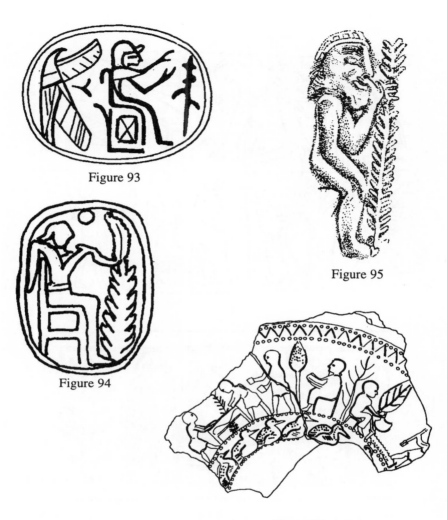

Figure 93

Figure 95

Figure 94

Figure 96

Figure 97

FIGURES FOR PART II AND APPENDICES

Figure 1 Figure 2

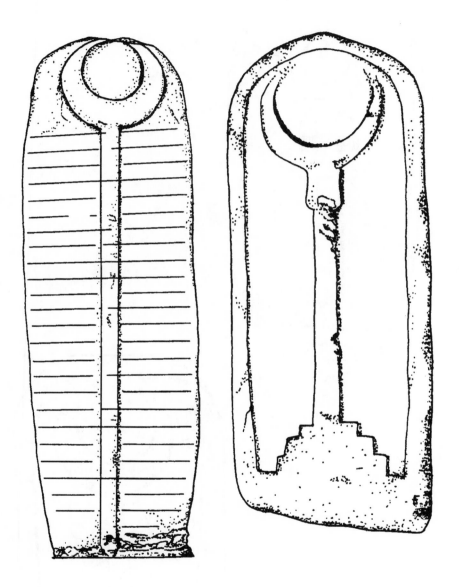

Figure 3 Figure 4

Figure 5

Figure 6

Figure 7 Figure 8

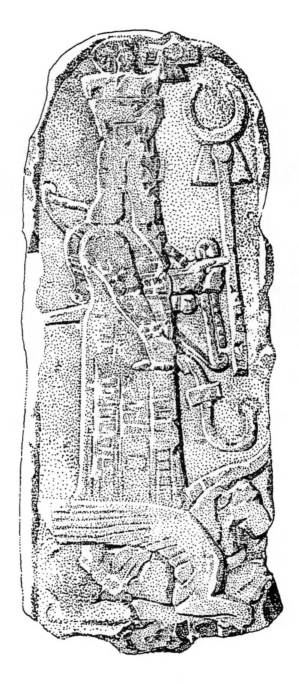

Figure 9

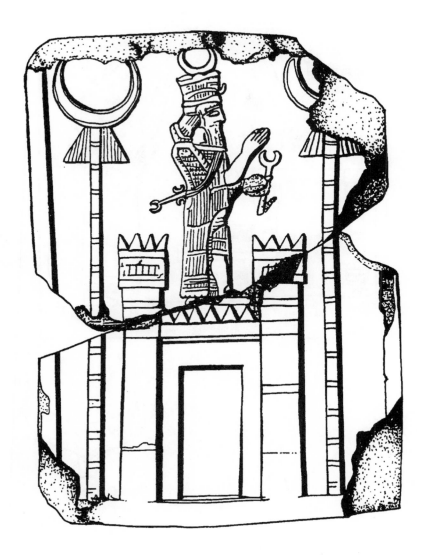

Figure 10

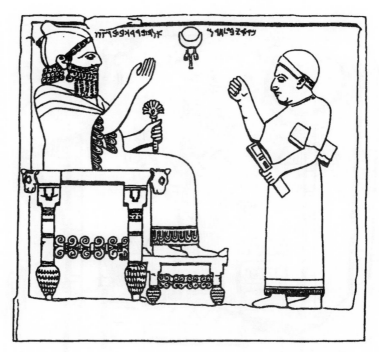

Figure 11

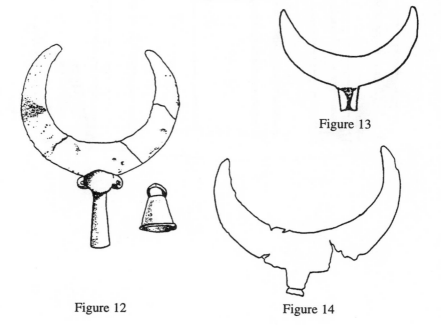

Figure 12

Figure 13

Figure 14

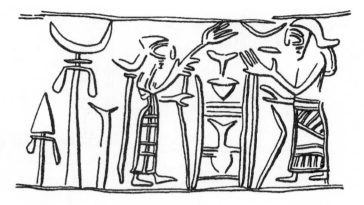

Figure 15

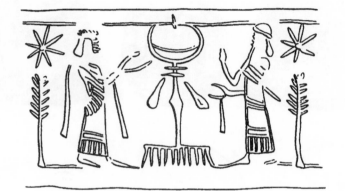

Figure 16

Figure 17

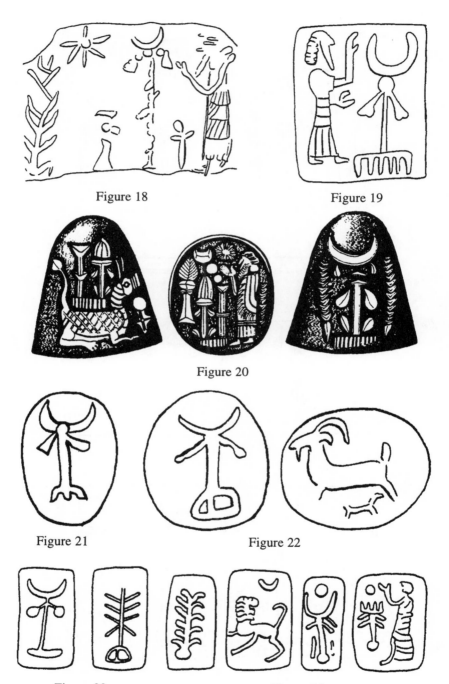

Figure 18

Figure 19

Figure 20

Figure 21

Figure 22

Figure 23

Figure 24

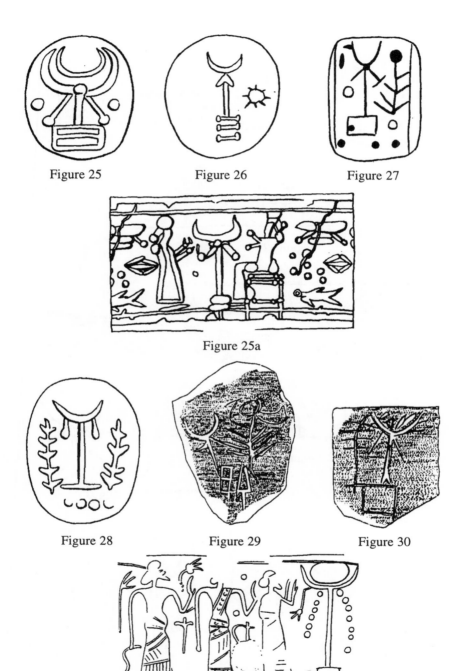

Figure 25

Figure 26

Figure 27

Figure 25a

Figure 28

Figure 29

Figure 30

Figure 31

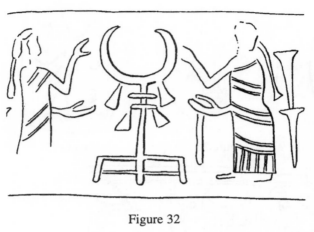

Figure 36

Figure 32

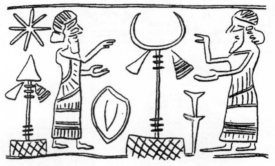

Figure 37

Figure 33

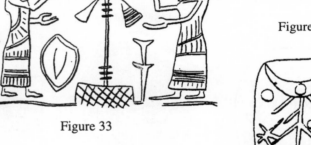

Figure 38

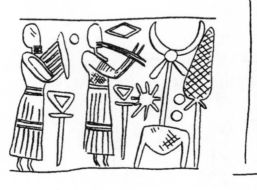

Figure 34

Figure 35

Figure 39

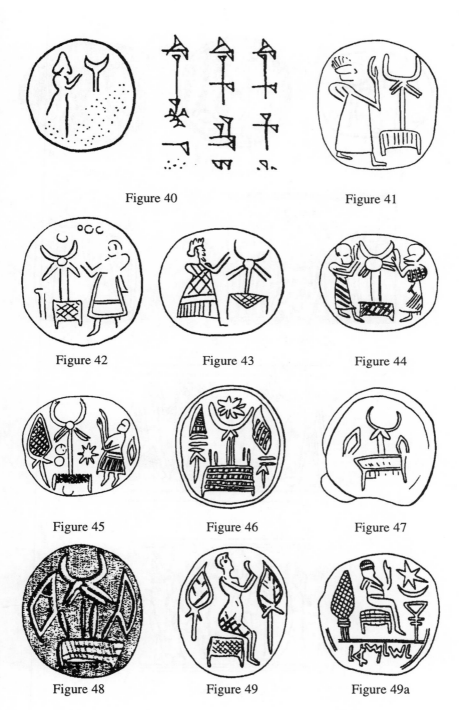

Figure 40

Figure 41

Figure 42

Figure 43

Figure 44

Figure 45

Figure 46

Figure 47

Figure 48

Figure 49

Figure 49a

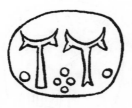

Figure 50

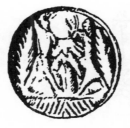

Figure 51

Figure 52

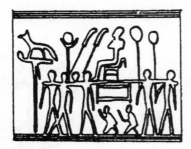

Figure 53

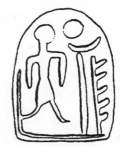

Figure 54

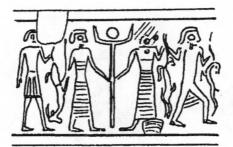

Figure 55

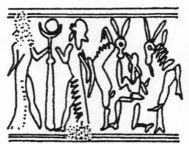

Figure 55a

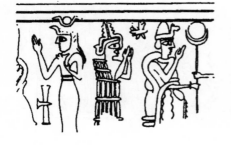

Figure 56

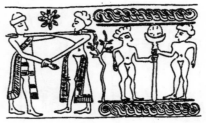

Figure 57

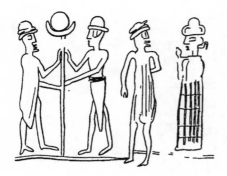

Figure 58

Figure 59

Figure 60

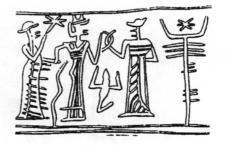

Figure 61

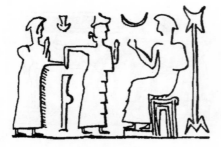
Figure 62

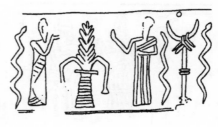
Figure 63

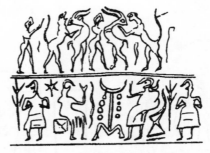
Figure 64

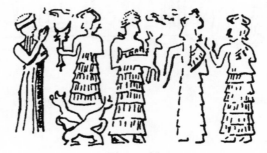
Figure 65

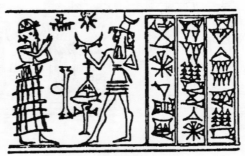
Figure 66

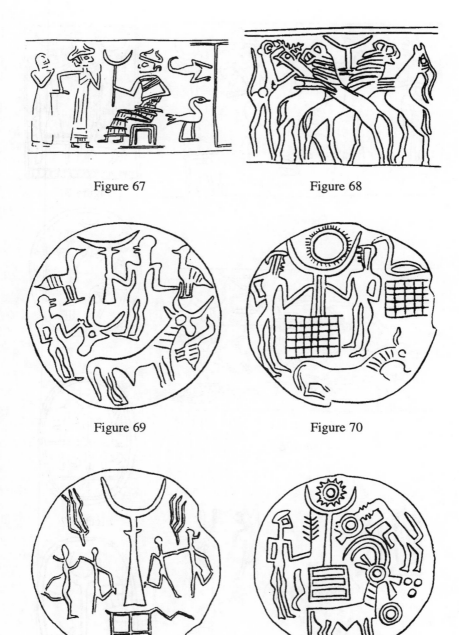

Figure 67

Figure 68

Figure 69

Figure 70

Figure 71

Figure 72

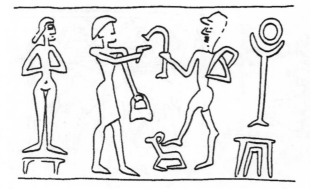

Figure 73

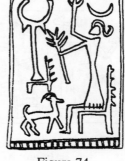

Figure 74

Figure 76

Figure 75

Figure 79

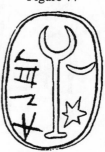

Figure 77

Figure 78

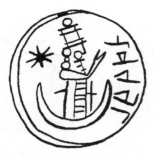

Figure 80

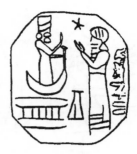

Figure 81

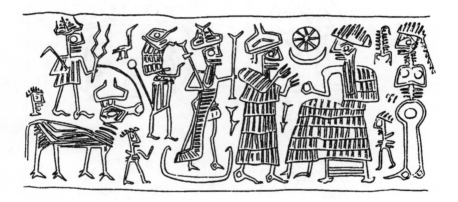

Figure 82

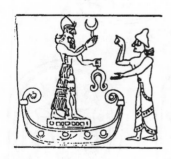

Figure 83

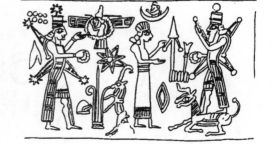

Figure 84

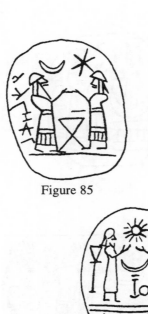

Figure 85

Figure 86

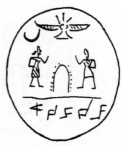

Figure 87

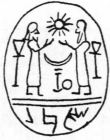

Figure 88

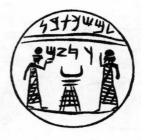

Figure 88a

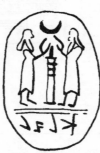

Figure 89

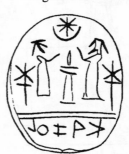

Figure 90

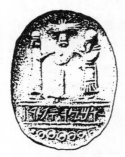

Figure 91

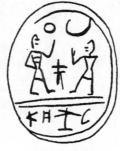

Figure 92

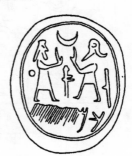

Figure 93

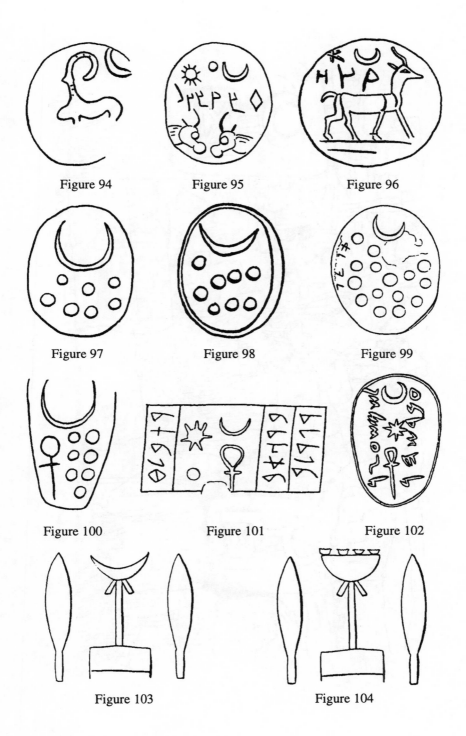

Figure 94

Figure 95

Figure 96

Figure 97

Figure 98

Figure 99

Figure 100

Figure 101

Figure 102

Figure 103

Figure 104

Figure 105

Figure 106

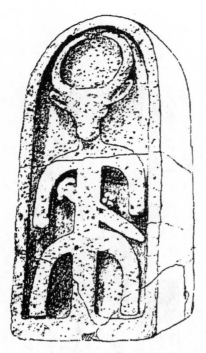

Figure 107

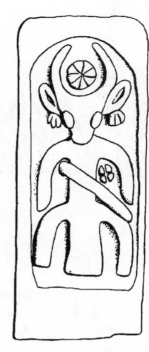

Figure 108

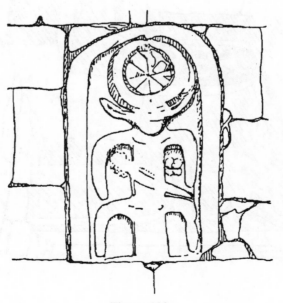

Figure 109

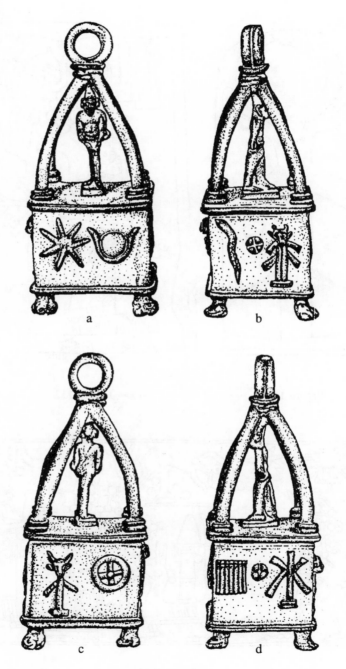

Figure 110

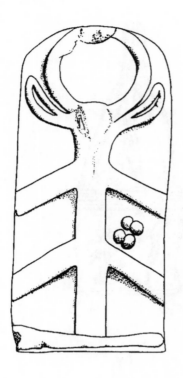

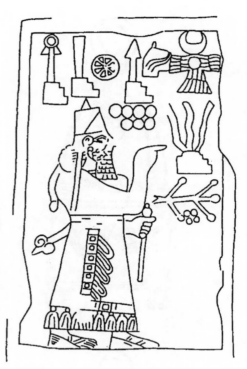

Figure 111 Figure 112

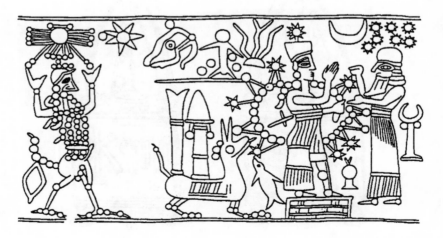

Figure 113

Sanctuary

Figure 114

Figure 115

BIBLIOGRAPHY

Al-Gailani, Werr *see* Gailani.
Amiet, P.
 1972 *Glyptique Susienne des origines à l'époque des Perses achéménides: Cachets, sceaux-cylindres et empreintes antiques découverts à Suse de 1913 à 1967* (Mémoires de la délégation archéologique en Iran, 43; 2 vols.; Paris: Libraire orientaliste Paul Geuthner).
 1977 'Pour une interprétation nouvelle du répertoire iconographique de la glyptique d'Agadé', *RA* 71: 107-16.
 1980 *La glyptique mésopotamienne archaïque* (Paris: Editions du centre nationale de la recherche scientifique, 2nd edn).
 1992 *Corpus des cylindres de Ras Shamra-Ougarit. II. Sceaux-cylindres en hématite et pierre diverses* (Ras Shamra-Ougarit, .9; Paris: Editions recherches sur les civilisations).
Amiet, P. *et al.*
 1996 *Tell el-Far'ah: Histoire, glyptique et céramologie* (OBO, Series Archaeologica, 14; Freiburg: Universitätsverlag; Göttingen: Vandenhoeck & Ruprecht).
Amiran, R.
 1969 *Ancient Pottery of the Holy Land: From its Beginning in the Neolithic Period to the End of the Iron Age* (Jerusalem–Ramat Gan: Massada Press).
Amr, A.
 1986 'Ruǧm al-Kurs´, *Archiv für Orientforschung* 33: 210-11.
Andersen, F.I., and D.N. Freedman
 1980 *Hosea* (AB, 24; Garden City, NY: Doubleday).
Attridge, H.W., and R.A. Oden
 1976 *The Syrian Goddess (De Dea Syria) Attributed to Lukian* (SBL, Texts and Traditions, 9; Missoula, MT: Scholars Press).
Avigad, N.
 1977 'New Moabite and Ammonite Seals at the Israel Museum' (Heb.), *Eretz Israel* 13: 108-10.
 1978 'Gleanings from Unpublished Ancient Seals', *BASOR* 230: 67-69.
 1986 'Three Ancient Seals', *BA* 49: 51-53.
Baines, J.
 1985 *Fecundity Figurines: Egyptian Personification and the Iconology of a Genre* (Warminster: Aris & Phillips).
Barnett, R.D.
 1935 'The Nimrud Ivories and the Art of the Phoenicians', *Iraq* 2: 179-210.

1939 'A Cylinder Seal from Syria', *Iraq* 6: 1-2.

1975 *A Catalogue of the Nimrud Ivories with other Examples of Ancient Near Eastern Ivories in the British Museum* (London: British Museum Publications Ltd).

1982 *Ancient Ivories in the Middle East and Adjacent Countries* (Qedem, 14; Jerusalem: Hebrew University of Jerusalem).

1986 'The Burgon Lebes and the Iranian Winged Horned Lion', in Kelly-Bucellati (ed.) 1986: 21-27.

Bass, G.F., *et al*.

1989 'The Bronze Age Shipwreck at Ulu Burun: 1986 Campaign', *AJA* 93: 1-29.

Baum, N.

1988 *Arbres et arbustes de l'Egypte ancienne: La liste de la tombe thébaine d'Ineni (no. 81)* (Orientalia Lovaniensia Analecta, 31; Leuven: Peeters).

Baumgartner, W.

1967 *Hebräisches und aramäisches Lexikon zum Alten Testament* (Lieferung, 1; Leiden: E.J. Brill).

Beck, P.

1977 'The Cylinder Seals', in S. Ben-Arie and G. Edelstein (eds.), *Akko: Tombs near the Persian Garden* ('Atiqot English Series, 12; Jerusalem: Department of Antiquities and Museums, Ministry of Education and Culture): 63-69.

1982 'The Drawings from Ḥorvat Teiman (Kuntillet 'Ajrud)', *Tel Aviv* 9: 3-68.

1986 'A New Type of Female Figurine', in Kelly-Buccellati (ed.) 1986: 29-34.

1986a 'A Bulla from Ḥorvat 'Uzza', *Qadmoniot* 19: 40-41.

1996 'Ḥorvat Qitmit Revisited via 'En Ḥazeva, *Tel Aviv* 23: 102-14.

Becking, B.

1983 'The Two Neo-Assyrian Documents from Gezer in their Historical Context', *Jaarbericht van het Vooraziatisch-Egyptisch Genootschap 'Ex Oriente Lux'* 27: 76-79.

Bennett, C.-M.

1984 'Excavations at Tawilan in Southern Jordan, 1982', *Levant* 16: 1-23.

Ben-Tor, A.

1993 'Qashish, Tel', in Stern (ed.) 1993: IV, 1200-203.

Bernett, M., and O. Keel

1998 *Mond, Stier und Kult am Stadttor: Die Stele von Betsaida (et-Tell)* (OBO, 161; Freiburg: Universitätsverlag; Göttingen: Vandenhoeck & Ruprecht).

Bisi, A.M.

1963 'Un bassorilievo di Aleppo e l'iconografia del dio Sin', *OrAnt* 2: 215-21.

Bissing, F.W. von, and H. Kees

1922 *Untersuchungen zu den Reliefs aus dem Re-Heiligtum des Rathures I* (Abhandlungen der Bayerischen Akademie der Wissenschaften, Phil.-Hist. Klasse, 32.1; Munich: Bayerische Akademie der Wissenschaften).

Bleibtreu, E.

1983 'Kulthandlungen im Feldlager Sanheribs', in I. Seybold (ed.), *Meqor Ḥajjim* (Festschrift G. Molin; Graz: Akademische Druck- und Verlagsanstalt): 43-52.

Bloch, A.A.
1995 'The Cedar and the Palm Tree: A Paired Male/Female Symbol in the
 Hebrew and Aramaic', in Z. Zevit *et al.* (eds.), *Solving Riddles and
 Untying Knots: Biblical, Epigraphic, and Semitic Studies in Honor of
 Jonas C. Greenfield* (Winona Lake, IN: Eisenbrauns): 13-17.
Boehmer, R.M.
1965 *Die Entwicklung der Glyptik während der Akkad-Zeit* (Berlin: W. de
 Gruyter).
Boehmer, R.M., and H.G. Güterbock
1987 *Glyptik aus dem Stadtgebiet von Boğazköy: Grabungskampagnen 1931–
 1939, und 1952–1978* (Boğazköy-Ḫattuša, Ergebnisse der Ausgrabungen,
 14; Die Glyptik von Boğazköy, 2; Berlin: Gebrüder Mann).
Bordreuil, P.
1986a *Catalogue des sceaux ouest-sémitiques inscrits de la Bibliothèque nation-
 ale, du Musée du Louvre et du Musée biblique de Bible et terre sainte*
 (Paris: Bibliothèque nationale).
1986b 'Perspectives nouvelles de l'épigraphie sigillaire ammonite et moabite',
 in A. Hadidi (ed.), *Studies in the History and Archaeology of Jordan*, III
 (Amman: Department of Antiquities): 283-86.
1993 'Le répertoire iconographique des sceaux araméens inscrits et son évo-
 lution', in Sass and Uehlinger 1993: 74-100.
Bordreuil, P., and A. Lemaire
1976 'Nouveaux sceaux hébreux, araméens et ammonites', *Sem* 26: 45-69.
Börker-Klähn, J.
1982 *Altvorderasiatische Bildstelen und vergleichbare Felsreliefs* (Baghdader
 Forschungen, 4; Mainz: Philipp von Zabern).
Brandl, B.
1997 'Achsib Nos. 129-162', in Keel 1997: 64-77.
Braun-Holzinger, E.A.
1996 'Altbabylonische Götter und ihre Symbole: Benennung mit Hilfe der
 Siegellegenden', *Baghdader Mitteilungen* 27: 235-359.
Bretschneider, J.
1991 *Architekturmodelle in Vorderasien und der östlichen Ägäis vom Neo-
 lithikum bis in das 1. Jahrtausend* (AOAT, 229; Kevelaer: Butzon &
 Bercker; Neukirchen–Vluyn: Neukirchener Verlag).
Brunner, H.
1975 'Chons', in W. Helck and E. Otto (eds.), *Lexikon der Aegyptologie*, I
 (Wiesbaden: Otto Harrassowitz): 960-63.
Buchanan, B.
1966 *Catalogue of Ancient Near Eastern Seals in the Ashmolean Museum*. I.
 Cylinder Seals (Oxford: Clarendon Press).
1981 *Early Near Eastern Seals in the Yale Babylonian Collection* (New Haven:
 Yale University Press).
Buchanan, B., and P.R.S. Moorey
1988 *Catalogue of Ancient Near Eastern Seals in the Ashmolean Museum*. III.
 The Iron Age (Oxford: Clarendon Press).
Budd, P.J.
1984 *Numbers* (WBC, 5; Waco, TX: Word Books).

Campbell Thompson, R.
 1940 'A Selection from the Cuneiform Historical Texts from Nineveh (1927–
 32)', *Iraq* 7: 85-131.
Caquot, A., and M. Sznycer
 1980 *Ugaritic Religion* (Iconography of Religions, 15.8; Leiden: E.J. Brill).
Cathcart K.J.
 1996 'Ilu, Yariḫu and the One with Two Horns and a Tail', in N. Wyatt, W.G.
 Watson and J.B. Lloyd (eds.), *Ugarit, Religion and Culture: Proceedings
 of the International Colloquium on Ugarit, Religion and Culture, Edin-
 burgh, July 1994: Essays Presented in Honour of Professor John C.L.
 Gibson* (Münster: Ugarit Verlag): 1-7.
Chambon, A.
 1984 *Tell el-Farah.* I. *L'âge du fer* (Recherches sur les grandes civilisations,
 31; Paris: Editions recherches sur les civilisations).
Christie's
 1993 Antiquities, New York, Monday, 14 June 1993.
Clerc, G. *et al.*
 1976 *Fouilles de Kition.* II. *Objets égyptiens et égyptisants* (Nikosia: Depart-
 ment of Antiquities).
Cogan, M.
 1974 *Imperialism and Religion: Assyria, Judah and Israel in the Eighth and
 Seventh Centuries B.C.E.* (SBLMS, 19; Missoula, MT: Scholars Press).
 1993 'Judah under Assyrian Hegemony: A Reexamination of *Imperialism and
 Religion*', *JBL* 112: 403-14.
Cohen, R., and Y. Yisrael
 1995 *On the Road to Edom: Discoveries from 'En Ḥazeva* (Jerusalem: Israel
 Museum).
Collon, D.
 1975 *The Seal Impressions from Tell Atchana/Alalakh* (AOAT, 27; Kevelaer:
 Butzon & Bercker; Neukirchen–Vluyn: Neukirchener Verlag).
 1982 *Catalogue of the Western Asiatic Seals in the British Museum: Cylinder
 Seals II. Akkadian—Post Akkadian—Ur III: Periods* (London: British
 Museum Publications).
 1985 'A North Syrian Cylinder Seal Style: Evidence of North–South Links
 with 'Ajjul', in J.N. Tubb (ed.), *Palestine in the Bronze and Iron Ages:
 Papers in Honour of Olga Tufnell* (London: Institute of Archaeology):
 57-68.
 1986 *Catalogue of the Western Asiatic Seals in the British Museum: Cylinder
 Seals III: Isin-Larsa and Old Babylonian Periods* (London: British
 Museum Publications).
 1987 *First Impressions: Cylinder Seals in the Ancient Near East* (London:
 British Museum Publications).
 1992 'The Near Eastern Moon God', in D.J.W. Meijer (ed.), *Natural Phenom-
 ena: Their Meaning, Depiction and Description in the Ancient Near East*
 (Amsterdam: Royal Academy of Arts and Sciences): 19-37.
Colson, F.H.
 1937 *Philo with an English Translation*, VII (LCL; London: Heinemann; Cam-
 bridge, MA: Harvard University Press).

Cook, S.A.
1925 *The Religion of Ancient Palestine in the Light of Archaeology* (Schweich Lectures 1925; London: British Academy).

Cornelius, I.
1994 *The Iconography of the Canaanite Gods Reshef and Ba'al: Late Bronze and Iron Age I Periods (c. 1500–1000 BCE)* (OBO, 140; Freiburg: Universitätsverlag; Göttingen: Vandenhoeck & Ruprecht).

Crowfoot, J.W., G.M. Kenyon and K.M. Kenyon
1957 *Samaria-Sebaste. III. The Objects from Samaria* (London: Palestine Exploration Fund).

Culican, W.
1970 'Problems of Phoenicio-Punic Iconography—a Contribution', *AJBA* 1.3: 28-57.
1986 *Opera selecta: From Tyre to Tartessos* (Gothenburg: Paul Åström).

Dalman, G.
1906 'Ein neu gefundenes Jahvehbild', *PJ* 2: 44-50.
1928 *Arbeit und Sitte in Palästina. I. Jahreslauf und Tageslauf* (Gütersloh: C. Bertelsmann).

Danthine, H.
1937 *Le palmier-dattier et les arbres sacrés dans l'iconographie de l'Asie Occidentale ancienne* (Bibliothèque archéologique et historique, 25; Paris: Librairie orientaliste Paul Geuthner).

Davies, N.G., and A.H. Gardiner
1948 *Seven Private Tombs at Qurnah* (Mond Excavations at Thebes, 2; London: Egypt Exploration Society).

Day, J.
1986 'Asherah in the Hebrew Bible and Northwest Semitic Literature', *JBL* 105: 385-408.

Delaporte, L.
1910 *Catalogue des cylindres orientaux et des cachets assyro-babyloniens, perses et syro-cappadociens de la Bibliothèque nationale* (2 vols.; Paris: Ernest Leroux).
1920–23 *Catalogue des cylindres orientaux, Musée du Louvre. I. Fouilles et Missions; II. Acquisitions* (2 vols.; Paris: Librairie Hachette).
1939 'Intailles orientales au palais des arts de la ville de Lyon', in *Mélanges syriens offerts à Monsieur René Dussaud*, II (Paris: Librairie orientaliste Paul Geuthner): 907-12.

Delcor, M.
1974 'Astarté et la féconditée des troupeaux en Deut. 7,13 et parallèles', *Ugarit-Forschungen* 6: 7-14.

Delougaz, P.
1952 *Pottery from the Diyala Region* (Oriental Institute Publication, 43; Chicago: University of Chicago Press).

Devries, L.
1977 *Incense Altars from the Period of the Judges and their Significance* (Ann Arbor, MI: University Microfilms).

Dietrich, M., and O. Loretz
1992 *'YHWH und seine Aschera': Anthropomorphes Kultbild in Mesopotamien, Ugarit und Israel: Das biblische Bilderverbot* (Ugaritisch-Biblische Literatur, 9; Münster: Ugarit Verlag).

Dion, P.-E.
1997 *Les araméens à l'âge du fer: Histoire politique et structures sociales* (Ebib, NS 34; Paris: Librairie Lecoffre J. Gabalda).

Dohmen, C.
1995 'Mond', in M. Görg and B. Lang (eds.), *Neues Bibel-Lexikon*, II (Zürich: Benzinger Verlag): 832-34.

Donbaz, V.
1990 'Two Neo-Assyrian Stelae in the Antakya and Kahramanmaraş Museums', *Annual Review of the Royal Inscriptions of Mesopotamia Project* 8: 5-24.

Donner, H., and W. Röllig
1962 *Kanaanäische und aramäische Inschriften*. I. *Texte* (Wiesbaden: Otto Harrassowitz, 2nd edn, 1966).
1968 *Kanaanäische und aramäische Inschriften*. II. *Kommentar* (Wiesbaden: Otto Harrassowitz, 2nd edn [1964]).

Dothan, T.
1976 'Forked Bronze Butts from Palestine and Egypt', *IEJ* 26: 20-34.

Duchesne-Guillemin, J.
1986 'Origines iraniennnes et babyloniennes de la nomenclature astrale', *Comptes rendues des séances de l'académie des inscriptions et belles lettres, avril–juin*: 234-50.

Eidevall, G.
1996 *Grapes in the Desert: Metaphors, Models, and Themes in Hosea 4-14* (ConBOT, 43; Stockholm: Almqvist & Wiksell).

Eisen, G.A.
1940 *Ancient Oriental Cylinder and Other Seals with a Description of the Collection of Mrs William H. Moore* (Oriental Institute Publications, 47; Chicago: University of Chicago Press).

Eitan, J.
1939 'Biblical Studies I. Philological Studies in Hosea', *HUCA* 14: 1-22.

El-Safadi *see* Safadi

Elan, S.
1979 'Der heilige Baum—ein Hinweis auf das Bild ursprünglicher Landschaft in Palästina', MDOG 111: 89-101.

Eliade, M.
1954 *Die Religionen und das Heilige: Elemente der Religionsgeschichte* (Salzburg: Otto Müller Verlag).

Fales, F.M.
1986 *Aramaic Epigraphs on Clay Tablets of the Neo-Assyrian Period* (Studia Semitica, NS 2; Rome: Università degli studi 'La Sapienza').

Fischer, P.M.
1994 'Tell Abu al-Kharaz: The Swedish Jordan Expedition 1992: Third Season Preliminary Excavation Report', *Annual of the Department of Archaeology of the Hashemaite Kingdom of Jordan* 38: 127-45.

Fleming, D.E.
1995 'New Moon Celebration once a Year: Emar's *ḤIDAŠU* of Dagan', in Van
 Lerberghe and Schoors (eds.) 1995: 57-63.
Fournier-Bidoz, A.
1984 'L'arbre et la demeure: Siracide XXIV 10-17', *VT* 34: 1-10.
Frahm, E.
1997 *Einleitung in die Sanherib-Inschriften* (AfO, 26; Vienna: Selbstverlag des
 Instituts für Orientalistik der Universität Wien).
Frankfort, H.
1955 *Stratified Cylinder Seals from the Diyala Region* (Oriental Institute Pub-
 lications, 72; Chicago: University of Chicago Press).
Freedberg, D.
1989 *The Power of Images: Studies in the History and Theory of Response*
 (Chicago: University of Chicago Press).
Frevel, Ch.
1995 *Aschera und der Ausschliesslichkeitsanspruch YHWHs* (BBB, 94; 2 vols.;
 Weinheim: Beltz Athenäum).
Fuhr, I.
1967 *Ein altorientalisches Symbol: Bemerkungen zum sogenannten 'Omega-
 förmigen Symbol' und zur Brillenspirale* (Wiesbaden: Otto Harrassowitz).
Gadd, C.J.
1951 'Note on the Stelae of Açaği Yarimca', *Anatolian Studies* 1: 108-10.
al-Gailani, W.L.
1988 *Studies in Chronology and Regional Style of Old Babylonian Cylinder
 Seals* (Bibliotheca Mesopotamica, 23; Los Angeles: Undena Publi-
 cations).
Galling, K.
1941 'Beschriftete Bildsiegel des ersten Jahrtausend v. Chr. vornehmlich aus
 Syrien und Palästina', *ZDPV* 64: 121-202, pls. 5-12.
1953 'Archäologisch-historische Ergebnisse einer Reise in Syrien und Liban
 (sic) im Spätherbst 1952', *ZDPV* 69: 180-87.
1977 *Biblisches Reallexikon* (Tübingen: J.C.B. Mohr [Paul Siebeck], 2nd edn).
Garelli, P.
1982 'Importance et rôle des araméens dans l'administration de l'empire
 assyrien', in H.-J. Nissen and J. Renger (eds.), *Mesopotamien und seine
 Nachbarn* (XXVᵉ Rencontre assyriologique internationale = Berliner Bei-
 träge zum Vorderen Orient, 1; Berlin: Dietrich Reimer Verlag, 2nd edn,
 1987): 437-47.
Geertz, C.
1973 *The Interpretation of Cultures: Selected Essays* (New York: Basic Books).
Gemünden, P. von
1993 *Vegetationsmetaphorik im Neuen Testament und seiner Umwelt* (NTOA,
 18; Freiburg: Universitätsverlag; Göttingen: Vandenhoeck & Ruprecht).
Genge, H.
1979 *Nordsyrisch-südanatolische Reliefs: Eine archäologisch-historische
 Untersuchung, Datierung und Bestimmung* (2 vols.; Copenhagen:
 Munksgard).

George A.R.
1993 *House Most High: The Temples of Ancient Mesopotamia* (Mesopotamian Civilizations, 5; Winona Lake, IN: Eisenbrauns).
Gese, H.
1970 'Die Religionen Altsyriens', in H. Gese, M. Höfner and K. Rudolph, *Die Religionen Altsyriens, Altarabiens und der Mandäer* (Die Religionen der Menschheit, 10.2; Stuttgart: Kohlhammer): 3-232.
Giveon, R.
1978 *The Impact of Egypt on Canaan: Iconographical and Related Studies* (OBO, 20; Freiburg: Universitätsverlag; Göttingen: Vandenhoeck & Ruprecht).
1985 *Egyptian Scarabs from Western Asia from the Collections of the British Museum* (OBO, Series Archaeologica, 3; Freiburg: Universitätsverlag; Göttingen: Vandenhoeck & Ruprecht).
1988 *Scarabs from Recent Excavations in Israel* (OBO, 83; Freiburg: Universitätsverlag; Göttingen: Vandenhoeck & Ruprecht).
Givon, S.
1995 *The Fifth Season of Excavation at Tel Harassim (Nahal Barkai) 1994: Preliminary Report *5* (Tel Aviv: Institute of Archaeology).
Gjerstad, E., *et al.*
1935 *The Swedish Cyprus Expedition: Finds and Results of the Excavations in Cyprus, 1927–1931*, II (Stockholm: Swedish Cyprus Expedition).
Goetze, A.
1964 'Remarks on the Old Babylonian Itinerary', *Journal of Cuneiform Studies* 18: 114-16.
Goldwasser, O.
1995 *From Icon to Metaphor: Studies in the Semiotics of the Hieroglyphs* (OBO, 142; Freiburg: Universitätsverlag; Göttingen: Vandenhoeck & Ruprecht).
Gombrich, E.H.
1979 *The Sense of Order* (Oxford: Phaidon Press).
Gordon, C.H.
1939 'Western Asiatic Seals in the Walters Art Gallery', *Iraq* 6: 3-34.
1953 'Near Eastern Seals in Princeton and Philadelphia', *Or* NS 22: 242-50.
Görg, M.
1993 'Die "Astarte des Kleinviehs" ', *BN* 69: 9-11.
Grant, E.
1931 *Ain Shems Excavations (Palestine)* (Haverford: Haverford College).
Gray, G.B.
1903 *A Critical and Exegetical Commentary on Numbers* (ICC; Edinburgh: T. & T. Clark).
Green, T.M.
1992 *The City of the Moon God: Religious Traditions of Harran* (Etudes préliminaires aux religions orientales dans l'empire romain, 114; Leiden: E.J. Brill): 19-43.
Greenfield, J.C.
1976 'The Aramean God Rammān/Rimmōn', *IEJ* 26: 195-98.

1987 'Aspects of Aramean Religion', in P.D. Miller, P.D. Hanson and S.D. McBride (eds.), *Ancient Israelite Religion: Essays in Honor of Frank Moore Cross* (Philadelphia: Fortress Press): 67-78.

Gressmann, H.
1927 *Altorientalische Bilder zum Alten Testament* (Berlin: W. de Gruyter, 2nd edn).

Gröndahl, F.
1967 *Die Personennamen der Texte aus Ugarit* (Studia Pohl, 1; Rome: Pontificium Institutum Biblicum).

Gubel, E.
1987 ' "Syro-Cypriote" Cubical Stamps: The Phoenician Connection (Corpus Glyptica Phoenicia 2)', in Lipinski (ed.) 1987: 195-224.

Guy, P.L.O.
1938 *Megiddo Tombs* (Oriental Institute Publication, 33; Chicago: University of Chicago Press).

Hachmann R.
1980 *Kamid el-Loz 1968–1970* (Saarbrücker Beiträge zur Altertumskunde, 22; Bonn: Rudolf Habelt).

Hadley, J.M.
1996 'The Fertility of the Flock? The Depersonalization of Astarte in the Old Testament', in B. Becking and M. Dijkstra (eds.), *On Reading Prophetic Texts: Gender Specific and Related Studies in Memory of Fokkelien van Dijk-Hemmes* (Biblical Interpretation Series, 18; Leiden: E.J. Brill): 115-33.

Haller, A.
1954 *Die Gräber und Grüfte von Assur* (Ausgrabungen der deutschen Orient Gesellschaft in Assur. A: Die Baudenkmäler aus assyrischer Zeit, VII; Berlin: Gebrüder Mann).

Hallo, W.W.
1964 'The Road to Emar', *Journal of Cuneiform Studies* 18: 57-78.
1977 'New Moons and Sabbaths: A Case-Study in the Contrastive Approach', *HUCA* 43: 1-13.

Harding, L.
1971 *An Index and Concordance of Pre-Islamic Names and Inscriptions* (Toronto).

Hartenstein, F.
1995 'Der Beitrag der Ikonographie zu einer Religionsgeschichte Kanaans und Israels', *VF* 40: 74-85.

Hennessy, J.B.
1985 'Thirteenth Century B.C. Temple of Human Sacrifice at Amman', in E. Gubel and E. Lipinski (eds.), *Phoenicia and its Neighbours* (Studia Phoenicia, III; Leuven: Peeters): 85-104.

Hermary, A., *et al.*
1989 *Catalogue des antiquités de Chypre: Sculptures: Musée du Louvre, Département des antiquités orientales* (Paris: Editions de la reunion des musees nationaux).

Hestrin, R.
1987a 'The Lachish Ewer and the Asherah', *IEJ* 37: 212-23.

1987b 'The Cult Stand from Ta'anach and its Religious Background', in Lipin-
 ski (ed.) 1987: 61-77.
Hestrin, R., and M. Dayagi-Mendels
1979 *Inscribed Seals: First Temple Period: Hebrew, Ammonite, Moabite,*
 Phoenician and Aramaic: From the Collections of the Israel Museum and
 the Israel Department of Antiquities and Museums (Jerusalem: Israel
 Museum).
Holloway, St.W.
1995 'Harran: Cultic Geography in the Neo-Assyrian Empire and its Impli-
 cations for Sennacherib's "Letter to Hesekiah" in 2 Kings', in G.W.
 Holloway and L.K. Handy (eds.), *The Pitcher is Broken: Memorial*
 Essays for G.W. Ahlströhm (JSOTSup, 190; Sheffield: Sheffield Aca-
 demic Press): 276-314.
Holzinger, N.
1903 *Numeri* (HKAT; Tübingen: J.C.B. Mohr [Paul Siebeck]).
Homès-Fredericq, D.
1976 'Glyptique sur les tablettes araméennes des Musées Royaux d'Art et
 d'Histoire', *RA* 70: 57-72.
1995 'Deux témoignages des cultes astraux dans les "Archives d'un centre
 provincial" (ACP) conservées aux Musées Royaux d'Art et d'Histoire,
 Bruxelles', in Van Lerberghe and Schoors (eds.), 1995: 107-17.
Hörig, M.
1979 *Dea Syria: Studien zur religiösen Tradition der Fruchtbarkeitsgöttin in*
 Vorderasien (AOAT, 208; Kevelaer: Butzon & Bercker; Neukirchen–
 Vluyn: Neukirchener Verlag).
Horn, S.H.
1962 'Scarabs from Shechem', *JNES* 21: 1-14.
Hornung, E.
1963 *Das Amduat: Die Schrift des verborgenen Raumes.* I. *Text* (Ägypto-
 logische Abhandlungen, 7; Wiesbaden: Otto Harrassowitz).
Hrouda, B.
1965 *Die Kulturgeschichte des assyrischen Flachbildes* (Saarbrücker Beiträge
 zur Altertumskunde, 2; Bonn: Rudolf Habelt).
Hübner, U.
1992 'Der Tanz um die Ascheren', *Ugarit-Forschungen* 24: 121-32.
1992 *Die Ammoniter: Untersuchungen zur Geschichte, Kultur und Religion*
 eines transjordanischen Volkes im 1. Jahrtausend v. Chr. (Abhandlungen
 des deutschen Palästinavereins, 16; Wiesbaden: Otto Harrassowitz).
Hunger, H.
1992 *Astrological Reports to Assyrian Kings* (State Archives of Assyria, 8;
 Helsinki: Helsinki University Press).
Israel, F.
1987 'Studi Moabiti. I. Rassegna di Epigrafia Moabita e i Sigilli', in G. Bernini
 and V. Brugnatelli (eds.), *Atti della 4a Giornata di Studi Camito-Semitici*
 e Indoeuropei (Milano: Edizioni Unicopli): 101-38.
Israeli, Y., and M. Tadmor *et al.*
1986 *Treasures of the Holy Land: Ancient Art from the Israel Museum* (New
 York: Metropolitan Museum of Art).

Jaeger, B.
1982 *Essai de classification et de datation des scarabées Menkhéperrê* (OBO,
 Series Archaeologica, 2; Freiburg: Universitätsverlag; Göttingen: Van-
 denhoeck & Ruprecht).

Jakob-Rost, L.
1975 *Die Stempelsiegel im vorderasiatischen Museum* (Staatliche Museen zu
 Berlin, Vorderasiatisches Museum; Berlin: Akademie Verlag).

Jaroš, J.
1980 'Die Motive der heiligen Bäume und der Schlange in Gen 2–3', *ZAW* 92:
 207-209.
1982 *Die Stellung des Elohisten zur kanaanäischen Religion* (OBO, 4;
 Freiburg: Universitätsverlag; Göttingen: Vandenhoeck & Ruprecht, 2nd
 edn).

Jeremias, J.
1983 *Der Prophet Hosea* (ATD, 24.1; Göttingen: Vandenhoeck & Ruprecht).

Keel, O.
1977 *Jahwe-Visionen und Siegelkunst: Eine neue Deutung der Majestäts-
 schilderungen in Jes 6, Ez 1 und 10 und Sach 4* (SBS, 84/85: Stuttgart:
 Katholisches Bibelwerk, 2nd edn).
1978a 'Grundsätzliches und das Neumondemblem zwischen den Bäumen', *BN*
 6: 40-55.
1978b *Jahwes Entgegnung an Ijob: Eine Deutung von Ijob 38–41 vor dem
 Hintergrund der zeitgenössischen Bildkunst* (FRLANT, 121; Göttingen:
 Vandenhoeck & Ruprecht).
1980 *Das Böcklein in der Milch seiner Mutter und Verwandtes: Im Lichte eines
 altorientalischen Bildmotivs* (OBO, 33; Freiburg: Universitätsverlag;
 Göttingen: Vandenhoeck & Ruprecht).
1984 *Deine Blicke sind Tauben* (SBS, 114/115; Stuttgart: Katholisches Bibel-
 werk).
1986 'Review Article: Ancient Seals and the Bible', *JAOS* 106.2: 307-11.
1989 'Yahweh as Mother Goddess', *TD* 36.3: 233-36.
1990 'Früheisenzeitliche Glyptik in Palästina/Israel', in Keel, Shuval and
 Uehlinger 1990: 331-421.
1992 *Das Recht der Bilder gesehen zu werden: Drei Fallstudien zur Methode
 der Interpretation altorientalischer Bilder* (OBO, 122; Freiburg: Univer-
 sitätsverlag; Göttingen: Vandenhoeck & Ruprecht).
1993a 'Der Wald als Menschenfresser, Baumgarten und Teil der Schöpfung in
 der Bibel und im Alten Orient', in D. Daphinoff (ed.), *Der Wald: Bei-
 träge zu einem interdisziplinären Gespräch* (Seges, 13; Freiburg: Univer-
 sitätsverlag; Göttingen: Vandenhoeck & Ruprecht): 47-71.
1993b 'Frühe Jerusalemer Kulttraditionen und ihre Träger und Trägerinnen', in
 F. Hahn *et al.* (eds.), *Zion Ort der Begegnung* (Festschrift L. Klein; BBB,
 90; Bodenheim: Athenäum): 439-502.
1994a *Studien zu den Stempelsiegeln aus Palästina/Israel*, IV (OBO, 135;
 Freiburg: Universitätsverlag; Göttingen: Vandenhoeck & Ruprecht).
1994b *The Song of Songs: A Continental Commentary* (Philadelphia: Fortress
 Press).

1994c 'Eine Kurzbiographie der Frühzeit des Gottes Israels—im Ausgang von Ausgrabungsbefunden im syro-palästinischen Raum', *Bulletin europäische Gesellschaft für katholische Theologie* 5: 158-75.

1995a *Corpus der Stempelsiegel-Amulette aus Palästina/Israel: Von den Anfängen bis zur Perserzeit. Einleitung* (OBO, Series Archaeologica, 10; Freiburg: Universitätsverlag; Göttingen: Vandenhoeck & Ruprecht).

1995b 'Stamp Seals—The Problem of Palestinian Workshops in the Second Millennium and Some Remarks on the Preceding and Succeeding Periods', in J. Goodnick Westenholz (ed.), *Seals and Sealing in the Ancient Near East* (Bible Lands Museum Jerusalem Publications, 1; Jerusalem: Bible Lands Museum Jerusalem): 93-142.

1995c 'Der zu hohe Preis der Identität oder von den schmerzlichen Beziehungen zwischen Christentum, Judentum und kanaanäischer Religion', in M. Dietrich and O. Loretz (eds.), *Ugarit: Ein ostmediterranes Kulturzentrum im Alten Orient. Ergebnisse und Perspektiven der Forschung. I. Ugarit und seine altorientalische Umwelt* (Münster: Ugarit Verlag): 95-113.

1997a *The Symbolism of the Biblical World: Ancient Near Eastern Iconography and the Book of Psalms* (Winona Lake, IN: Eisenbrauns, 2nd edn).

1997b *Corpus der Stempelsiegel-Amulette aus Palästina/Israel. Von den Anfängen bis zur Perserzeit. Katalog Band I. Von Tell Abu Farağ bis 'Atlit* (OBO, Series Archaeologica, 13; Freiburg: Universitätsverlag; Göttingen: Vandenhoeck & Ruprecht).

Keel, O., and S. Schroer

1985 *Studien zu den Stempelsiegeln aus Palästina/Israel*, I (OBO, 67; Freiburg: Universitätsverlag; Göttingen: Vandenhoeck & Ruprecht).

Keel, O., and Ch. Uehlinger

1994 'Jahwe und die Sonnengottheit von Jerusalem', in W. Dietrich and M.A. Klopfenstein (eds.), *Ein Gott allein? JHWH-Verehrung und biblischer Monotheismus im Kontext der israelitischen und altorientalischen Religionsgeschichte* (OBO, 139; Freiburg: Universitätsverlag; Göttingen: Vandenhoeck & Ruprecht): 269-306.

1995 *Göttinnen, Götter und Gottessymbole: Neue Erkenntnisse zur Religionsgeschichte Kanaans und Israels aufgrund bislang unerschlossener ikonographischer Quellen* (Quaestiones Disputatae, 134; Freiburg: Herder, 3rd edn).

1996 *Altorientalische Miniaturkunst: Die ältesten visuellen Massenkommunikationsmittel: Ein Blick in die Sammlungen des biblischen Instituts der Universität Freiburg* (Freiburg: Universitätsverlag; Göttingen: Vandenhoeck & Ruprecht, 2nd edn).

Keel, O., H. Keel-Leu and S. Schroer

1989 *Studien zu den Stempelsiegeln aus Palästina/Israel*, II (OBO, 88; Freiburg: Universitätsverlag; Göttingen: Vandenhoeck & Ruprecht).

Keel, O., M. Shuval and Ch. Uehlinger

1990 *Studien zu den Stempelsiegeln aus Palästina/Israel. III. Die frühe Eisenzeit: Ein Workshop* (OBO, 100; Freiburg: Universitätsverlag; Göttingen: Vandenhoeck & Ruprecht).

Keel-Leu, H.
1991 *Vorderasiatische Stempelsiegel: Die Sammlung des biblischen Instituts der Universität Freiburg Schweiz* (OBO, 110; Freiburg: Universitäts-verlag; Göttingen: Vandenhoeck & Ruprecht).

Kelly-Buccellati, M. (ed.)
1986 *Insight through Images: Studies in Honor of Edith Porada* (Bibliotheca Mesopotamica, 21; Los Angeles: Undena Publications).

Kepinski, C.
1982 L'arbre stylisée en Asie Occidentale au 2e millénaire avant J.-C. (Editions recherches sur les civilisations, 7; 3 vols.; Paris: Editions recherches sur les civilisations).

Kjaerum, P.
1983 *Failaka/Dilmun: The Second Millenium Settlements I,1: The Stamp and Cylinder Seals* (Jutland Archaeological Society Publications, 17.1; Aarhus: Jysk Arkaeologisk Selskab, Moesgård).

Klengel-Brandt, E.
1989 'Altbabylonische Siegelabrollungen (VS VII-IX)', *Altorientalische Forschungen* 16.2: 253-356.

Kletter, R.
1996 *The Judean Pillar-Figurines and the Archaeology of Asherah* (BAR IS, 636; Oxford: Hadrian Books).

Kloner, A.
1983 'The Synagogue at Ḥorvat Rimon', *Qadmoniot* 16: 65-71.

Knauf, E.A.
1990 ' "O Gott ein Tau vom Himmel giess"': Kanaanäische Mythologie im Kirchenlied', *BN* 50: 34-45.

Koch, K.
1988 'Aschera als Himmelskönigin in Jerusalem', *Ugarit-Forschungen* 20: 97-120.

Kohlmeyer, K.
1992 'Drei Stelen mit Sin-Symbolen aus Nordsyrien', in B. Hrouda, S. Kroll and P.Z. Spanos (eds.), *Von Uruk nach Tuttul* (Festschrift E. Strommenger; Münchner vorderasiatische Studien, 12: Munich: Profil Verlag): 91-100.
1992a 'Ein weiteres Relief mit dem Symbol des Mondgottes von Ḥarran', *Acta praehistorica et archaeologica* 24: 187-89.

Korpel, M.Ch.A.
1990 *A Rift in the Clouds: Ugaritic and Hebrew Descriptions of the Divine* (Münster: Ugarit Verlag).

Kottsieper, I.
1988 'Papyrus Amherst 63—Einführung Text, Übersetzung von 12,11-19', in O. Loretz, *Die Königspsalmen: Die altorientalisch-kanaanäische Königstradition in jüdischer Sicht*, I (Ugaritisch-Biblische Literatur, 6; Münster: Ugarit Verlag): 55-75.
1997 'El—ferner oder naher Gott? Zur Bedeutung einer semitischen Gottheit in verschiedenen sozialen Kontexten im 1. Jahrtausend v. Chr.' in R. Albertz (ed.), *Religion und Gesellschaft* (AOAT, 248; Münster: Ugarit-Verlag): 25-47.

Krebernik, M., and U. Seidl
 1997 'Ein Schildbeschlag mit Bukranion und alphabetischer Inschrift', *ZA* 87: 101-11.

Kühne, H.
 1997 'Der Gott in der Mondsichel', *Altorientalische Forschungen* 24: 375-82.

Lambert, W.G.
 1966 'Ancient Near Eastern Seals in Birmingham Collections', *Iraq* 28: 64-83.
 1969 'A Middle Assyrian Medical Text', *Iraq* 31: 28-39.
 1971 'Götterlisten', in E. Weidner and W. von Soden (eds.), *Reallexikon der Assyriologie III* (Berlin: W. de Gruyter): 473-79.

Lamon, R.S., and G.M. Shipton
 1939 *Megiddo I: Seasons of 1925–1934, Strata I–V* (Oriental Institute Publication, 42; Chicago: University of Chicago Press).

Landsberger, B., and W. von Soden
 1965 *Die Eigenbegrifflichkeit der babylonischen Welt: Leistung und Grenze sumerischer und babylonischer Wissenschaft* (Libelli, 142; Darmstadt: Wissenschaftliche Buchgesellschaft).

Lapp, P.W.
 1969a 'The 1968 Excavations at Tell Ta'annek', *BASOR* 195: 1-49.
 1969b 'A Ritual Incense Stand from Taanak', *Qadmoniot* 2: 16-17.

Laroche, E.
 1955 'Divinités lunaires d'Anatolie', *RHR* 74: 1-24.

Layard, H.A.
 1853 *A Second Series of Monuments of Niniveh from Drawings made on the Spot* (London: John Murray).

Legrain, L.
 1951 *Ur Excavations. X. Seal Cylinders* (London: British Museum; Philadelphia: University Museum).

Lemaire, A.
 1983 'Nouveaux sceaux nord-ouest sémitiques' *Sem* 33: 17-31.
 1990 'Cinq nouveaux sceaux ouest-sémitiques', *Studi di egittologia e di antichità puniche* 7: 97-109.

Lewy, J.
 1945–46 'The Late Assyro-Babylonian Cult of the Moon and its Culmination at the Time of Nabonidus', *HUCA* 19: 405-89.

Lipinski, E.
 1988 'Art. Aramäer', in M. Görg and B. Lang (eds.), *Neues Bibel lexikon* (Zürich: Benzinger): 146-48.
 1994 'The Moon-God of Ḥarran in Aramaean Cult and Onomastics', in *idem*, *Studies in Aramaic Inscriptions and Onomastics II* (Orientalia Lovaniensia Analecta, 57; Leuven: Peeters): 171-92.
 1996 'Egypto-Canaanite Iconography of Reshef, Ba'al, Ḥoron, and Anat', *Chronique d'Egypte* 71 (fasc. 142): 254-62.

Lipinski, E. (ed.)
 1987 *Phoenicia and the East Mediterranean in the First Millennium BC: Proceedings of the Conference Held in Leuven from the 14th to the 16th of November 1985* (Studia Phoenicia, 5; Orientalia Lovaniensia Analecta, 22; Leuven: Peeters).

Lloyd, S.
1954 'Sultantepe II', *Anatolian Studies* 4: 101-10.

Lloyd, S., and N. Gökçe
1953 'Sultantepe: Anglo-Turkish Joint Excavations, 1952', *Anatolian Studies* 3: 27-51.

Loewenstamm, S.E.
1992 'Ostracon 7 from Arad Attesting the Observance of the New-Moon Day', in *idem, From Babylon to Canaan: Studies in the Bible and its Oriental Background* (Jerusalem: Magnes Press): 131-35.

Loud, G.
1948 *Megiddo. II. Seasons of 1935–39* (Oriental Institute Publication, 62; Chicago: University of Chicago Press).

Loud, G., and C.B. Altman
1938 *Khorsabad. II. The Citadel and the Town* (Oriental Institute Publication, 40; Chicago: University of Chicago Press).

Luckenbill, D.D.
1926 *Ancient Records of Assyria and Babylonia*, I (Chicago: Chicago University Press).

Luschan, F. von, and W. Andrae
1943 *Ausgrabungen in Sendschirli. V. Die Kleinfunde von Sendschirli* (Staatliche Museen zu Berlin, Mitteilungen aus den Orientalischen Sammlungen, 15; Berlin: W. de Gruyter).

Macalister, R.A.S.
1912 *The Excavation of Gezer: 1902–1905 and 1907–1909* (3 vols.; London: John Murray).

Machinist, P.
1984–85 'The Assyrians and their Babylonian Problem: Some Reflections', in *Wissenschaftskolleg—Institute for Advanced Study—zu Berlin: Jahrbuch 1984/1985*: 353-64.

Mackay, E.J.H., and M.A. Murray
1952 *Ancient Gaza V* (British School of Archaeology in Egypt, 64; London: British School of Aechaeology in Egypt).

Maier, C., and J. Tropper
1998 'El—ein aramäischer Gott?, *Biblische Notizen* 93, forthcoming.

Mallet, J.
1988 *Tell el-Fâr'ah. II.2. Le Bronze Moyen* (Editions recherches sur les civilisations, 66; Paris: Editions recherches sur les civilisations).

Marinatos, N.
1989 'The Tree as a Focus of Ritual Action in Minoan Glyptic Art', in I. Pini (ed.), *Fragen und Probleme der bronzezeitlichen ägäischen Glyptik. Beiträge zum 3. Internationalen Marburger Siegel-Symposium, 5.-7. 9. 1985* (Corpus der Minoischen und Mykenischen Siegel, 3; Berlin: Gebrüder Mann): 125-42.

1993 *Minoan Religion: Ritual, Image and Symbol* (Studies in Comparative Religion; Columbia, SC: University of South Carolina Press).

Markoe, G.
1985 *Phoenician Bronze and Silver Bowls from Cyprus and the Mediterranean* (University of California Publications: Classical Studies, 26; Berkeley: University of California Press).

Matthäus, H.
1985 *Metallgefässe und Gefässuntersätze der Bronzezeit, der geometrischen und archaischen Periode auf Cypern* (Prähistorische Bronzefunde II, 8; Munich: C.H. Beck).

Matthews, D.M.
1990 *Principles of Composition in Near Eastern Glyptic of the Later Second Millennium B.C.* (OBO, Series Archaeologica, 8; Freiburg: Universitäts-verlag; Göttingen: Vandenhoeck & Ruprecht).
1992 *The Kassite Glyptic of Nippur* (OBO, 116: Freiburg: Universitätsverlag; Göttingen: Vandenhoeck & Ruprecht).
1997 *The Early Glyptic of Tell Brak: Cylinder Seals of Third Millennium Syria* (OBO, Series Archaeologica, 15; Freiburg: Universitätsverlag; Göttingen: Vandenhoeck & Ruprecht).

Matthiae, P.
1993 'L'air sacrée d'Ishtar à Ebla: Résultats des fouilles de 1990–1992', *Académie des inscriptions et belles lettres: Comptes rendus des séances de l'année 1993* (juillet–octobre): 613-62.

May, H.G.
1939 'The Sacred Tree on Palestine Painted Pottery', *JAOS* 59: 251-59.

McCown, Ch.
1947 *Tell en-Naṣbeh: Excavated under the Direction of the Late William Frederic Badè*. I. *Archaeological and Historical Results* (Berkeley: Palestine Institute of Pacific School of Religion; New Haven: American School of Oriental Research).

McKay, J.
1973 *Religion in Judah under the Assyrians 732–609 BC* (SBT, 2.26; London: SCM Press).

Meekers, M.
1987 *The Sacred Tree on Cypriote Cylinder Seals* (Cyprus: Report of the Department of Antiquities): 66-76.

Menant, J.
1888 *Collection de Clercq: Catalogue méthodique et raisonné*. I. *Cylindres orientaux* (Paris: Editeur Ernest Leroux).

Merhav, R. (ed).
1987 *Treasures of the Bible Lands* (Tel Aviv: Modan).

Mettinger, T.N.D.
1995 *No Graven Image: Israelite Aniconism in its Ancient Near Eastern Context* (ConBOT, 42; Stockholm: Almqvist & Wiksell).

Metzger, M.
1983 'Gottheit, Berg und Vegetation in vorderorientalischer Bildtradition', *ZDPV* 99: 54-94.
1991 'Zeder, Weinstock und Weltenbaum', in D.R. Daniels, U. Glessmer and M. Rösel (eds.), *Ernten, was man sät* (Festschrift K. Koch; Neukirchen–Vluyn: Neukirchener Verlag): 197-229.

1992 'Der Weltenbaum in vorderorientalischer Bildtradition', in *Unsere Welt—Gottes Schöpfung* (Festschrift E. Wölfel; Marburger Theologische Studien, 32; Marburg: N.G. Elwert): 1-34.

Meyers, C.L.
1976 *The Tabernacle Menorah* (ASOR Dissertation Series, 2; Missoula, MT: Scholars Press).

Millard, A.R.
1983 'Assyrians and Arameans', *Iraq* 45: 101-108.

Mode, H.
1950 'Über einige syrische Rollsiegel aus Schweizer Sammlungen', *Archiv Orientální* 18: 82-87.

Moortgat, A.
1940 *Vorderasiatische Rollsiegel: Ein Beitrag zur Geschichte der Steinschneidekunst* (Berlin: Gebrüder Mann).

Moortgat-Correns, U.
1968 'Die ehemalige Rollsiegelsammlung Erwin Oppenländer', *Baghdader Mitteilungen* 4: 233-93.

Moussa, A.M., and H. Altenmüller
1971 *The Tomb of Nefer and Ka-hay* (Mainz: Philipp von Zabern).
1977 *Das Grab des Nianchchnum und Chnumhotep* (Mainz: Philipp von Zabern).

Naveh, J.
1982 *Early History of the Alphabet* (Jerusalem: Magnes Press; Leiden: E.J. Brill).

Negbi. O.
1970 *The Hoards of Goldwork from Tell el-'Ajjul* (Studies in Mediterranean Archaeology, 25; Göteborg: Södra Vägen).
1976 *Canaanite Gods in Metal: An Archaeological Study of Ancient Syro-Palestinian Figurines* (Tel Aviv: Institute of Archaeology).

Nielsen, K.
1989a *There Is Hope for a Tree: The Tree as Metaphor in Isaiah* (JSOTSup, 65; Sheffield: Sheffield Academic Press).
1989b 'עץ *'eṣ*', *ThWAT*, VI, 286-97.

Noth, M.
1966 *Das vierte Buch Mose: Numeri* (ATD, 7; Göttingen: Vandenhoeck & Ruprecht).

Nougayrol, J.
1939 *Cylindres-sceaux et empreintes de cylindres trouvés en Palestine* (Bibliothèque archéologique et historique, 33; Paris: Librairie orientaliste Paul Geuthner).

Nulman, M.
1987–88 'Rosh Hodesh; Musical and Liturgical Observations', *Journal of Jewish Music and Liturgy* 10: 18-31.

Oestreich, B.
1997 'Metaphors and Similes for Yahweh in Hosea 14.2-9 (1-8): A Study of Hoseanic Pictorial Language' (unpublished PhD dissertation; Berrien Springs, MI).

Oestreicher, T.
1923 *Das deuteronomische Grundgesetz* (Beiträge zur Förderung christlicher Theologie, 27.4; Gütersloh: Gütersloher Verlagshaus).

Ohnefalsch-Richter, M.
1893 *Kypros, die Bibel und Homer: Beiträge zur Kultur-, Kunst-, und Religionsgeschichte des Orients im Alterthume* (2 vols.; London: Asher).

Olyan, S.M.
1987 'Some Observations Concerning the Identity of the Queen of Heaven', *Ugarit-Forschungen* 19: 161-74.

Oren, E.D.
1993 'Tel Sera'', in Stern (ed.) 1993: IV, 1329-35.

Orthmann, W.
1971 *Untersuchungen zur späthethitischen Kunst* (Saarbrücker Beiträge zur Altertumskunde, 8; Bonn: Rudolf Habelt Verlag).
1975 *Der Alte Orient* (Propyläen Kunstgeschichte, 14; Berlin: Propyläen Verlag).

Osten, H.H. von der
1934 *Ancient Oriental Seals in the Collection of Mr. Edward T. Newell* (Oriental Institute Publications, 22; Chicago: University of Chicago Press).
1936 *Ancient Oriental Seals in the Collection of Mrs. Agnes Baldwin Brett* (Oriental Institute Publications, 37; Chicago: University of Chicago Press).
1957 *Altorientalische Siegelsteine der Sammlung H. Silvius von Aulock* (Studia Ethnographica Upsaliensia, 13; Uppsala: Almqvist & Wiksell).

Palagia, O.
1986 'Daphne', in J.-Ch. Balty *et al.*, *Lexicon Iconographiae Mythologiae Classicae* III.1 (Munich: Artemis Verlag): 344-48.

Parker, B.
1949 'Cylinder Seals from Palestine', *Iraq* 11: 1-43.
1955 'Excavations at Nimrud, 1949–1953: Seals and Seal Impressions', *Iraq* 17: 93-125.

Parpola, S.
1970 *Neo-Assyrian Toponym Names* (AOAT, 6; Kevelaer: Butzon & Bercker; Neukirchen–Vluyn: Neukirchener Verlag).
1983 *Letters from Assyrian Scholars to the Kings Esarhaddon and Assurbanipal. II. Commentary and Appendices* (AOAT, 5.2; Kevelaer: Butzon & Bercker; Neukirchen–Vluyn: Neukirchener Verlag).
1993 *Letters from Assyrian and Babylonian Scholars* (State Archives of Assyria, 10; Helsinki: Helsinki University Press).

Parrot, A.
1954 'Les fouilles de Mari: 9ème campagne (Automne 1953)', *Syria* 31: 151-71.
1958 *Mission archéologique de Mari. II. Peintures murales* (Bibliothèque archéologique et historique, 69; Paris: Librairie orientaliste Paul Geuthner).
1962 *Sumer, Die mesopotamische Kunst von den Anfängen bis zum XII. vorchristlichen Jahrhundert* (Munich: C.H. Beck, 2nd edn).

Paterson, A.
1917 *Assyrian Sculptures: Palace of Sinnacherib* (The Hague: Martinus Nij-
 hoof).
Petrie, F.
1928 *Gerar* (British School of Archaeology in Egypt, 43; London: British
 School of Archaeology in Egypt).
1930 *Beth-Pelet.* I. *Tell Fara* (British School of Archaeology in Egypt, 48;
 London: British School of Archaeology in Egypt).
1931 *Ancient Gaza.* I. *Tell el-Ajjūl* (British School of Archaeology in Egypt,
 53; London: British School of Archaeology in Egypt).
Pieper, M.
1930 'Die Bedeutung der Skarabäen für die palästinenische Altertumskunde',
 ZDPV 53: 185-99.
Porada, E.
1947 *Seal Impressions of Nuzi* (AASOR, 24; Cambridge, MA: American
 Schools of Oriental Research).
1948 *Corpus of Ancient Near Eastern Seals in American Collections.* I. *The
 Collection of the Pierpoint Morgan Library* (Bollingen Series, 15; New
 York: Pantheon).
1957 'Syrian Seal Impressions on Tablets Dated in the Time of Hammu-rabi
 and Samsu-iluna', *JNES* 16: 192-97.
1983 'A Syrian Seal from East Karnak', *Journal for the Society for the Study of
 Egyptian Antiquities* 13: 237-40.
Postgate, J.N.
1975 Ḥarrān, in D.O. Edzard (ed.), *Reallexikon der Assyriologie und vorder-
 asiatischen Archäologie* (Berlin: W. de Gruyter), IV, 122-25.
Pritchard, J.B.
1954 *Ancient Near Eastern Pictures Relating to the Old Testament* (Princeton,
 NJ: Princeton University Press).
1969 *The Ancient Near East: Supplementary Texts and Pictures Relating to the
 Old Testament* (Princeton, NJ: Princeton University Press).
Puech, E.
1980 'Inscriptions sur sceaux et tessons incisés', in J. Briend and J.B. Humbert
 (eds.), *Tell Keisan (1971–1976): Une cité phénicienne en Galilée* (OBO,
 Series Archaeologica, 1; Freiburg: Universitätsverlag; Göttingen: Van-
 denhoeck & Ruprecht; Paris: J. Gabalda): 296-99.
Refai, H.
1996 *Die Göttin des Westens in den thebanischen Gräbern des Neuen Reiches*
 (Abhandlungen des deutschen archäologischen Instituts, Abteilung Kairo,
 Ägyptologische Reihe, 12; Berlin: Achet Verlag).
Reich, R., and B. Brandl
1985 'Gezer under Assyrian Rule', *PEQ* 117: 41-54.
Reichert, A.
1977 'Kultgeräte', in Galling 1977: 189-94.
Reinhold, G.G.G.
1989 *Die Beziehungen Altisraels zu den aramäischen Staaten in der
 israelitisch-judäischen Königszeit* (Europäische Hochschulschriften,
 23.368; Bern: Peter Lang).

Reisner, G.A., C.S. Fisher and D.G. Lyon
1924 *Harvard Excavations at Samaria*, I (Cambridge, MA: Harvard University Press).

Robertson Smith, W.
1889 *Lectures on the Religion of the Semites* (London); German translation: *Die Religion der Semiten* (Tübingen: J.C.B. Mohr [Paul Siebeck], 1899; repr. Darmstadt: Wissenschaftliche Buchgesellschaft, 1967).

Ronzevalle, P.S.
1938 'Notes et études d'archéologie orientale: Jupiter Héliopolitain, nova et vetera', *Mélanges de l'Université Saint Joseph* 21.1: 1-181.

Rowe, A.
1936 *A Catalogue of Egyptian Scarabs, Scaraboids, Seals and Amulets in the Palestine Archaeological Museum* (Cairo: Institut français d'archéologie orientale).

Rudolph, W.
1966 *Hosea* (KAT, 13.1; Gütersloh: Gütersloher Verlagshaus).

Safadi
1974 'Die Entstehung der syrischen Glyptik und ihre Entwicklung in der Zeit von Zimrilim bis Ammitaqumma. I', *Ugarit-Forschungen* 6: 313-52.

Salje, B.
1990 *Der 'Common Style' der Mitanni-Glyptik und die Glyptik der Levante und Zyperns in der Späten Bronzezeit* (Baghdader Forschungen, 11; Mainz Philipp von Zabern).

Sass, B.
1988 *The Genesis of the Alphabet and its Development in the Second Millennium B.C.* (Ägypten und Altes Testament, 13; Wiesbaden: Otto Harrassowitz).

Sass, B., and C. Uehlinger (eds.)
1993 *Studies in the Iconography of Northwest Semitic Inscribed Seals* (OBO, 125; Freiburg: Universitätsverlag; Göttingen: Vandenhoeck & Ruprecht).

Schaeffer, C.F.A.
1929 'Les fouilles de Minet el-Beida et de Ras Shamra', *Syria* 10: 285-97.
1937 'Les fouilles de Ras-Shamra-Ugarit: Huitième campagne (printemps 1936), rapport sommaire', *Syria* 17: 105-48.
1938 'Les fouilles de Ras-Shamra-Ugarit: Neuvième campagne (1937)', *Syria* 19: 313-27.

Schaeffer-Forrer, C.F.A.
1983 *Corpus des cylindres-sceaux de Ras Shamra-Ugarit et d'Enkomi-Alasia I* (Paris: Editions recherche sur les civilisations).

Schmidt, B.B.
1995 'Moon', in Van der Toorn, Becking and Van der Horst 1995: 1098-13.

Schmitt, G.
1995 *Siedlungen Palästinas in griechisch-römischer Zeit* (Beihefte zum Tübinger Atlas des Vorderen Orients. Reihe B, 93; Wiesbaden: Dr Ludwig Reichert Verlag).

Schmitt, J.J.
1995 'Yahweh's Divorce in Hosea 2—Who is that Woman?', *SJOT* 9: 119-32.

Schroer, S.
1987a *In Israel gab es Bilder: Nachrichten von darstellender Kunst im Alten*
 Testament (OBO, 74; Freiburg: Universitätsverlag; Göttingen: Vanden-
 hoeck & Ruprecht).
1987b 'Die Zweiggöttin in Palästina/Israel: Von der Mittelbronze IIB–Zeit bis
 zu Jesus Sirach', in M. Küchler and C. Uehlinger (eds.), *Jerusalem:*
 Texte—Bilder—Steine (NTOA, 6; Freiburg: Universitätsverlag; Göt-
 tingen: Vandenhoeck & Ruprecht): 201-25.
1989 'Die Göttin auf den Stempelsiegeln aus Palästina/Israel', in Keel, Keel-
 Leu and Schroer 1989: 89-207.
1990 'Psalm 65—Zeugnis eines integrativen JHWH-Glaubens', *Ugarit-*
 Forschungen 22: 285-301.
1996 *Die Weisheit hat ihr Haus gebaut: Studien zur Gestalt der Sophia in den*
 biblischen Schriften (Mainz: Matthias Grünewald Verlag).
Schroer, S., and T. Staubli
1993 Der Vergangenheit auf der Spur: Ein Jahrhundert Archäologie im Lande
 der Bibel (Zürich: Freunde des Kinderdorfs Kirjath Jearim).
Seidl, U.
1989 *Die Babylonischen Kudurru-Reliefs: Symbole mesopotamischer Gott-*
 heiten (OBO, 87; Freiburg: Universitätsverlag; Göttingen: Vandenhoeck
 & Ruprecht).
1993 'Kleine Stele aus Til Barsip', *Nouvelles assyriologiques brèves et uti-*
 litaires 3 (September): 72.
Sellers, O.R.
1933 *The Citadel of Beth Zur* (Philadelphia: Westminster Press).
Sellin, E.
1904 *Tell Ta'annek* (Denkschriften der kaiserlichen Akademie der Wissen-
 schaften, Philosophisch-Historische Klasse 50.4; Vienna: Verlag der
 kaiserlichen Akademie der Wissenschaften).
Seyrig, H.
1959 'Antiquités syriennes: No. 69. Deux reliquaires', *Syria* 36: 43-48.
Speleers, L.
1917 *Catalogue des intailles et empreintes orientales des Musées royaux du*
 Cinquantenaire (Brussels: Vromant).
Spieckermann, H.
1982 *Juda unter Assur in der Sargonidenzeit* (FRLANT, 129; Göttingen: Van-
 denhoeck & Ruprecht).
Spycket, A.
1973 'Le culte du dieu-lune à Tell Keisan', *RB* 80: 384-95.
1974 'Nouveaux documents pour illustrer le culte du dieu-lune', *RB* 81: 258-
 59.
Stähli, H.-P.
1985 *Solare Elemente im Jahweglauben des Alten Testaments* (OBO, 66;
 Freiburg: Universitätsverlag; Göttingen: Vandenhoeck & Ruprecht).
Stark, J.K.
1971 *Personal Names in Palmyrene Inscriptions* (Oxford: Clarendon Press).

Starkey, J.L., and L. Harding
1932 *Beth-Pelet II* (British School of Archaeology in Egypt: 52; London: British School of Archaeology in Egypt).

Staubli. T.
1996 *Die Bücher Levitikus: Numeri* (Neuer Stuttgarter Kommentar, Altes Testament, 3; Stuttgart: Katholisches Bibelwerk).

Stern, E.
1978 'New Types of Phoenician Style Decorated Pottery Vases from Palestine', *PEQ* 110: 11-21.

Stern, E. (ed.)
1993 *The New Encyclopedia of Archaeological Excavations in the Holy Land* (4 vols.; Jerusalem: Israel Exploration Society & Carta).

Stoof, M.
1992 *Ägyptische Siegelamulette in menschlicher und tierischer Gestalt: Eine archäologische und motivgeschichtliche Studie* (Europäische Hochschulschriften 38.41; Bern: Peter Lang).

Strommenger, E., and M. Hirmer
1962 *Fünf Jahrtausende Mesopotamien: Die Kunst von den Anfängen um 5000 v. Chr. bis zu Alexander dem Grossen* (Munich: Himer Verlag).

Stuart, D.
1987 *Hosea–Jonah* (WBC, 31; Waco, TX: Word Books).

Tadmor, H.
1982 'The Aramaization of Assyria: Aspects of Western Impact', in H.-J. Nissen and J. Renger (eds.), *Mesopotamien und seine Nachbarn* (XXVe rencontre assyriologique internationale = Berliner Beiträge zum Vorderen Orient, 1; Berlin: Dietrich Reimer Verlag, 2nd edn, 1987): 449-70.

Tångberg, K.A.
1989 ' "I Am Like an Evergreen Fir; From Me Comes Your Fruit": Notes on Meaning and Symbolism in Hosea 14,9b (MT)', *SJOT* 2: 81-93.

Taylor, J.G.
1993 *Yahweh and the Sun: Biblical and Archaeological Evidence for Sun Worship in Ancient Israel* (JSOTSup, 111; Sheffield: Sheffield Academic Press).

Teissier, B.
1984 *Ancient Near Eastern Cylinder Seals from the Marcopoli Collection* (Berkeley: University of California Press; Beverly Hills: Summa).
1993 'The Ruler with the Peaked Cap and other Syrian Iconography on Glyptic from Kültepe in the Early Second Millennium B.C.', in M.J. Mellink, E. Porada and T. Özgüç (eds.), *Aspects of Art and Iconography: Anatolia and its Neighbors: Studies in Honor of Nimet Özgüç* (Ankara: Türk Tarih Kurumyu Basimevi): 601-12.
1994 *Sealing and Seals on Texts from Kültepe KĀRUM Level 2* (Publications de l'Institut historique-archéologique néerlandais de Stamboul, 70; Leiden: Nederlands Instituut voor het Nabije Oosten).
1996 *Egyptian Iconography on Syro-Palestinian Cylinder Seals of the Middle Bronze Age* (OBO, Series Archaeologica, 11; Freiburg: Universitätsverlag; Göttingen: Vandenhoeck & Ruprecht).

Thausing, G., and H. Goedicke
1971 *Nofretari: Eine Dokumentation der Wandgemälde ihres Grabes* (Graz: Akademische Druck- und Verlaganstalt).

Thompson, R.C.
1921 'The Cuneiform Tablet from House D', in C.L. Woolley, *Carchemish: Report on the Excavations at Jerablus on Behalf of the British Museum. II. The Town Defences* (London: Trustees of the British Museum): 135-42.
1940 'A Selection from the Cuneiform Historical Texts from Nineveh (1927–1932)', *Iraq* 7: 85-131.

Thornton, T.C.G.
1989 'Jewish New Moon Festivals, Galatians 4: 3-11 and Colossians 2: 16', *JTS* 40.1: 97-100.

Thureau-Dangin, F., and M. Dunand
1936 *Til-Barsib* (Bibliothèque archéologique et historique, 23; Paris: Librairie orientaliste Paul Geuthner).

Timm, S.
1989 *Moab zwischen den Mächten: Studien zu historischen Denkmälern und Texten* (Ägypten und Altes Testament, 17; Wiesbaden: Otto Harrassowitz).

Tufnell, O., *et al.*
1940 *Lachish II (Tell ed-Duweir): The Fosse Temple* (London: Trustees of the Late Sir Henry Wellcome; Oxford: Oxford University Press).
1953 *Lachish III (Tell ed-Duweir): The Iron Age* (2 vols.; London: Trustees of the Late Sir Henry Wellcome; Oxford: Oxford University Press).
1958 *Lachish IV (Tell ed-Duweir): The Bronze Age* (2 vols.; London: Trustees of the Late Sir Henry Wellcome; Oxford: Oxford University Press).

Tunca, Ö.
1979 'Catalogue des sceaux-cylindres du Musée régional d'Adana', *Syro-Mesopotamian Studies* 3.1: 1-27.

Tushingham, A.D.
1971 'God in a Boat', *AJBA* 1.4: 23-28.

Uehlinger, C.
1992 'Audienz in der Götterwelt: Anthropomorphismus und Soziomorphismus in der Ikonographie eines altsyrischen Zylindersiegels', *Ugarit-Forschungen* 24: 339-59.
1995 'Gab es eine joschijanische Kultreform?', in W. Gross (ed.), *Jeremia und die 'deuteronomistische Bewegung'* (BBB, 98; Weinheim: Beltz Athenäum): 57-89.
1996 'Astralkultpriester und Fremdgekleidete, Kanaanvolk und Silberwäger: Zur Verknüpfung von Kult- und Sozialkritik in Zef 1', in W. Dietrich and M. Schwantes (eds.), *Der Tag wird kommen: Ein interkulturelles Gespräch über das Buch des Propheten Zefanja* (SBS, 170; Stuttgart: Katholisches Bibelwerk): 49-83.
1997a 'Figurative Policy, Propaganda und Prophetie', in J.A. Emerton (ed.), *Congress Volume Cambridge 1995* (VTSup, 66; Leiden: E.J. Brill): 297-349.

1997b 'Anthropomorphic Cult Statuary in Iron Age Palestine and the Search for Yahweh's Cult Images', in K. Van der Toorn (ed.), *The Image and the Book: Iconic Cults, Aniconism, and the Veneration of the Holy Book in Israel and in the Ancient Near East* (Contributions to Biblical Exegesis and Theology, 21; Leuven: Peeters): 97-155).

1998 ' "...und wo sind die Götter von Samarien?" Die Wegführung syrisch-palästinischer Kultstatuen auf einem Relief Sargons II. in Ḫorṣābād/Dūr-Šarrukīn', in M. Dietrich and I. Kottsieper (eds.), *'Und Mose schrieb dieses Lied auf': Studien zum Alten Testament und zum Alten Orient. Festschrift für Oswald Loretz* (Münster: Ugarit-Verlag): 739-76.

Van Buren, E.D.
1933 *The Flowing Vase and the God with Streams* (Berlin: Hans Schoetz).
1945 *Symbols of the Gods in Mesopotamian Art* (AnOr, 23; Rome: Pontificium Institutum Biblicum).
1954 'Seals of the Second Half of the Layard Collection', *Or* 23: 97-113.

Van der Toorn, K.
1996 *Family, Religion in Babylonia, Syria and Israel: Continuity and Change in the Forms of Religious Life* (Studies in the History and Culture of the Ancient Near East, 7; Leiden: E.J. Brill).

Van der Toorn, K., B. Becking and P.W. Van der Horst (eds.)
1995 *Dictionary of Deities and Demons in the Bible* (Leiden: E.J. Brill).

Van Lerberghe, K. and A. Schoors (eds.)
1995 *Immigration and Emigration within the Ancient Near East* (Festschrift E. Lipinski; Orientalia Lovaniensia Analecta, 65; Leuven: Peeters).

Vanel, A.
1965 *L'iconographie du Dieu de l'orage dans le Proche-Orient ancien jusqu'au VIIe siècle avant J.C.* (Cahiers de la Revue biblique, 2; Paris: J. Gabalda).

Veldhuis, N.
1991 *A Cow of Sîn* (Library of Oriental Texts, 1.2; Groningen: Styx).

Vigneau, A.
1935 *Encyclopédie photographique de l'art I* (Paris: Editions 'TEL').

Vincent, H.
1903 'Notes d'épigraphie palestinienne', *RB* 12: 605-12.

Wacker, T.
1991 'Aschera oder die Ambivalenz des Weiblichen', in M.-T. Wacker and E. Zenger (eds.), *Der eine Gott und die Göttin: Gottes-vorstellungen des biblischen Israel im Horizont feministischer Theologie* (Quaestiones Disputatae, 135; Freiburg: Herder): 137-50.

1996 *Figurationen des Weiblichen im Hosea-Buch* (Herders Biblische Studien, 8; Freiburg: Herder).

Ward, W.H.
1910 *The Seal Cylinders of Western Asia* (Washington: Carnegie Institution).

Weippert, H.
1978 'Siegel mit Mondsichelstandarten aus Palästina', *BN* 5: 43-58.
1988 *Palästina in vorhellenistischer Zeit* (Handbuch der Archäologie, 2.1; Munich: Beck).

Wellhausen, J.
1892 *Skizzen und Vorarbeiten*. V. *Die kleinen Propheten übersetzt, mit Noten* (Berlin: W. de Gruyter).

Whitt, W.D.
1992 'The Divorce of YAHWEH and Ashera in Hos 2,4–7.12ff', *SJOT* 6: 31-67.

Wiese, A.
1990 *Zum Bild des Königs auf ägyptischen Siegelamuletten* (OBO, 96; Freiburg: Universitätsverlag; Göttingen: Vandenhoeck & Ruprecht).

Williams Forte, E.
1983 'The Snake and the Tree in the Iconography and Texts of Syria during the Bronze Age', in L. Gorelick and *idem* (eds.), *Ancient Seals and the Bible* (Los Angeles: Undena Publications): 18-43.

Wilke F.
1951 'Das Neumondfest im israelitisch-jüdischen Altertum', *Jahrbuch der Gesellschaft für die Geschichte des Protestantismus in Österreich* 6: 171-83.

Winter, U.
1986a 'Der "Lebensbaum" in der altorientalischen Bildsymbolik', in H. Schweizer (ed.), '... *Bäume braucht man doch!' Das Symbol des Baumes zwischen Hoffnung und Zerstörung* (Sigmaringen: Jan Thorbecke Verlag): 57-88.

1986b 'Der stilisierte Baum: Zu einem auffälligen Aspekt der altorientalischen Baumsymbolik und seiner Rezeption im Alten Testament', *BK* 41: 171-77.

1987 *Frau und Göttin: Exegetische und ikonographische Studien zum weiblichen Gottesbild im Alten Israel und in dessen Umwelt* (OBO, 53; Freiburg: Universitätsverlag; Göttingen: Vandenhoeck & Ruprecht, 2nd edn).

Wolff, H.W.
1961 *Dodekapropheton*. I. *Hosea* (BKAT, 14.1; Neukirchen–Vluyn: Neukirchener Verlag).

1974 *Hosea* (Hermeneia; Philadelphia: Fortress Press).

Yadin, Y.
1958 *Hazor*. I. *An Account of the First Season of Excavations, 1955* (Jerusalem: Magnes Press).

1960 *Hazor*. II (Jerusalem: Magnes Press).

1975 *Hazor: The Rediscovery of a Great Citadel of the Bible* (London: Weidenfeld & Nicolson).

Zadok, R.
1985 'Samarian Notes', *BibOr* 42: 567-72.

Zatelli, I.
1995 'Constellations מַזָּלוֹת', in Van der Toorn, Becking and Van der Horst 1995: 386-91.

Zimmerli, W.
1969 *Ezechiel* (BKAT, 13.2; Neukirchen–Vluyn: NeukirchenerVerlag).

Zwickel, W.
1996 'Review of Frevel 1995', *Die Welt des Orients* 27: 187-89.

INDEXES

INDEX OF REFERENCES

Other Ancient References
Philo
Spec. Leg.
2.140 — 108
2.143 — 85

Josephus
Apion
1.199 — 55

Classical
Euripides
The Bacchanals
274-76 — 51

Ovid
Metamorphoses
1.545-56 — 37

INDEX OF AUTHORS